PSYCHEDELIC CHIC

Artistic Fashions of the Late 1960s & Early 1970s

Roseann Ettinger

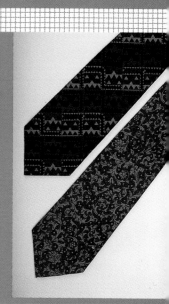

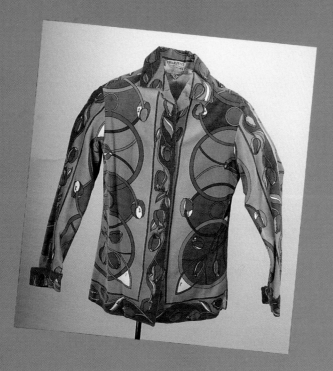

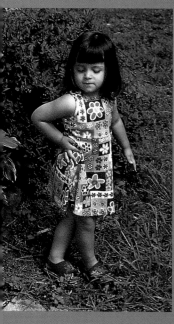

Schiffer Publishing Ltd®

4880 Lower Valley Road, Atglen, PA 19310 USA

Dedication

To Ann. You are dearly missed.

Acknowledgments

Gracious thanks to the following people for either finding me some great stuff to buy or allowing me to photograph their great stuff: Lee Herling, Anita Davis, Marlene Franchetti, and Pat McElwee.

I am also grateful to Doug Congdon-Martin for giving my daughter, Amber, the encouragement she needed in front of the camera in a studio setting.

Last but certainly not least, to my four children, Clint, Amber, Alexandra, and Sabrina. You were all great models and I am extremely happy that you became a part of this book. Thank you kids!

**Library of Congress
Cataloging in-Publication Data**

Ettinger, Roseann.
 Psychedelic chic: artistic fashions of the late 1960s & early 1970s/Roseann Ettinger.
 p. cm.
 Includes bibliographical references.
 ISBN 0-7643-0811-4
 1. Costume--United States--History--20th century.
2. Psychedelic art--United States. 3. Nineteen sixties.
4. Nineteen seventies. I. Title.
 GT615.E886 1999
 391'.00973'09046--dc21 99-14562
 CIP

Designed by "Sue"
Type set in Van Dijk/Souvenir Lt BT

ISBN: 0-7643-0811-4
Printed in China
1 2 3 4

Published by Schiffer Publishing Ltd.
4880 Lower Valley Road
Atglen, PA 19310
Phone: (610) 593-1777; Fax: (610) 593-2002
E-mail: Schifferbk@aol.com
Please visit our web site catalog at **www.schifferbooks.com**

This book may be purchased from the publisher.
Include $3.95 for shipping.
Please try your bookstore first.
We are interested in hearing from authors
with book ideas on related subjects.
You may write for a free catalog.

In Europe, Schiffer books are distributed by
Bushwood Books
6 Marksbury Rd.
Kew Gardens
Surrey TW9 4JF England
Phone: 44 (0)181 392-8585; Fax: 44 (0)181 392-9876
E-mail: Bushwd@aol.com

Contents

Preface

Out of all the books I have written over the past eight years, I don't think any one of them excited me as much as this one. I am still trying to figure out if it was the subject matter or the fact that my children were a part of it. Honestly, I believe it was a little of both!

In any case, while working on this book I began to appreciate the artistry involved in the fashions from the late '60s and early '70s, but more specifically the prints. I tried to recall my own wardrobe from that era. In retrospect, having been a teenager in the late '60s, I would call myself a "Mod." For a short time, I had an asymmetrical haircut, made popular at that time by Vidal Sassoon. My wardrobe consisted of short baby doll dresses printed with small floral prints sometimes referred to as "granny prints." Many of the dresses had matching shoulder bags made of the same fabric as the dress, attached to a chain handle. Mods also loved stripes and I had quite a few horizontal-striped mini dresses which I wore with chain-link belts and vinyl go-go boots. I also wore belted tunic tops with matching flared-leg pants, plaid and checked jumpers, and vinyl mini-skirts.

One of my favorite outfits, which really stands out in my mind, was a two-piece "hot pants" outfit. The blouse was made of a semi-sheer voile fabric which was printed with vertical stripes in fluorescent orange, pink, purple, and a touch of white. The hot pants were fluorescent orange with a 4-inch wide vinyl belt printed with the same vertical stripes as the blouse. I wish I knew what my mother ever did with that outfit!

In 1971, the hot pants craze was still going strong in my town. All of my friends were wearing them. To my dismay, however, my date appeared at my high school graduation party wearing hot pants as well. You can be sure I never felt the same about them again!!!

After that silly craze, I remember the wide assortment of printed polyester knit blouses I loved to wear. They were extremely colorful, comfortable, and very artistic. I probably had about twenty of them, all printed with unusual designs. Some were flowery, some were geometric, and some told stories. I wore them all through college with my hip hugger bell-bottomed jeans and platform shoes. Those were some crazy days!

Unfortunately, when I was young, I was not familiar with the wonderful prints designed by Emilio Pucci or some of the other great Sixties' designers. I really don't think that the stores in my town carried those designs or catered to the "jet set." Fortunately, however, as the years went by and I became involved in the vintage clothing business, I was always on the lookout for that unique design or that wonderful print to add to my collection. It wasn't until the early 1990s that I would even consider buying polyester, let alone the psyche-

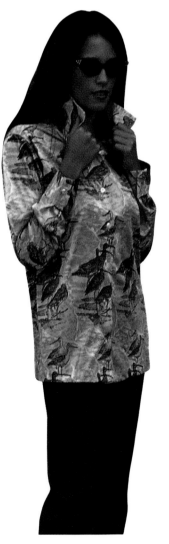

delic prints that I grew up with. All through the 1980s, if I found a garment made of polyester while on my buying trips, I would not even look at it, let alone buy it. If the colors were too loud or the print was too wild, I'd pass it up. But something happened to me in the 1990s. I began to look at the 1960s in a whole different light. I think it all started when I bought my first Pucci!

Nylon blouse with bird motif. Labeled: Lanvin, Paris, New York. Modeled by the author's daughter, Amber Ettinger. $35-50.

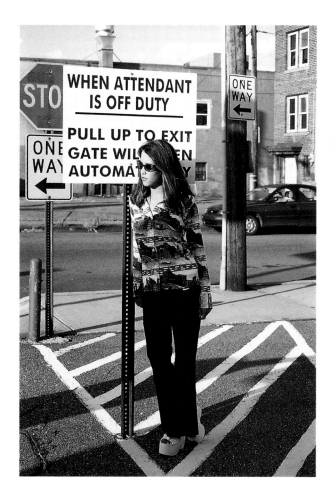

Conversation print blouse made of polyester with Italian scenic motif. No label. $25-35.

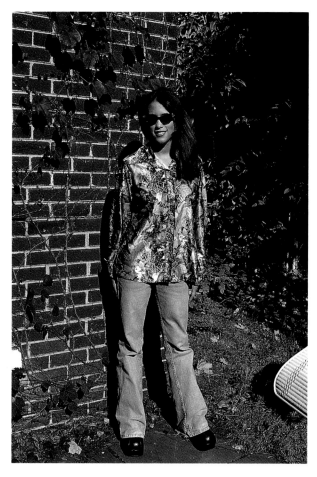

Conversation print blouse made of polyester with scenic motif. Labeled: Russ Togs, Inc. $20-30.

Conversation print blouse made of polyester with photographic print of birds in the woods. Labeled: Styled by Terry, Chicago. $25-35.

Introduction

The overall fashion picture of the late 1960s and early 1970s was one of brilliant color and artistic design. A tremendous amount of experimentation by designers, apparel manufacturers, and textile mills took place to ultimately create one of the most colorful periods in twentieth century fashion. New yarns were constantly being developed to create better fabrics. Natural yarns, synthetic yarns, and a large assortment of blends were made available for weaving and knitting new fabrics. Technology created infinite variety.

The knitting industry boomed in the late 1960s, actually tripling its volume of business since 1960. Comfort in dress became a significant factor at that time. According to *American Fabrics* in 1967, the factors contributing to this change were as follows:

As our society becomes more industrialized, more affluent and more sophisticated, it seeks to avoid the additive qualities, the fripperies and extravagant display of earlier periods. Our architecture and our product design have become simpler in form and decoration. And so has the fashion silhouette, a silhouette geared to a modern, fast-paced way of life where human relationships are more casual, more informal, more democratic and less imbedded in protocol than those of any previous society. In this society, for this way of life, knit (stretch) fabrics truly fill a need. Not only do they satisfy the physical needs of the people who wear them; not only are they psychologically attuned to the patterns of our living today; but on a quite different level they fill a technical need in a society where the disappearing hand skills of tailor and seamstress are being replaced by automation.

The above paragraph was actually printed twice in *American Fabrics* in the 1960s. In the earlier part of the decade, these words were written about "stretch" fabrics, which became revolutionary at that time. Later on, in 1967, the word stretch was replaced by the word "knit."

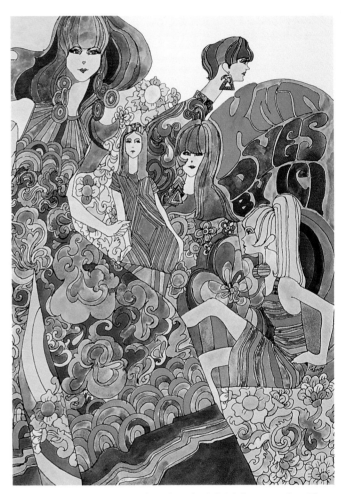

Original advertisement for knit dyes by I.C.I./ Organics, Inc. This colorful ad displays florals, stripes, psychedelics, Art Nouveau, and Op Art prints. *American Fabrics*, 1967.

Opposite page, top:
The caption from this original ad, which read: "Great Fashion starts with great Fibers From Celanese," tells it all. This picture is worth a thousand words! *American Fabrics*, Fall & Winter, 1967.

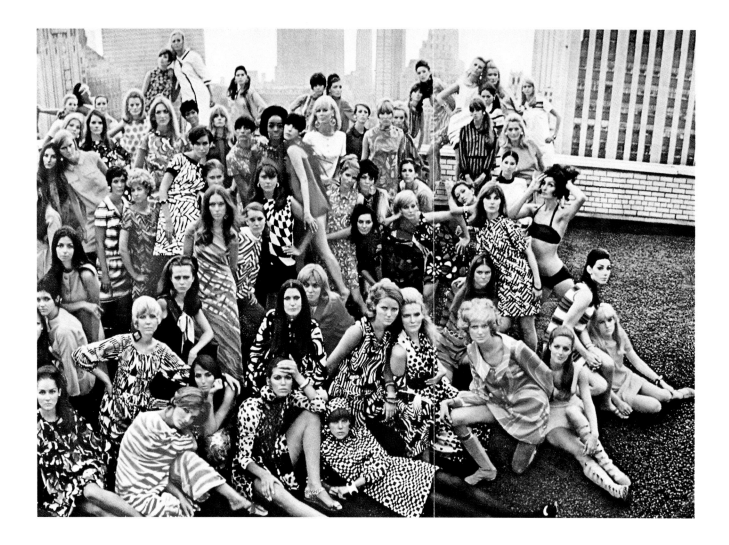

We cannot, however, forget that it was the "youth movement" of the 1960s which set the pace for change and that ultimately stirred the fashion industry. Enthusiasm was running rampant in this era and young people, breaking away from the values, the ideas, and the dress codes of their parents, began setting their own trends. Old-fashioned tradition was a thing of the past. It now became a revolution in fashion.

The Mod, for instance, strove for a unique and individual approach to fashion. Although wanting to be "elegant," the Mod was also somewhat "rebellious." It all began in London. Carnaby Street was headquarters for the male Mod, and top British designer, John Stephens, set the pace. For the female Mod, it was King's Road and Mary Quant who provided the inspiration.

Female Mods loved polka dots, stripes, and checked patterns as well as small floral prints. Bright colors were a must and most of the time displayed with unusual color combinations. Vinyl coats, boots, paper dresses, chunky-heeled shoes, and colorful plastic jewelry were all part of the Mods' repertoire. The boyish look for Mods, which was also popularized by Mary Quant, went perfectly with the boyish haircuts made popular by Vidal Sassoon.

Male Mods loved tight-fitting checked "hipster" pants worn with double-breasted jackets. They were also fond of patterned shirts, especially small floral prints. Shoes for British male Mods were square-toed and made of leather and suede. This type of shoe was first designed by Steve Topper, an eighteen-year-old Carnaby Street shoe designer.

From London, the craze spread to New York City and other metropolitan areas. Boutiques catering to the Mod were opening up in major cities across the country. Sears, J.C.Penny, and other nationwide chains also opened Mod boutiques in the 1960s. The trend eventually filtered its way down to the small town, family-owned department stores.

From the select group of London's "individualists," the trend picked up speed and spread far and wide, adapting itself to the mass market. Major manufacturers of men's and women's apparel began promoting "Mod" clothing for those with discriminating taste. Ironically, it was no longer just for the youth, although it began with them and because of them.

The social climate of the 1960s was blustery, to say the least. Many factors contributed to these unstable conditions. Vietnam, the Pill, drugs, hippies, race riots

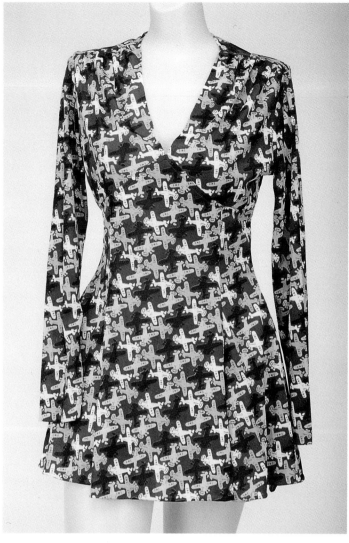

Long sleeve mini-dress designed with a v-neckline and Empire waist made of nylon jersey with an airplane print rendered in beige, white, and purple on a red background. $45-55.

consumer dared to be different. So different, in fact, that on one side of the fashion picture one found elegant, sophisticated, trendy, groovy, and expensive chic, while on the other side the fashion picture featured the anti-establishment look made up of those who wore jeans, T-shirts, and recycled military clothing. Clothing was worn as an expression of personal feelings, ideas, and attitudes. Ironically, the youth movement which created the 1960s revolution in fashion ultimately influenced all age groups and all financial levels.

Thirty years later, our youth are once again wearing bell-bottomed pants and platform shoes. Short dresses are designed with floral prints, animal prints, and psychedelic prints reminiscent of the past. Contemporary designers and collectors are avidly seeking vintage Pucci dresses and accessories, Op Art and Pop Art designs, paper fashions, and polyester shirts with wild conversation prints. High prices are being paid for vintage apparel from the late 1960s and early 1970s. In 1997, for example, William Doyle Galleries in New York City held a "Couture & Textile" auction. An A-line paper dress printed in an all-over pattern of the Campbell Soup label sold for $2,185, well above the auction estimate of $200-300. A Pucci silk jersey day dress designed with short sleeves and printed in black and white, with a long stemmed rose separating the two tones, sold for over $450. In 1998, a Pucci two-piece sequined evening gown sold for $4,312 at the same auction house. Pucci clothing and accessories, currently being sold over the Internet, are realizing extremely high prices. On the West Coast, silk jersey day dresses are selling for $800 and up. Although prices will vary considerably from one part of the country to another, they are escalating rapidly. These fashions are now viewed as "art."

Fashion, and particularly the prints from the late 1960s and early 1970s, are full of life; they have movement; they are attention-getters; and above all, they are extremely artistic. If you have never given the fashions from this period a second look, by all means, do it now. Sit down, relax, and feast your eyes on some of the most memorable prints in fashion history. Enjoy!

and the space age are but a few examples. Fashion, at that time, was influenced by all of the above. Previous "haute couture" was tossed aside for fun fashions found in boutique settings. Clothing was not designed to be worn for more than a short period of time. New styles and new trends were evolving rapidly. Clothing was designed for the young and the young at heart. The

Emilio Pucci

Emilio Pucci (1914-1992) was born into a family of wealth and nobility. His father was Marchese Orazio Pucci and his mother was Contessa Augusta Pavonelli. Their residence, the Palazzo Pucci, located on Via de Pucci in Florence, Italy, was an impressive structure. The roots of this aristocratic Florentine family can be traced back to the Italian Renaissance.

Marchese Emilio Pucci was a remarkable, intelligent, and dignified man with creative genius coupled with a multitude of skills and ambitions. He earned three degrees in social science towards a diplomatic career. Pucci also joined the Italian Air Force in 1938 and, two years later, he was flying torpedo bombers over the Mediterranean.

After winning a skiing scholarship to Reed College in Portland, Oregon, Pucci became the captain of the college ski team. As a young man, Pucci's first design was the Reed ski team uniforms, which were manufactured by White Stag. A few years later, while on a skiing trip, Pucci was photographed for *Harper's Bazaar* wearing ski clothes he designed for himself. He was immediately asked to design a line of ski clothes for women, which he did; again, they were manufactured by White Stag.

Pucci's designs became an overnight sensation. His outfits were extremely comfortable and colorful. They were made of a European stretch fabric called Helenca. By 1949, Pucci's famous tight-fitting "Capri" pants were popular with the tourists in resort areas. The following year, his first boutique, "Emilio of Capri," opened on the island of Capri. This casual, sexy look in women's fashions, designed by an Italian nobleman, would instinctively transform the way women dressed from that point on. His clothes were a breath of fresh air, especially after the devastation caused by World War II.

After leaving the Italian Air Force, Pucci decided to design fashions on a full-time basis. The demand for his designs became overwhelming, especially the shantung or cotton "Pucci" pants, printed over blouses, and, around 1954, the lightweight printed silk jersey dresses he eventually became so famous for.

Where it all began—resort fashions by Emilio Pucci made of printed silk. *American Fabrics,* 1959.

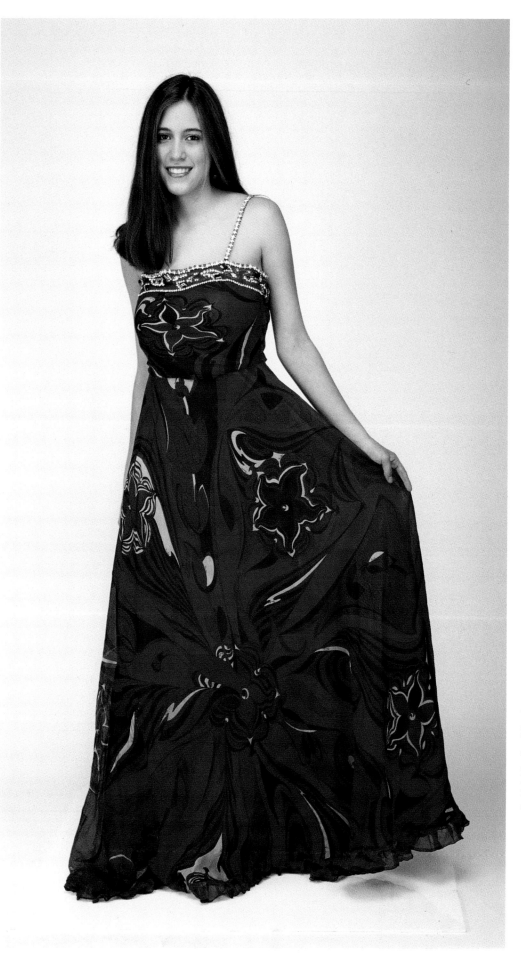

Pucci evening gown made of silk chiffon designed with an Empire waist and a flowing full skirt accented with a ruffled hemline. The neckline and straps are embellished with hand-set Austrian crystals. Labeled: Emilio Pucci, Florence, Italy. Exclusively for Sak's Fifth Avenue. $1500 and up.

10

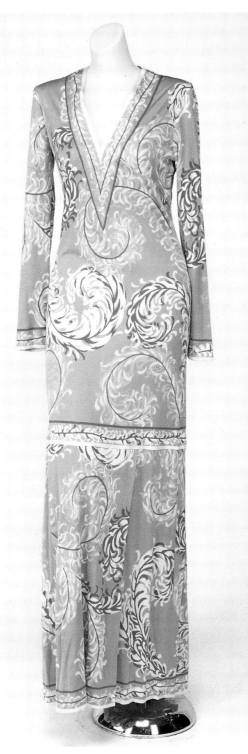

Pucci evening dress made of silk jersey designed with a round neckline, dropped waist, and pleated skirt. The feather print is rendered in shades of pink and yellow on a blue background. Labeled: Emilio Pucci, Florence, Italy. $700 and up.

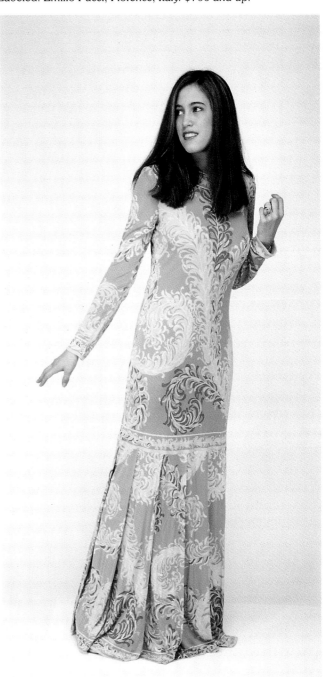

Pucci evening dress made of silk jersey designed with a v-neckline and dropped waist. The feather print is rendered in shades of pink and gold. Labeled: Emilio Pucci, Florence, Italy. Exclusively for Sak's Fifth Avenue. $700 and up.

11

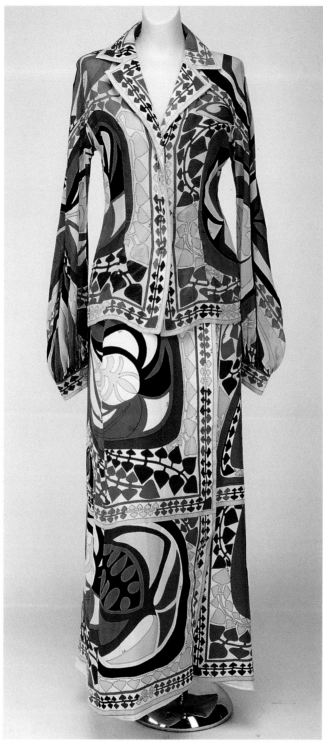

Pucci two-piece evening ensemble made of silk. The sheer blouse and long skirt are decorated with an abstract print in fuchsia, lavender, blue, grey, and black. A banded border decorates both pieces. Labeled: Emilio Pucci, Florence, Italy. Exclusively for Sak's Fifth Avenue. $650 and up.

Pucci floor-length, sleeveless evening dress made of silk jersey. The geometric print is rendered in shades of orange and yellow accented with black, white, and grey. Labeled: Emilio Pucci, Florence, Italy. $750 and up.

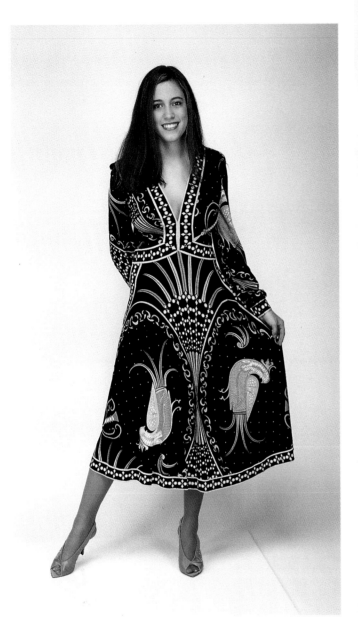

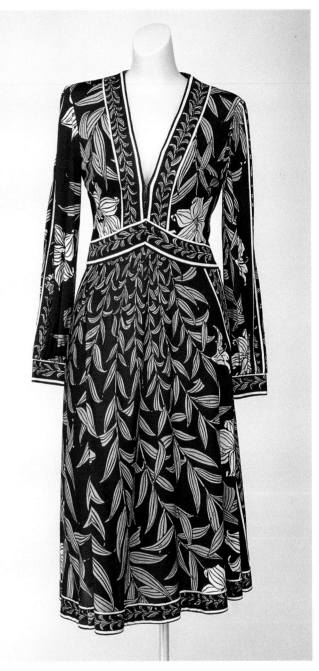

Pucci dress designed with Empire waist and v-neckline made of silk jersey. The stylized bird motif is printed in shades of pink on a black ground. Banding defines the waist and the neckline. Labeled: Emilio Pucci, Florence, Italy. $650 and up.

Pucci dress designed with Empire waist and v-neckline made of silk jersey. The three-toned stylized floral print is accented with a banded border. Labeled: Emilio Pucci, Florence, Italy. Made in Italy. Sak's Fifth Avenue. Emilio Pucci Boutique. $550 and up.

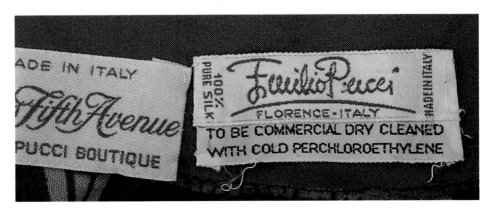

Close-up of Pucci dress fabric and labels.

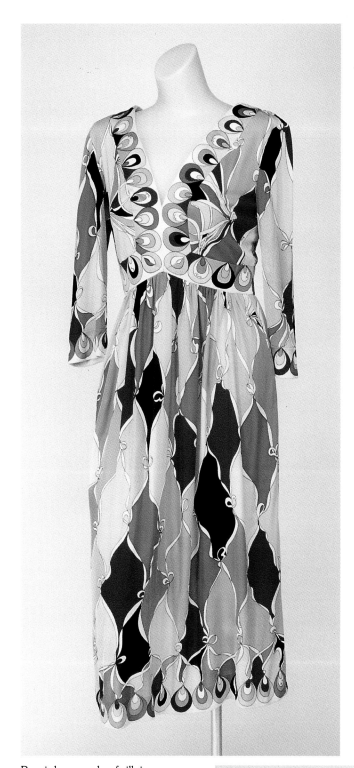

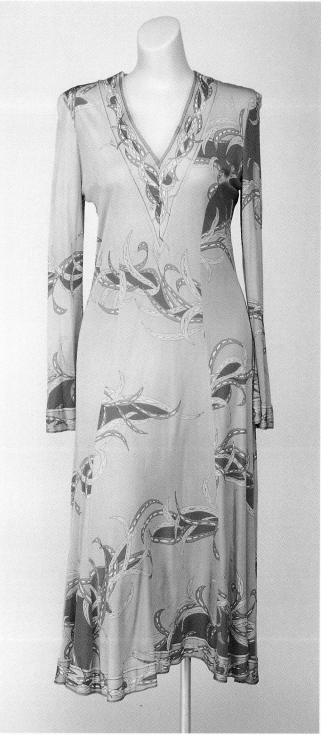

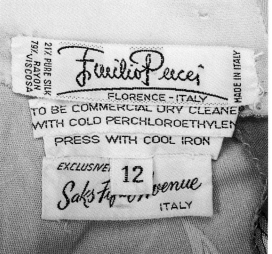

Pucci dress made of silk jersey designed with a v-neckline, Empire waist, and gathered skirt. The ribbon and diamond print is further enhanced by peacock feather designs bordering the neckline, waistline, and hemline. Labeled: Emilio Pucci, Florence, Italy. $450 and up.

Pucci dress designed with v-neckline and long sleeves made of silk jersey. The stylized leaf print is rendered in shades of green on a two-toned pink background. Labeled: Emilio Pucci, Florence, Italy. Exclusively for Sak's Fifth Avenue, Italy. $450 and up.

Close-up of Pucci fabric and labels.

14

Pucci day dress designed with long sleeves, fitted bodice, and slightly gathered waist. Labeled: Emilio Pucci, Florence, Italy. $400 and up.

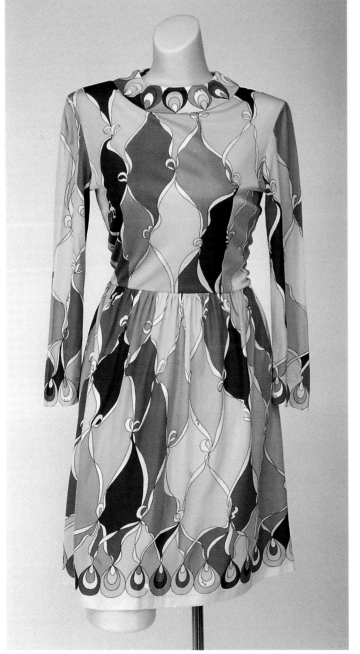

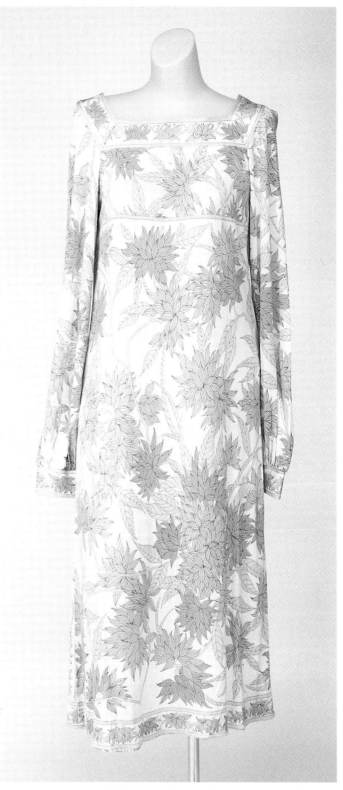

Pucci dress designed with boat-neckline and long sleeves, made of pure silk and rayon viscosa. Banding adds extra elegance to this stylized floral print rendered in pastel shades. Labeled: Emilio Pucci, Florence, Italy. $325 and up.

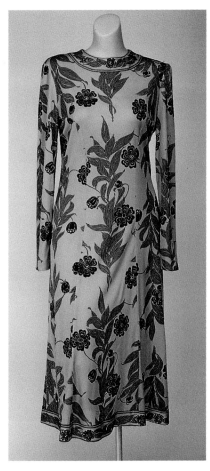

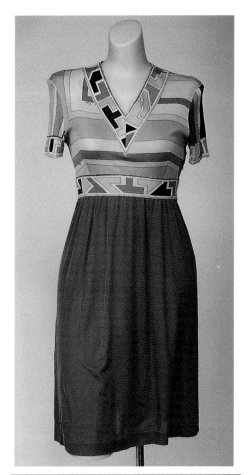

Pucci dress with short sleeves, Empire waist and v- neckline. The bodice is printed with a multi-colored geometric design while the skirt is a solid color. Banding adds definition. Labeled: Emilio Pucci, Florence, Italy. $300 and up.

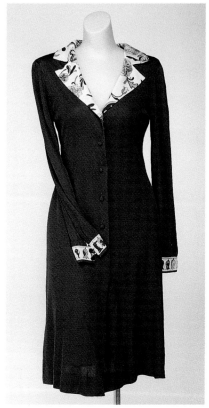

Pucci form-fitting dress made of silk jersey with a four-toned floral print accented with a banded neckline and hemline. Labeled: Emilio Pucci, Florence, Italy. Made in Italy. Sak's Fifth Avenue. Emilio Pucci Boutique. $400 and up.

A conservative Pucci dress with button-down front. The chocolate brown silk jersey is further enhanced by a printed collar and cuffs. Labeled: Emilio Pucci, Florence, Italy. $250 and up.

Pucci day dress made of silk jersey. The bodice is printed with colorful geometrics; the slightly gathered skirt is solid turquoise. Labeled: Emilio Pucci, Florence, Italy. $350 and up.

16

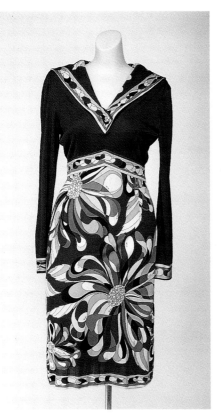

Pucci dress with v-neckline, Empire waist and sailor collar. The stylized floral print in shades of pink and purple is combined with a solid-color bodice. Labeled: Emilio Pucci, Florence, Italy. Exclusively for Sak's Fifth Avenue. $375 and up.

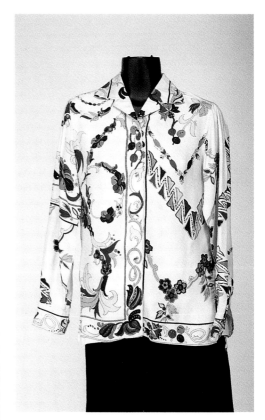

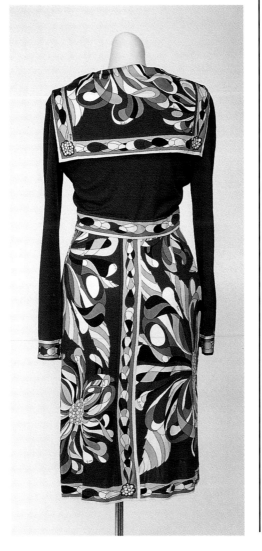

Rear view showing sailor collar and banding on Pucci dress.

Pucci blouse made of pure silk with stylized floral print in shades of pink, red, and black on a cream background. This blouse is an earlier example dating from the late '50s or early '60s. Labeled: Emilio Pucci, Florence, Italy. Exclusively for Sak's Fifth Avenue. $200 and up.

Pucci Silk Jerseys

Pucci's Renaissance palazzo in Florence had been a target for vandals during the war. In the early 1950s, Pucci decided to restore the palazzo and set up shop there. Many women were employed on the premises to do the sewing of the garments. His business continued to grow throughout this decade. He had already been selling his clothing to major American department stores such as Neiman-Marcus, Marshall Field, and Lord & Taylor; by the mid-60s, all the major Sak's Fifth Avenue stores had "Pucci Boutiques." Americans had a penchant for all things Italian at that time. The Capri pants, stiletto heels, shift dresses, and bold print silk tops were gaining popularity in major resort areas such as Palm Beach, the Riviera, and the Caribbean. These fashions were exciting, sexy, and wonderfully colorful. In the Spring of 1959, *American Fabrics* stated that:

> Emilio Pucci, the Italian designer, started a one man resort wear fashion with his printed silk shirts, and pants. These literally swept the fashion scene in Jamaica and Florida this winter and should go on to even greater success in the future.

By 1962, the penchant for prints had become even more overwhelming. The consumer, according to *American Fabrics,*

> . . . had a growing hunger for decoration and in textiles, this need is well satisfied through prints. Whether we like it or not, it is no longer possible to satisfy this need by decoration achieved through intricate weaving alone. More and more the burden of success or failure with a line depends on the talents of designer and colorist who can adorn plain surfaces with exciting print ideas.

Pucci traveled extensively throughout his lifetime and the many exotic and far-off lands he visited became sources of design inspiration for his unique printed garments. Trips to Spain, Portugal, Russia, China, Japan, Egypt, Greece, Hawaii, and Bali were common. After every trip, fresh inspirations were evident in his new lines. The Marchese was intrigued with the different cultures in each country. Unusual architecture was a common inspiration for his designs, as were exotic flowers, elaborate plumage, colorful landscapes, mosaic tiles, and stained glass windows. The vivid colors he used in addition to the profusion of color was awe-inspiring. Deep purple, bright pink, aqua, violet, magenta, fuchsia, emerald green, orange, and yellow were common. Some designs had up to a dozen color combinations. Pucci prints were full of excitement, they were fun to wear, and extremely figure flattering. They were prints that "catch the eye" and make an immediate impact.

Pucci silk jersey dresses were extremely lightweight, weighing only about four ounces. They were perfect for travel, since quite a few dresses could be put into an overnight bag without the fear of being wrinkled. They combined comfort with figure-flattery. So comfortable, in fact, that it was like wearing nothing at all!

In complete opposition to what Christian Dior had established in 1947 with his "New Look," consisting of tailored dresses designed with cinched waists and flowing skirts and the use of constrictive undergarments, Pucci advised women to liberate themselves, and, if possible, to do away with their girdles. He did, however, design a pantygirdle for Formfit-Rogers which he called "Viva." This pantygirdle was designed to accentuate the rounded curves of the derrière. If a woman felt that a girdle was necessary, then Viva was the right choice for under the clinging, sexy, silk jersey Pucci dresses.

By the 1960s, the sexy, Italian fashions designed by Emilio Pucci were worn by all age groups. Celebrities, movie actresses, royalty, and jet-setters from all over the world wanted to own a Pucci. Those who were able to afford a Pucci usually had more than one. They were expensive, even in the 1960s: the silk jersey dresses sold for about $200 each; shirts and blouses were about $50 each; wide-legged palazzo pants about $150 each; and beaded evening wear about $500 and up. Unfortunately, the average person could not afford to own a Pucci. The appeal, although tremendous, became somewhat limited due to the price. This, however, did not stop the "knock-off artists" who realized that the prints were extremely desirable and there was money to be made by copying the designs. Because of this, Pucci knock-offs began to flood the market. The fabric that the imitations were made of was usually inferior to the luxurious silk jerseys and velvets that Pucci used, but for someone who just wanted the look without the expensive price tag, they fit the bill.

As a result, Pucci was legally advised to sign his fabric, which he did, with the word "Emilio" in script. His name appears throughout his designs. Pucci's signature fabric also began a trend which was eventually copied by other designers. From the 1960s forward, the signature look became a sign of wealth and status.

As early as the Spring of 1960, *American Fabrics* documented that:

> Silk stretch fabric for pants is on its way to great fashion excitement. Pucci's introduction of this fabric in Italy created a furor of interest among blasé fashion observers. Experiments are going on in this country to produce this type of fabric on a practical, merchandisable basis.

In 1962, Cohama Mills, knowing the great fashion appeal of silk knits, developed a silk knit jersey at a "more popular price." A year later, a blend of 60% Antron and 40% Nylon resulted in a lightweight, figure-flattering, wrinkle-free fabric that was an affordable alternative to Pucci's silk jersey. The less affluent woman was able to "easily duplicate such a wardrobe in less prestigious knits at any department store," wrote *American Fabrics* in the Winter of 1968. By this time, the consumer loved knits for "their comfort, packability, ease of care and sophisticated elegance."

Pucci prints belong in a class all of their own. Emilio Pucci's genius was in designing the overall print and adding the color. Each print was silk-screened to perfection. Because of the size and complexity of the overall print, when dresses and other garments were constructed, the print on the front would be completely different than that on the back. That's what made them even more exciting.

Pucci's impact on fashion in general and prints in particular was extremely strong by the mid-60s. In 1966, *American Fabrics* wrote:

> The industry owes a debt of gratitude to Emilio Pucci for a seemingly bottomless creative outpouring. Sak's Fifth Avenue has happily described Pucci prints as "lighting up" their boutique. Whether used on silk knit dresses, wild little toppers, beach fantasies or pants, Pucci's designs and colors are not only stand-outs—they set standards. If one designer has earned credit for our present print revival, that one is Pucci.

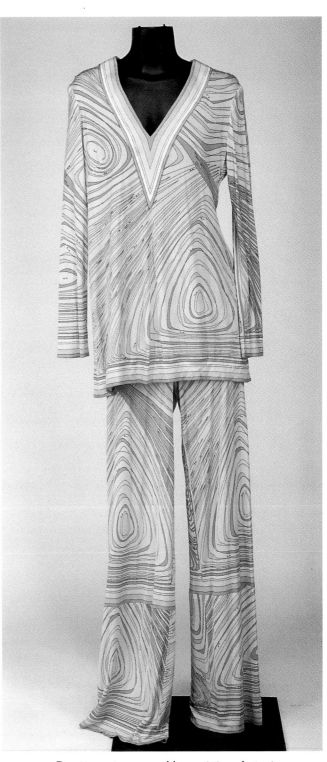

Pucci two-piece ensemble consisting of a tunic top and wide-legged pants made of silk jersey in a five-toned abstract print. Labeled: Made in Italy. Sak's Fifth Avenue. Emilio Pucci Boutique. $500 and up.

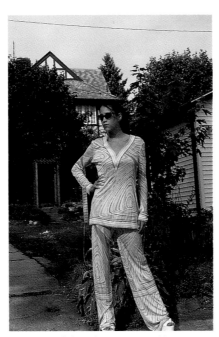

Amber modeling the two-piece Pucci ensemble with abstract print.

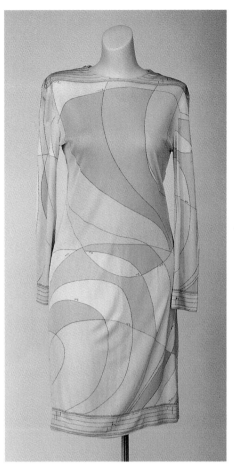

Pucci shift made of silk jersey with geometric print in shades of pink, beige, cream, and yellow outlined in black. Labeled: Emilio Pucci, Florence, Italy. $350 and up.

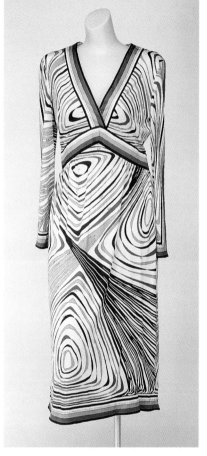

Pucci dress made of 21% silk and 79% rayon viscosa. The length is mid-calf and the abstract print is executed in shades of lavender and purple on a white background. Labeled: Emilio Pucci, Florence, Italy. Made in Italy. Sak's Fifth Avenue. Emilio Pucci Boutique. $400 and up.

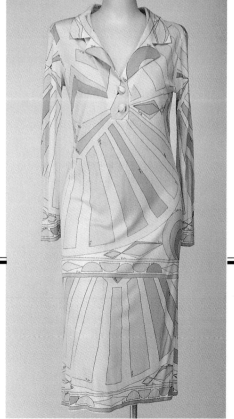

Pucci day dress designed with notched-collar and long sleeves. The geometric print is rendered in pastel shades. Labeled: Emilio Pucci, Florence, Italy. $400 and up.

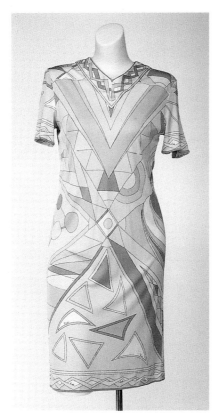

Pucci shift designed with short sleeves and made of silk jersey. The geometric print is rendered in pastel shades. Labeled: Emilio Pucci, Florence, Italy. Exclusively for Sak's Fifth Avenue. $375 and up.

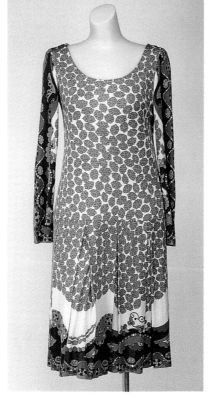

Pucci day dress designed with a dropped waist and pleated skirt. The cute floral print is executed in lavender and blue and further enhanced with black, white, and shades of grey. A bolder print defines the sleeves and hemline. Labeled: Emilio Pucci, Florence, Italy. $325 and up.

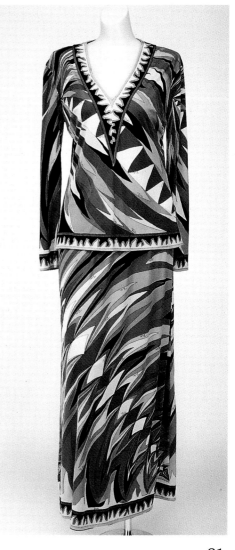

Pucci two-piece ensemble designed with a long skirt and v-necked top. The abstract print is executed in shades of brown, beige, grey, black, and off-white. Banded borders add further excitement to this print. Labeled: Emilio Pucci, Florence, Italy. $600 and up.

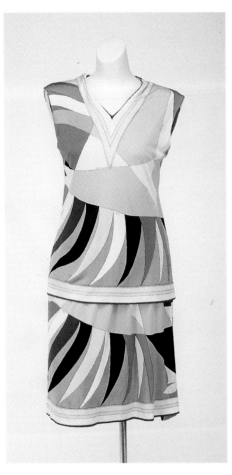

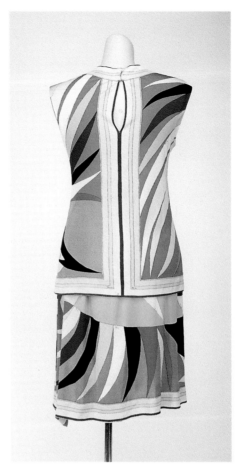

Far left:
Pucci two-piece ensemble designed with a mini-skirt and sleeveless top made of silk jersey with a geometric design in peach, melon, orange, black, and grey. Labeled: Emilio Pucci, Florence, Italy. Exclusively for Sak's Fifth Avenue. $375 and up.

Left:
Rear view of Pucci two-piece ensemble showing a slightly different print on the back.

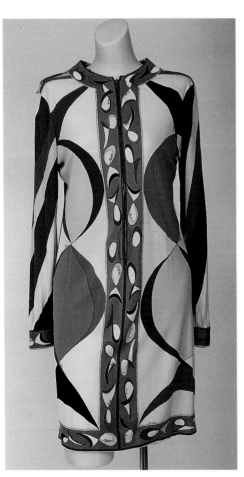

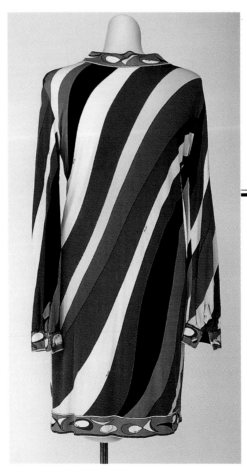

Far left:
Pucci shift designed with long sleeves made of silk jersey with an abstract print in shades of brown, beige, grey, and black. Banded borders add extra excitement. Labeled: Emilio Pucci, Florence, Italy. $400 and up.

Left:
Rear view of Pucci shift showing a completely different print on the back.

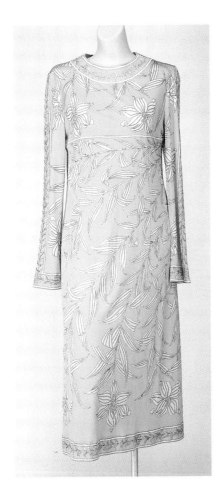

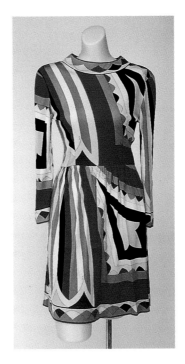

Pucci shirtwaist dress made of silk jersey with an abstract print in shades of pink and grey and further accented with black and white. Banding defines the neckline, cuffs, and hemline. Labeled: Emilio Pucci, Florence, Italy. $450 and up.

Pucci dress designed with Empire waist and long sleeves, made of silk jersey with a simple yet elegant flower and leaf print. Labeled: Emilio Pucci, Florence, Italy. $350 and up.

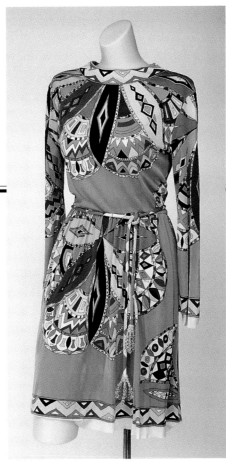

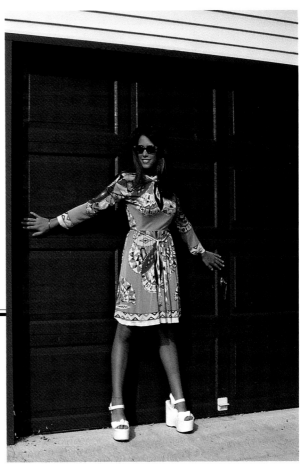

Pucci shirtwaist dress designed with a fitted bodice and slightly gathered skirt made of silk jersey. The Art Deco print is rendered in shades of blue, lavender, and purple accented with black, white, and grey. The matching belt is beaded at both ends. Labeled: Emilio Pucci, Florence, Italy. $450 and up.

Amber modeling the Pucci shirtwaist dress with Art Deco print.

Pucci Velvets

Velvet, which dates back to the fourteenth century, has always been described as a luxurious fabric "fit for a king." In the Middle Ages, and especially during the Italian Renaissance, velvet manufacture was centered in some of the major cities of Italy. With the passing of time, this elite fabric, initially used to make robes for royalty and church officials, still retained a special place in the world of fashion.

By the 1960s, modern technology and mass production brought velvet within the reach of the average consumer. Coats, hats, purses, dresses, smoking jackets, sport jackets, leisure suits, men's ties, and clothing for children were made of velvet and velveteen. The appeal of velvet, with its rich look and "surface luxury," was available for the mass market and not necessarily just for evening wear.

Italy went through another Renaissance period in the 1960s, and textile manufacturers concentrated on perfecting the process of printing on velvet and velveteen. Again, Emilio Pucci created an impact with his stunning printed velvet jackets, palazzo pants, vests, evening gowns, and two-piece pants outfits. The prints found on the velvets were just as exciting as those found on the silk jerseys. They displayed rhythm and motion with an explosion of color.

Pucci dress made of velvet designed with an Empire waist and v-neckline in shades of pink, fuchsia, and burgandy accented with black, white, and grey. Banding adds extra excitement to the solid-color bodice. Labeled: Emilio Pucci, Florence, Italy. $600 and up.

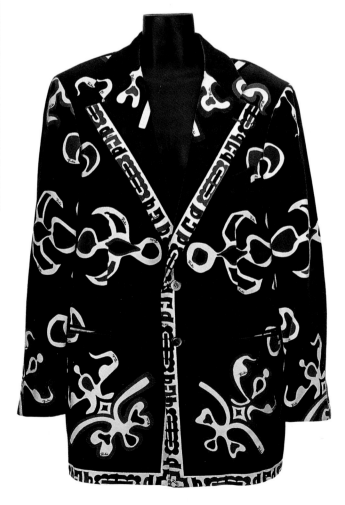

Pucci velvet jacket designed with an abstract print on a deep purple ground. Labeled: Made in Italy for Sak's Fifth Avenue. $375 and up.

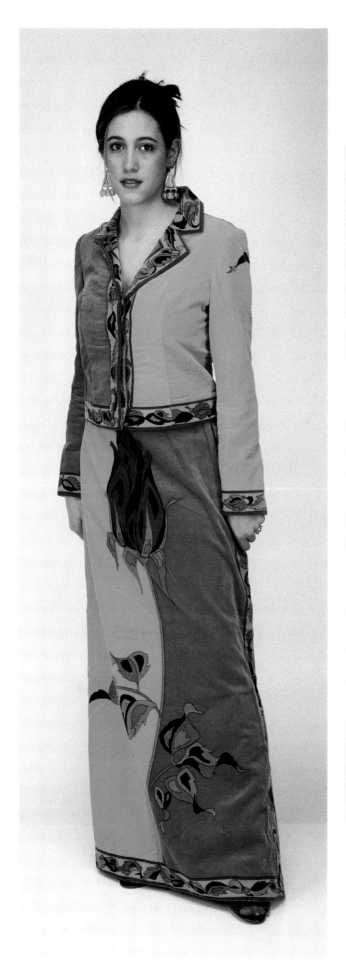

Pucci two-piece ensemble designed with a short jacket and long skirt made of velvet. The elegant long-stemmed rose marks the division between the two shades of blue. The banding of leaves adds more interest to the existing elegance of the design.
Labeled: Emilio Pucci, Florence, Italy. Exclusively for Sak's Fifth Avenue. $1000 and up.

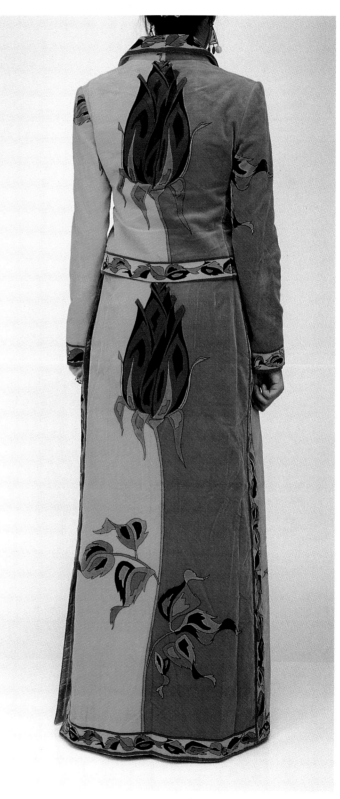

Rear view of the elegant Pucci two-piece ensemble with rose print.

25

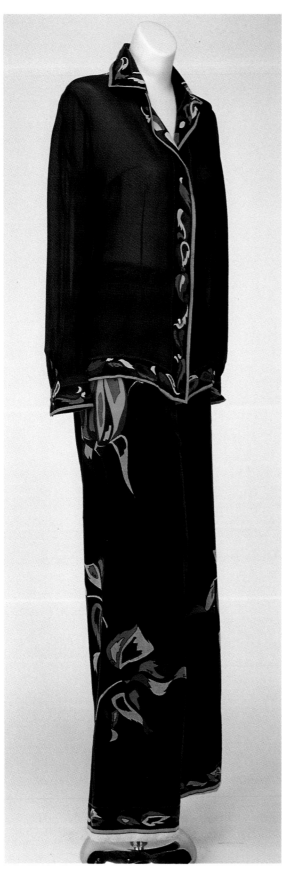

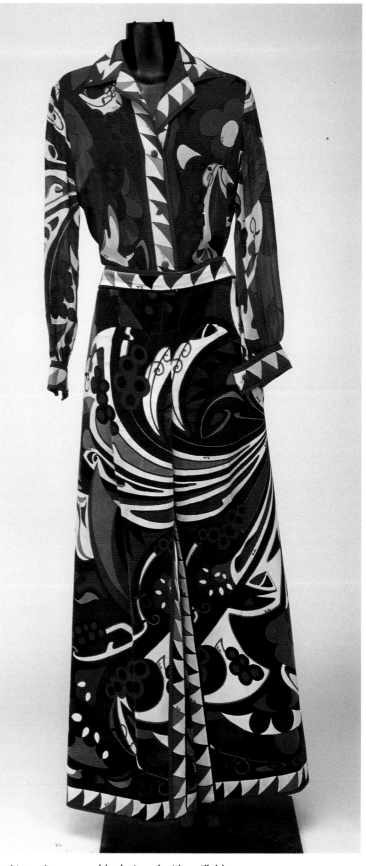

Pucci two-piece ensemble designed with a sheer silk blouse and velvet palazzo pants. Long-stemmed roses, decorating the pants and the back of the blouse, divide the ground colors of black and brown. Labeled: Emilio Pucci, Florence, Italy. $795 and up.

Pucci two-piece ensemble designed with a silk blouse and matching wide-legged velvet pants. Notice the meticulous skill in constructing the pants so that the abstract print matches perfectly when worn. Labeled: Emilio Pucci, Florence, Italy. $850 and up.

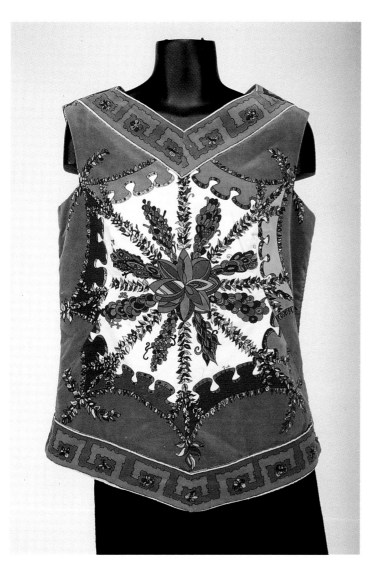

Pucci sleeveless top made of velvet with a kaleidescope print executed in vibrant colors. Banding defines the v-neckline and waistline. Labeled: Emilio Pucci, Florence, Italy. $295 and up.

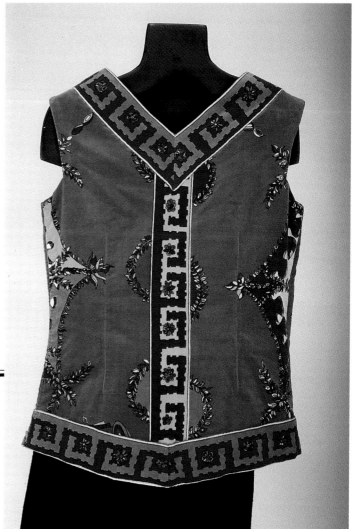

Rear view of Pucci velvet top showing a completely different print on the back.

Pucci Cottons

Pucci also created some wonderful garments made of cotton. Two-piece outfits consisting of blouses with matching skirts, or blouses with matching pants were especially common. Unfortunately, the cotton garments did wrinkle, so while still as beautiful as the silk jerseys, they were not as popular.

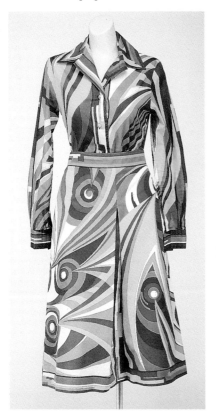

Left:
Pucci two-piece cotton outfit designed with flared skirt and tapered blouse. The wild pinwheel print is executed in psychedelic colors. Labeled: Emilio Pucci, Florence, Italy. $375 and up.

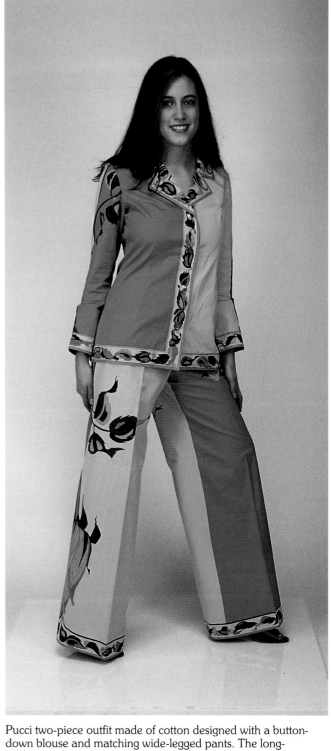

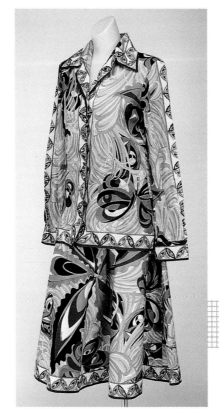

Pucci two-piece outfit designed with fuller skirt and matching button-down overblouse. The stylized butterfly print is rendered in shades of brown, grey, black, and white while the background leaf print is done in shades of orange and yellow. Labeled: Emilio Pucci, Florence, Italy. Exclusively for Sak's Fifth Avenue. $400 and up.

Pucci two-piece outfit made of cotton designed with a button-down blouse and matching wide-legged pants. The long-stemmed rose print is utilized again, dividing the two shades of green. Labeled: Emilio Pucci, Florence, Italy. $450 and up.

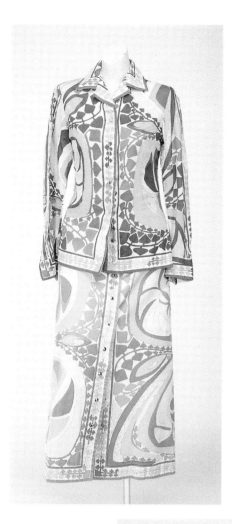

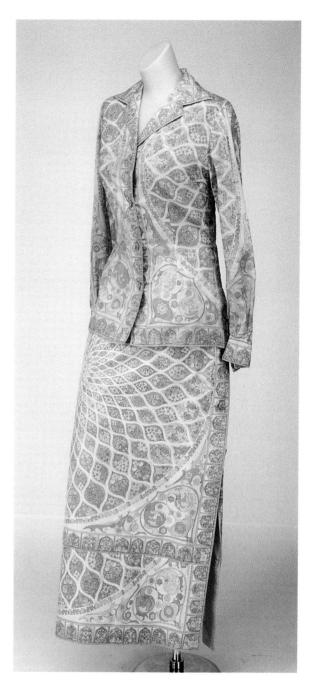

Left:
Pucci two-piece outfit designed with a long skirt and matching overblouse. The abstract print is rendered in psychedelic colors. Labeled: Emilio Pucci, Florence, Italy. $475 and up.

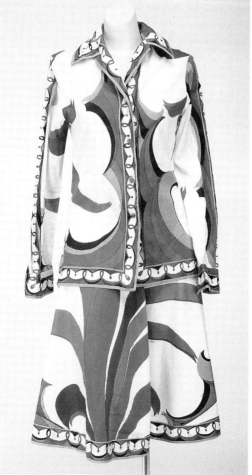

Pucci two-piece ensemble designed with a long skirt and matching form-fitting long sleeve overblouse. The skirt buttons down the side and the Persian-style print is executed in shades of apricot, beige, orange, and yellow on a cream-colored background. Labeled: Emilio Pucci, Florence, Italy. $495 and up.

Pucci two-piece outfit designed with a flared skirt and matching long sleeve overblouse. The oversized abstract print is done in psychedelic pink and orange on a white ground. Labeled: Emilio Pucci, Florence, Italy. Sak's Fifth Avenue. $350 and up.

29

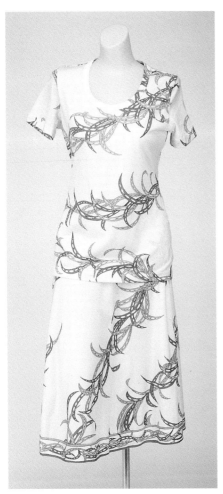

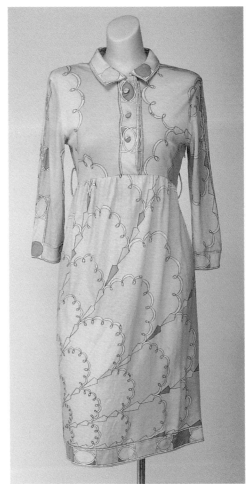

Far left:
Pucci two-piece summer outfit made of cotton with stylized leaf print in shades of green on a plain white background. Labeled: Made in Italy. Sak's Fifth Avenue. Emilio Pucci Boutique. $175 and up.

Left:
Pucci day dress designed with Empire waist, long sleeves and slightly gathered skirt. Bright yellow, gold, and apricot, trimmed in black, makes this print eye-catching. Creative use of banded borders adds more interest. Although this dress appears to be made of cotton, it is a silk and cashmere blend. Labeled: Emilio Pucci, Florence, Italy. $300 and up.

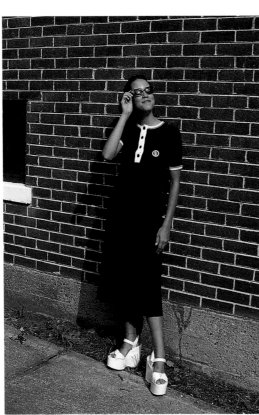

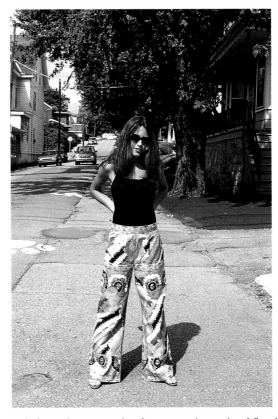

Pucci shirt dress made of cotton in a very basic navy blue trimmed in white. The Pucci logo appears on the front. Labeled: Emilio Pucci, Florence, Italy. $150 and up.

Pucci wide-legged pants made of cotton with a stylized floral print in shades of turquoise, lavender, purple, blue, grey, black, and white. Labeled: Emilio Pucci, Florence, Italy. Exclusively for Sak's Fifth Avenue. $195 and up.

Art Nouveau Influence & Pucci

The original expressions of turn of the century Art Nouveau consisted of free-flowing lines artistically interpreted through abstract linear floral designs, animals, insects, birds, and the female form. A nineteenth century interest in botany, especially in Europe, created a sensation for flowering plants. Designers and artists utilized these beauties of nature and incorporated naturalistic decorations into their work. By the turn of the century, Art Nouveau design was in full bloom and everything from jewelry to decorative arts and wallpaper prints to textiles were exhibited for the world to see at the Paris Exhibition of 1900.

This short-lived artistic movement lasted about fifteen years, ending around 1910. Fifty years later, however, a renewed interest in Art Nouveau became evident. As early as the summer of 1960, the Art Nouveau influence was already visible as "a growing design trend" in fashion and textiles, according to *American Fabrics*. This rebirth occurred due to the joint efforts of Liberty of London and Fontana of Rome. Liberty of London revived their block prints from the turn of the century, which were originally commissioned by Arthur Liberty. They were re-created in the 1960s with a contemporary flair. Fontana of Rome used the new Art Nouveau prints to design a line of silk dresses.

Italian designers were highly instrumental in popularizing the Art Nouveau influence in fashion and textiles. Again we must acknowledge Emilio Pucci for creating an international sensation in the 1960s with his fabulous silk jersey dresses, velvet evening gowns, and two-piece pants outfits. Pucci designed the most wonderful Art Nouveau prints imaginable, using a palette of colors that has never been matched. Writhing flowers, creeping vines intermingled with ribbons and bows were some of his design themes. Many have tried to imitate the work of Pucci but no one ever came close to actually mastering his creative genius.

In the Fall of 1966, *American Fabrics* wrote:

Pucci's art-nouveau-ish prints had a completely "other-world" look and were worth waiting for.

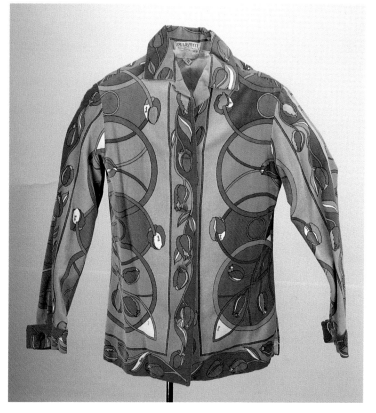

Pucci velvet jacket designed with Art Nouveau floral print in shades of green, pink, and blue with touches of white. Banding adds further interest. Labeled: Emilio Pucci, Florence, Italy. Made in Italy Exclusively for Sak's Fifth Avenue. $400 and up.

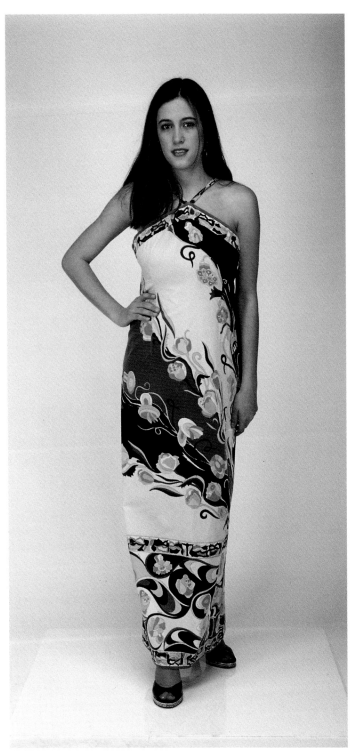

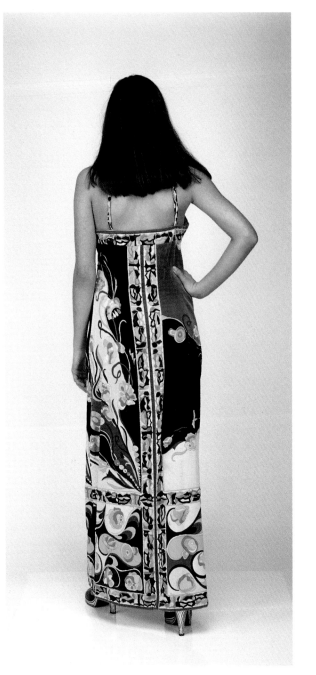

Rear view of Pucci velvet gown with wonderful Art Nouveau print.

Extemely elegant Pucci velvet evening gown with Art Nouveau floral print in shades of pink, sea foam green, mauve, and black. Labeled: Emilio Pucci, Florence, Italy. Made in Italy Exclusively for Sak's Fifth Avenue. $1500 and up.

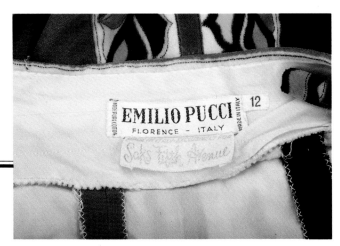

Close-up of Pucci fabric and labels.

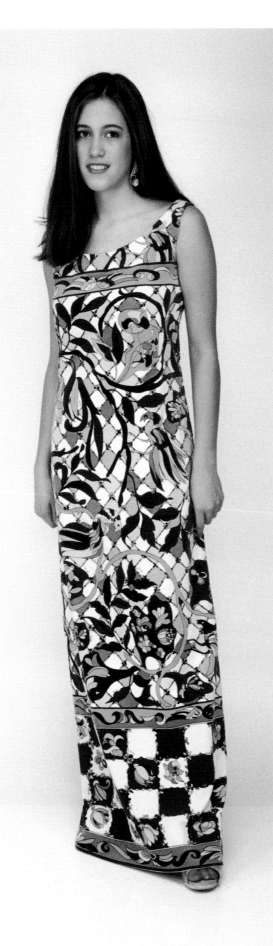

Pucci velveteen evening gown with Art Nouveau print incorporating birds, feathers, and flowers. The banding adds extra excitement. Labeled: Emilio Pucci, Florence, Italy. $1200 and up.

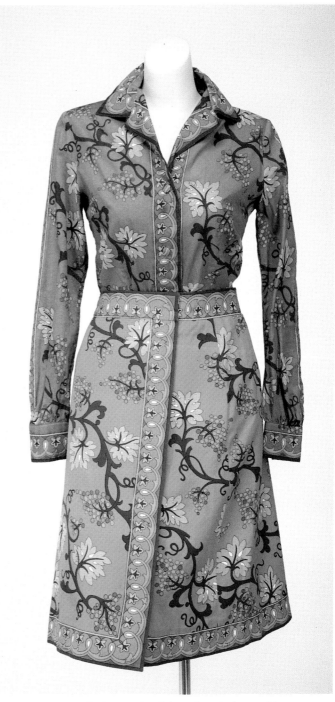

Pucci two-piece outfit designed with knee-length skirt and long sleeve blouse. Art Nouveau influences abound with the climbing vine print executed in vibrant shades of green and purple accented with lilac and blue. Labeled: Emilio Pucci, Florence, Italy. Exclusively for Sak's Fifth Avenue. $395 and up.

Pucci two-piece ensemble designed with long skirt and matching overblouse made of silk jersey. The stylized floral print combined with the banded borders creates a stunning outfit. Labeled: Emilio Pucci, Florence, Italy. Made Exclusively for Sak's Fifth Avenue. $795 and up.

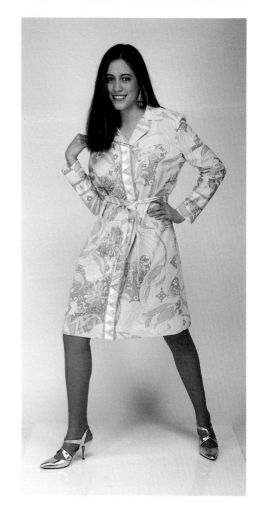

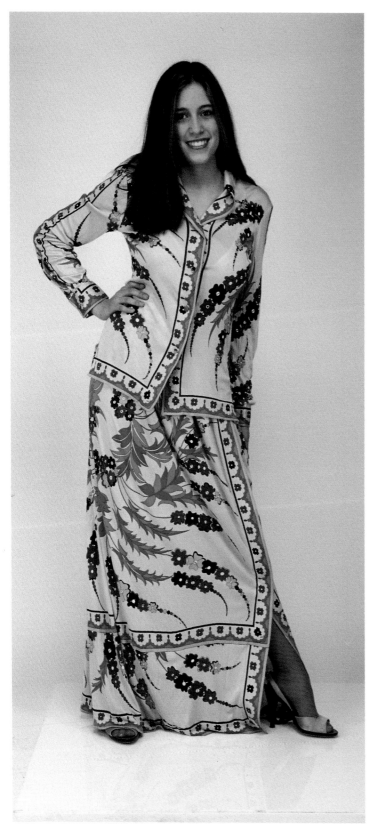

A Pucci knock-off made of polyester with an Art Nouveau style print in orange, yellow, and gold tones. Labeled: Kay Windsor. The Look You Love. $75-100.

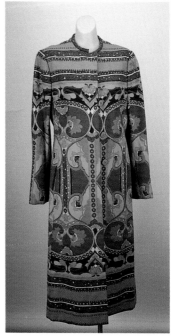

Embellished stripes and stylized flowers form the Art Nouveau style print found on this exquisite coat with rolled collar. The coat is lined and of very good quality but unfortunately there is no label. $200-300.

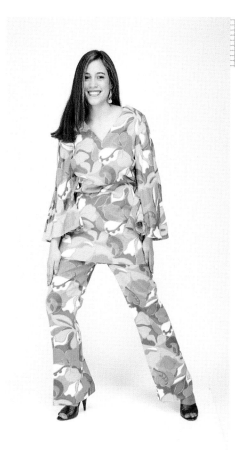

Tunic top with bell sleeves and matching pants decorated with an exotic floral print in vibrant colors. Labeled: Boutique Dione. Four Ambassadors, Miami. $75-125.

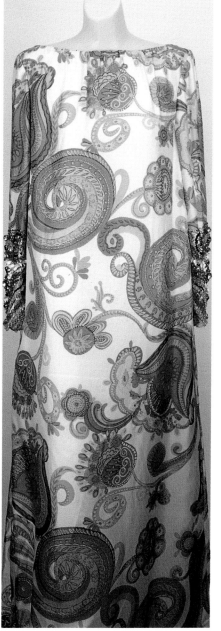

An oversized floral print rendered in psychedelic colors creates a stunning evening dress designed with detachable hood. The sleeves are hand jeweled with beads, sequins, and multi-colored rhinestones. No label. $95-125.

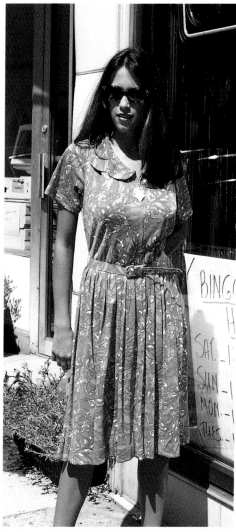

Zip-front polyester shirtwaist dress designed with short sleeves and scalloped collar with an Art Nouveau style print. No label. $35-45.

Art Deco Influence & Pucci

There were many exciting influences creating new print directions in the 1960s, ultimately making top fashion news. One of the most popular periods that was copied and adapted for contemporary taste was the Art Deco period, which was a style consisting mainly of abstract and geometric forms. The original Art Deco movement of the 1920s and 1930s was a style that was derived from an international display of modern decorative arts held in Paris in 1925. Influences from Africa, the Orient, Egypt, and South America were instrumental in design inspiration, especially architecture like the Egyptian pyramids and the Aztec temples. Other sources of inspiration were artistic influences like Cubism, Futurism, and Expressionism.

It was not until the 1960s that the term *Art Deco* was applied to this movement. When this happened, however, it created another sensation. Contemporary designers of the period began interpreting this geometric style and adapting it to modern day living. Textiles for use in the home as well as fabrics for fashion both displayed the Art Deco flair. Modern abstract artists also created impetus for the modern textile designer.

In the mid-1960s, the designs of Emilio Pucci were bursting with color and geometric form. Cubes, circles, squares, triangles, and diamond patterns were found throughout his prints, which were always wildly silk-screened in bright colors. Pucci's inspirations, just like those of the original Art Deco designers, were found in far-off places like Africa, India, Mexico, and South America.

Pucci two-piece velveteen evening outfit designed with long skirt and short jacket displaying a wonderful Art Deco print executed in vibrant shades of green, blue, and lavender trimmed with black and white. Labeled: Emilio Pucci, Florence, Italy. $1200 and up.

In 1965, *American Fabrics* recorded that:

Italy likes small geometrics and abstracts. Small geometrics, often with blurred edges, were noted again and again in silk and other fabric prints. Their softened effects are the result of a decided toning-down of the primary colors and one receives an over-all impression of femininity at its elegant best. Here and there, small geometric motifs were gathered within floral paisley or abstract outlines. The visual effects were strikingly new.

In 1966, *American Fabrics* wrote:

Suddenly the fashion world is geometry-conscious. The symbols of mathematics hold a special fascination for young females who would never dream of taking courses in higher math or physics. Geometry in fashion means the squares, circles, triangles—all elegant symbols introduced by Euclid himself. They take on new zest when presented in zingy contemporary colors and in unexpected dynamic arrangements.

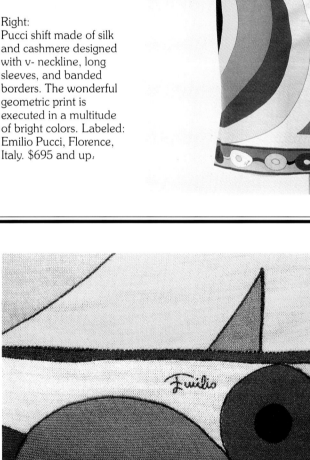

Right:
Pucci shift made of silk and cashmere designed with v- neckline, long sleeves, and banded borders. The wonderful geometric print is executed in a multitude of bright colors. Labeled: Emilio Pucci, Florence, Italy. $695 and up.

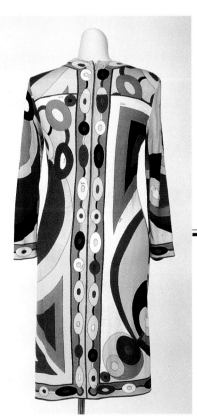

Rear view of geometric Pucci dress above right. Notice how the vertical banding alters the print on the back.

Close-up of Pucci silk and cashmere fabric showing the signature "Emilio."

37

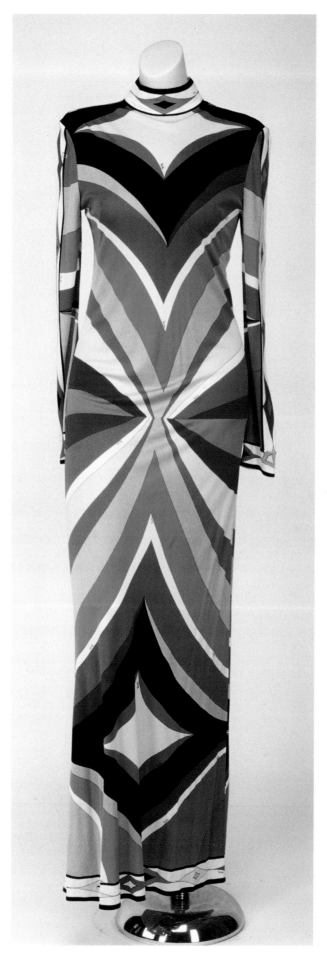

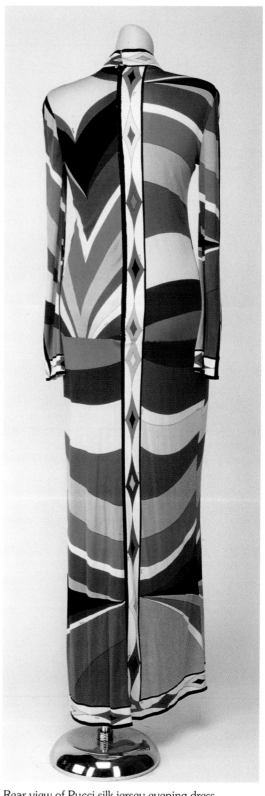

Pucci form-fitting evening dress made of silk jersey designed with banded neckline. The chevron print really makes this dress extremely chic! Labeled: Emilio Pucci, Florence, Italy. $1200 and up.

Rear view of Pucci silk jersey evening dress showing a completely different print on the back.

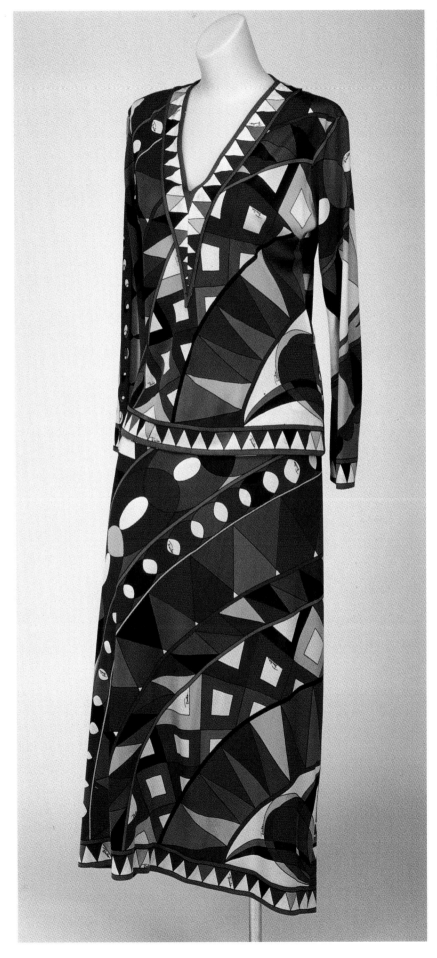

Pucci two-piece ensemble made of silk jersey designed with a long skirt and v-necked tunic top. The Art Deco print is rendered in vibrant shades of green, purple, lilac, magenta, and white. Labeled: Emilio Pucci, Florence, Italy. $750 and up.

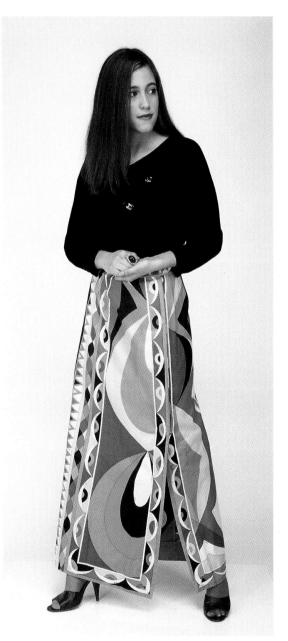

Pucci long skirt designed with Art Deco print in shades of turquoise, green, lavender, black, and white. The skirt is made of cotton. Labeled: Emilio Pucci, Florence, Italy. $300 and up.

39

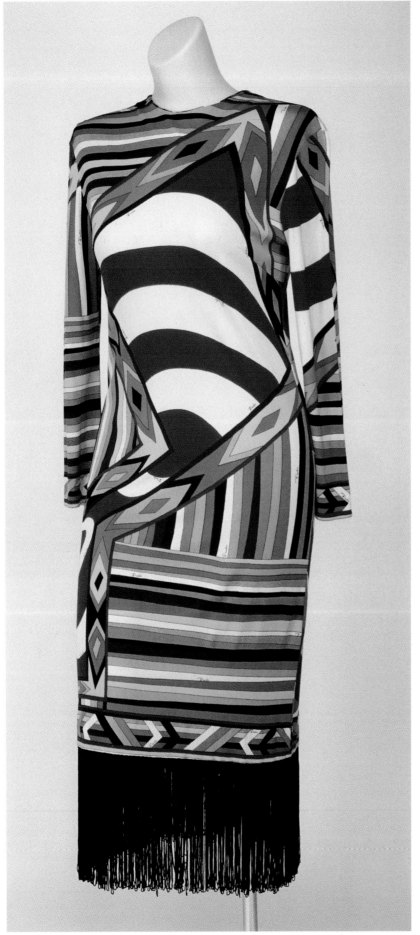

Pucci flapper-style dress made of silk jersey accented with black fringe. The print encompasses a myriad of wild colors and geometric shapes. Labeled: Emilio Pucci, Florence, Italy. $995 and up.

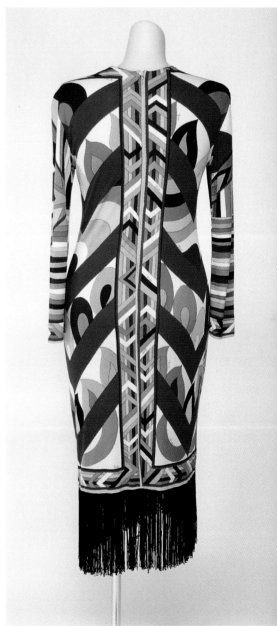

Rear view of Pucci flapper-style dress showing a completely different print on the back.

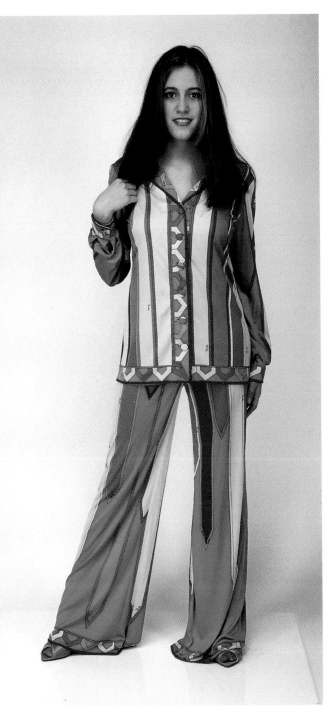

Pucci two-piece outfit designed with bell-bottom pants and matching overblouse made of silk jersey. The striped print is done in psychedelic pinks and greens. Labeled: Emilio Pucci, Florence, Italy. Exclusively for Sak's Fifth Avenue. $495 and up.

Pucci flapper-style dress designed with v-neckline and fringed hemline. The geometric print is executed in shades of pink, fuchsia, black, white, and grey. Labeled: Emilio Pucci, Florence, Italy. Made in Italy Exclusively for Sak's Fifth Avenue. 100% Silk. $950 and up.

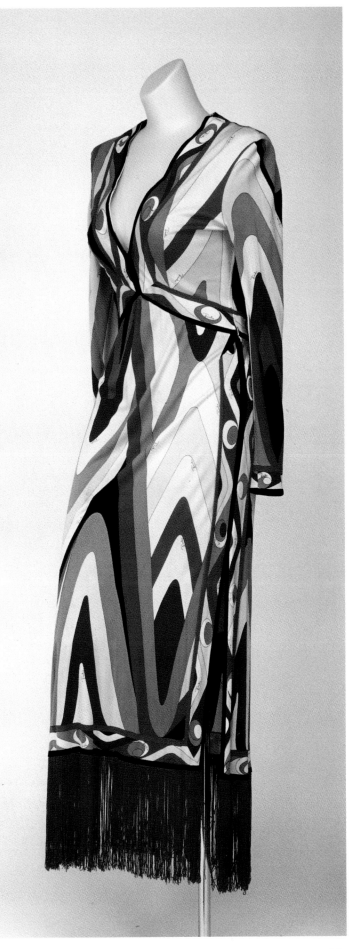

Pucci shift made of silk jersey designed with short sleeves, v-neckline, and banded borders in a colorful geometric print. Labeled: Emilio Pucci, Florence, Italy. $550 and up.

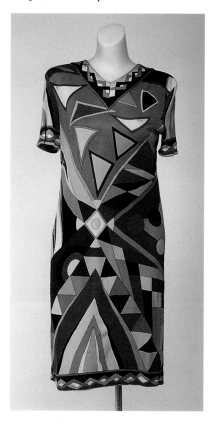

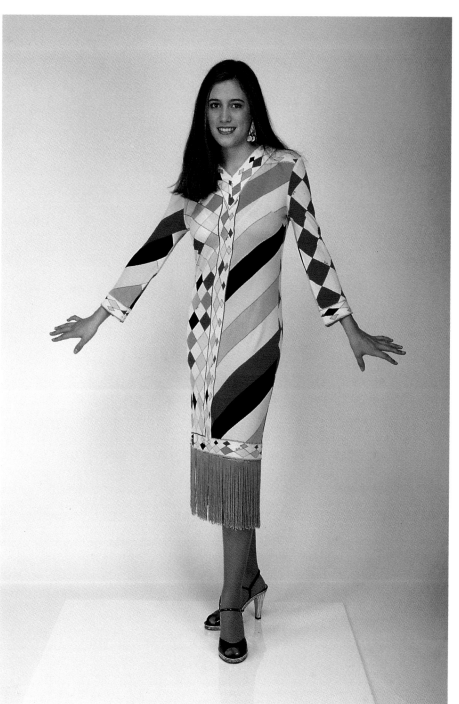

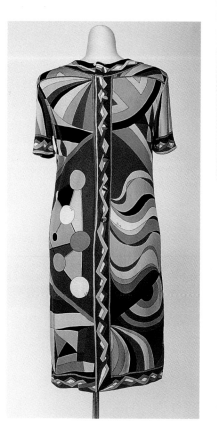

Pucci flapper-style dress made of silk jersey designed with v-neckline and fringed hemline. The harlequin-style print, further enhanced by diagonal stripes, is done in shades of pink and yellow accented with black and white. Labeled: Emilio Pucci, Florence, Italy. $950 and up.

Rear view of Pucci silk jersey shift showing how the vertical banding alters the print on the back.

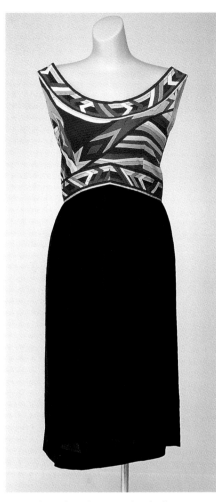

Amber modeling the Pucci sleeveless dress.

Pucci sleeveless dress made of silk jersey designed with an Empire waist and banded borders. The bodice is a geometric print while the slightly gathered skirt is solid black. There is no label but the fabric is signed "Emilio." $375 and up.

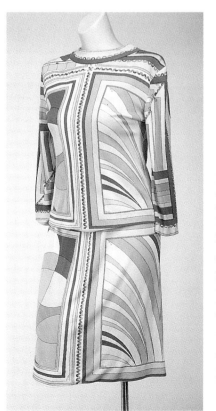

Left:
Pucci two-piece outfit designed with a short skirt and matching top made of silk jersey. The abstract print and banded borders are rendered in shades of pink and green.
Labeled: Emilio Pucci, Florence, Italy. $400 and up.

Right:
Amber modeling the Pucci short skirt and matching top.

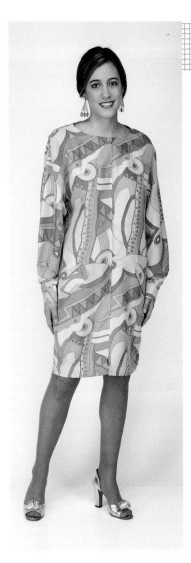

Long sleeve shift designed with zip front made of pure silk with geometric print in shades of blue, lavender, turquoise, and yellow. This Pucci knock-off is labeled Gillian. $100-150.

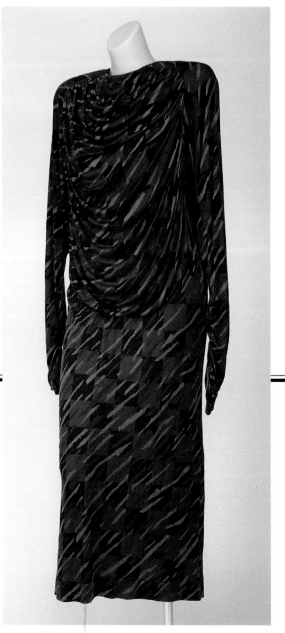

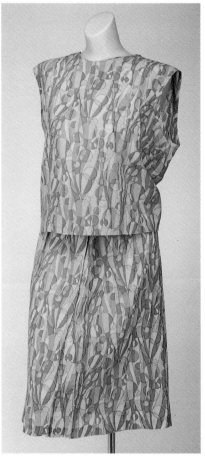

Two piece outfit made of cotton constructed with a sleeveless top and matching skirt. The geometric print is in shades of green, pink, and yellow. $25-35.

A purple and black checkerboard pattern forms the background of this pure silk dress with draped front. Labeled: Missoni, Made in Italy. $200-300.

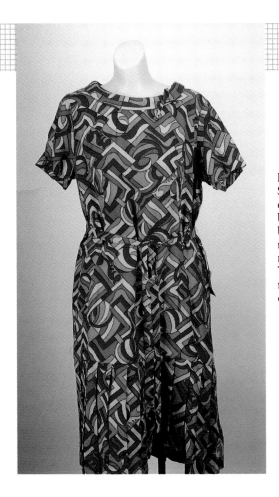

Left:
Short sleeve shift designed with pleated bottom, fold-over boatneck collar and matching self-tied belt made of Orlon acrylic. The geometric print is rendered in psychedelic colors. $25-35.

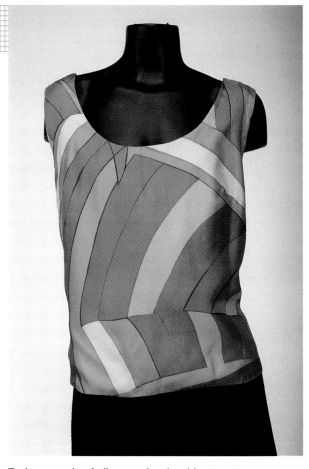

Tank top made of silk printed with wild stripes in psychedelic colors. No label. $35-45.

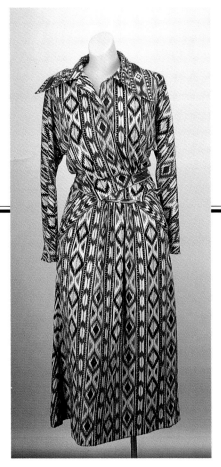

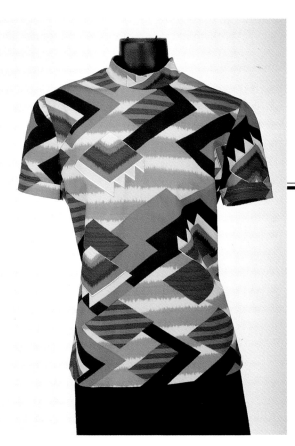

Far left:
This two-piece outfit with Indian-style print is made of polyester. Labeled: Roberta di Camerino, 1976. $30-40.

Left:
Short sleeve top made of polyester stretch knit designed with a stand-up collar. The geometric print is done in shades of green, red, brown, and black. No label. $25-35.

45

Tunic top designed with stand-up collar made of polyester. The wonderful Art Deco print is rendered in black on a beige background. Labeled: Trissi. $50-75.

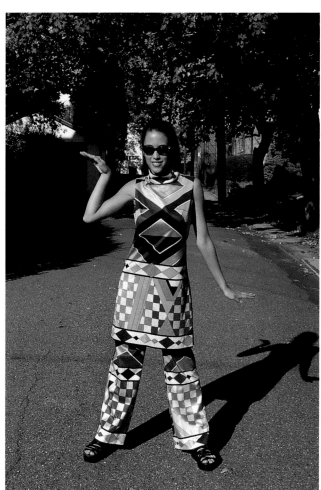

Two-piece ensemble designed with a sleeveless tunic top with stand-up collar and matching wide-legged pants. The striking geometric print is executed in lavender, purple, turquoise, black, grey, and white. Banding creates more interest. The tunic can also be worn as a dress. This Pucci knock-off is labeled Lord & Taylor. $175-250.

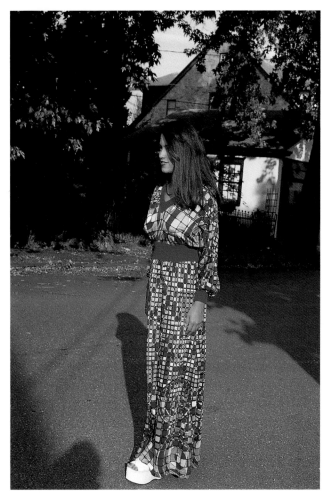

Hostess gown designed with v-neckline and ribbed waistline made of double-knit polyester. The geometric print is rendered in bright colors. Labeled: AT HOME WEAR for Van Raalte. $75-100.

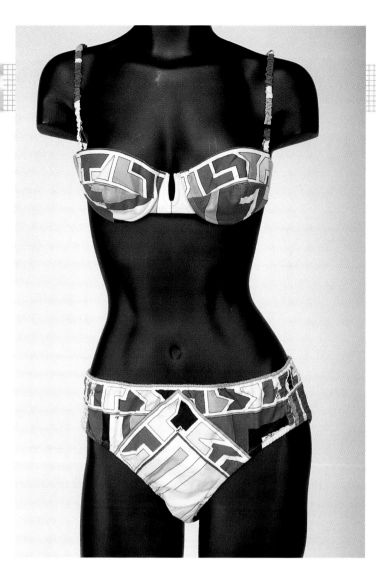

Pucci two-piece bathing suit made of cotton with geometric print in shades of pink, purple, grey, and white. Labeled: Emilio Pucci, Florence, Italy. $295 and up.

Pucci two-piece bathing suit made of 100% Lycra with an abstract print in shades of lavender, purple, mauve, green, yellow, and white. Labeled: Emilio Pucci, Florence, Italy. $295 and up.

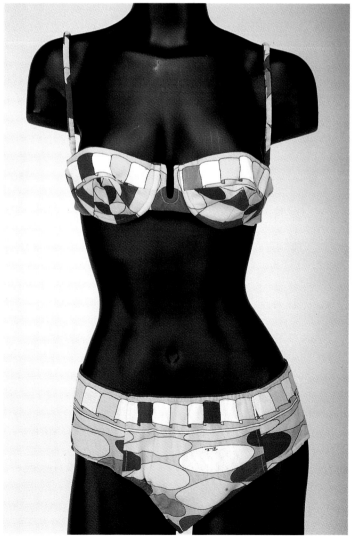

Flower Power

Prints have always been a dynamic way for women to express their individuality. During the 1960s and early 1970s, floral prints were everywhere in a multitude of styles, from large exotic floral prints to small nostalgic granny prints. Season after season, endless varieties of floral prints would enter the fashion scene. This was definitely a period in fashion history when designers could also express themselves. In essence, floral forms offered infinite variety for the textile designer as well as for the consumer.

In the early 1960s, abstract floral prints were extremely common. In 1963, finely-etched floral prints and those inspired from impressionistic art were top fashion news. By 1964, crewel-designed floral prints, oversized white floral prints on dark grounds, flat-floral renditions, and three-dimensional floral prints all were offered.

By 1967, the "humble daisy" became one of the "noblest designs" according to *American Fabrics*. Realistic, abstract, stylized, and oversized versions of this little flower were created by "imaginative textile designers." Not only was the daisy design found on fabrics, it also adorned purses, scarves, headbands, make-up bags, lipstick tubes, and compacts. Jewelry, especially brooches, earrings, and pendants, were also designed like daisies and most of the time enameled in bright colors, set with colored rhinestones or made of plastic.

The fashionable flower print of the late 1960s, initially designed for the younger generation, adapted itself to fashions designed and geared for the sophisticated woman. Floral designs were found on many fabrics of the period. Assorted cottons and cotton blends, crepe, nylon, seersucker, jersey knits, silk, velvet, and corduroy were popular choices. Jacquard knits and metallic brocades also incorporated floral themes. Modern textile technology coupled with the space age of the mid-1960s even created vinyl fabrics displaying flower power motifs.

In 1968, *American Fabrics* noted:

> The POWer of the flower continues to amaze us. Prints bloom, grow bigger; see an oversized, super-spring on the avenues. Bigness does not mean a lack of restraint; there is as much good taste in grandiose designs as there is in Lilliputia.

Print directions for the Spring and Summer season of 1969 still included the lovely perennials, sometimes incorporated with butterflies, bees, ribbons, and bows. The designs were systematically arranged with striped effects resembling wallpaper, thus termed wallpaper prints. Such wallpaper prints, originally modeled after nineteenth century English wallpaper, were fashionable throughout the entire decade but became extremely stylish in the late 1960s.

Giant flower print fabrics were fashioned into shifts, shirtwaist dresses, hostess gowns, jackets, tunic tops, bathing suits, and bell bottoms. Gargantuan flower prints were simultaneously popular with the wallpaper prints and the small granny prints. In 1971, Sears offered a line of granny print dresses described as being reminiscent of the "frontier days." These nostalgic dresses were ankle-length, made of small floral printed fabric or gingham checks, and accented with lace ties, and rick rack. In the same catalog, dresses, blouses, jumpsuits, maxiskirts, midi-skirts, and summer cover-ups were also designed with large florals and psychedelic prints.

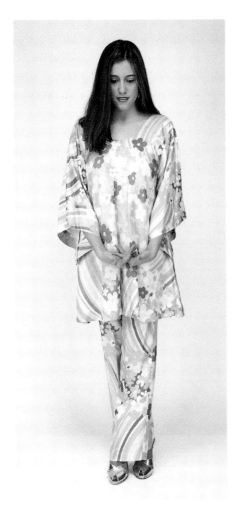

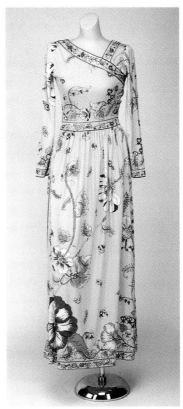

A lovely floral print is found on this jersey knit dress designed with fitted bodice and slightly gathered skirt. Banding accentuates the neckline. Labeled: Maurice by C. Rizza. $75-95.

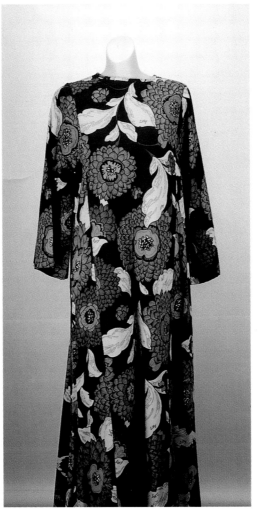

Tent-style tunic top with matching wide-legged pants made of acetate with a funky floral print. No label. $75-100.

Hostess gown made of a heavy weight acrylic fiber with an oversized floral print in shades of blue, green, and yellow. The fabric bears the signature "Lilly" throughout the design. Labeled: The Lilly. Lilly Pulitzer, Inc. $100-150.

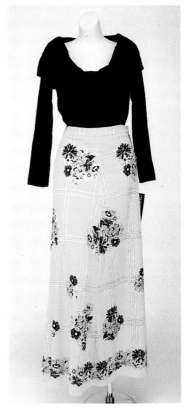

Long skirt made of stretch knit accented with black and white daisies on a bright yellow background. No label. Black stretch knit top with open neckline accented with a bow. Labeled: Tapemeasure, New York. $30-60 each.

Floral-printed shift with self-tied belt and lattice yoke, offered for sale in 1970 from Aldens.

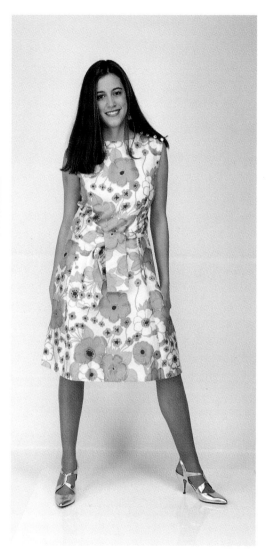

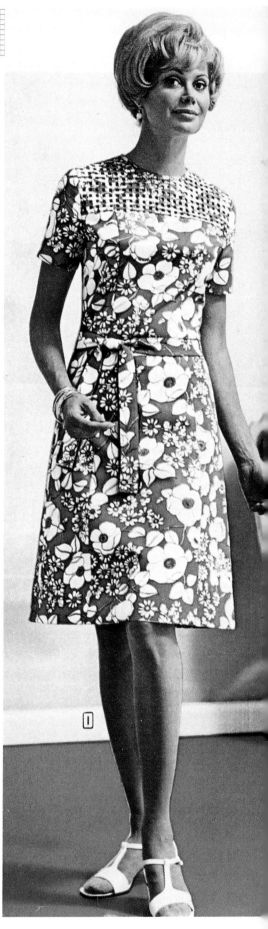

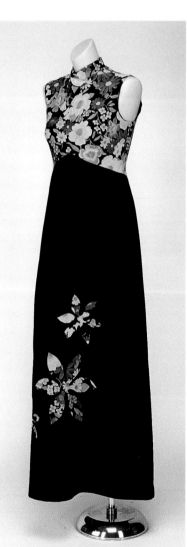

Sleeveless shift with self-tied belt made of silk with a floral pattern in shades of pink, bright orange, olive green, gold, and tan on a white ground. Labeled: Lane's, Wilkes-Barre. $45-65.

Sleeveless gown made of polyester designed with an Empire waist and floral printed bodice. The solid-color skirt is accented with appliquéd flowers. *Courtesy of Marlene Franchetti.* $50-75.

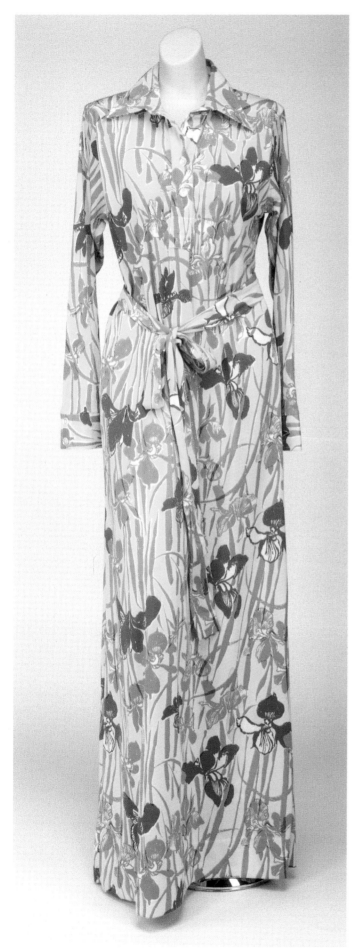

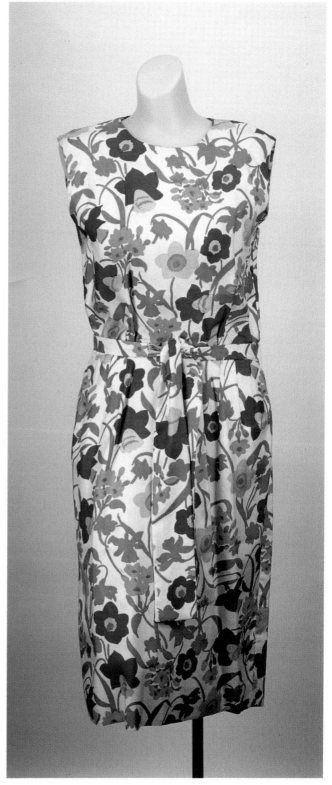

Sleeveless shirtwaist dress with matching sash rendered in a five-toned floral print. Labeled: Tanner of North Carolina by Dorothy Fox. $30-45.

Long shift dress with self-tied belt made of stretch knit with a floral pattern in shades of pink, green, and yellow. Labeled: The Lilly. Lilly Pulitzer, Inc. $75-125.

51

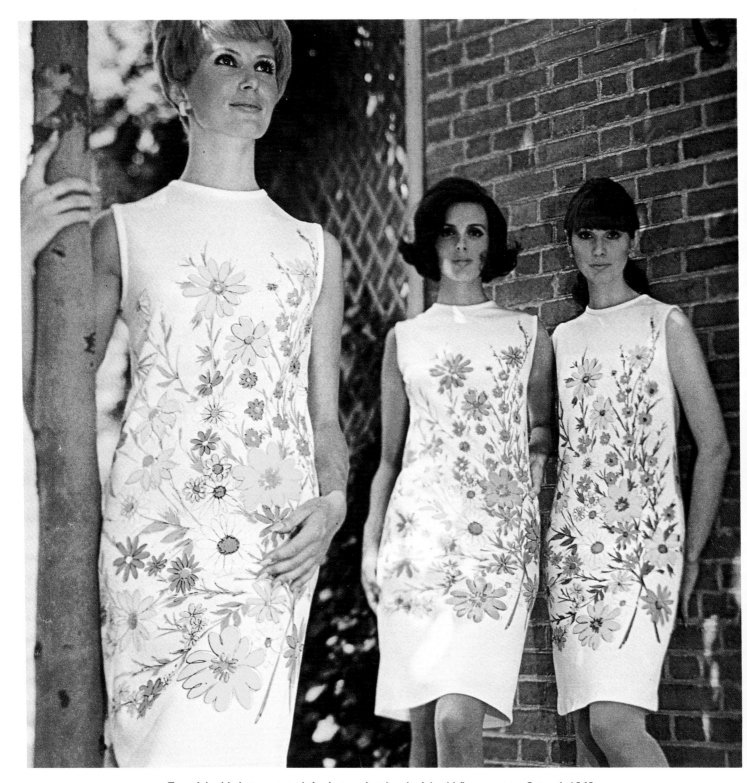

Trio of double knit acetate shifts designed with colorful wild flower prints. Spiegel, 1969.

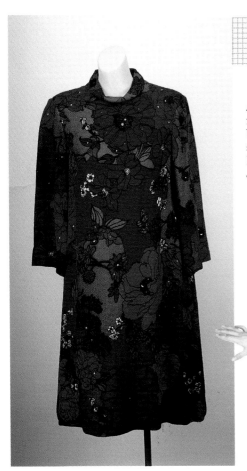

A lovely oversized floral print executed in rich shades of purple, fuchsia, olive green, burgandy, and orange is found on this long sleeve wool dress. The dress is also embellished with colored rhinestones. Labeled: Junior Accent by Frank Adams. $75-95.

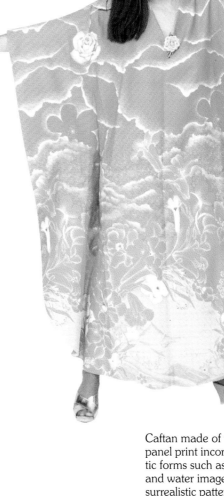

Caftan made of polyester with an oversized panel print incorporating stylized and naturalistic forms such as cabbage roses, day lilies, sky and water images, combined to form a surrealistic pattern. Labeled: David Brown, California. *Courtesy of Marlene Franchetti.* $95-145.

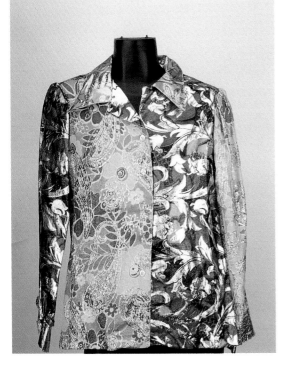

Evening blouse designed with long sleeves in a brightly colored stylized floral and paisley print made of nylon and Mylar Gold. Labeled: Sak's Fifth Avenue. $50-75.

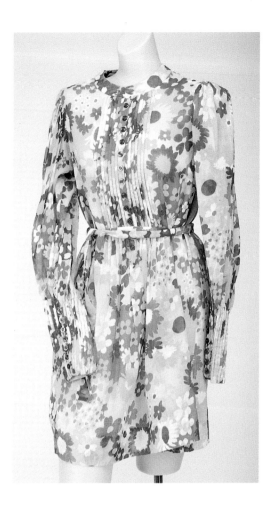

Long sleeve shift with self-tied belt accented with rows of tucks down the center of the dress and around the cuffs. The cute floral print is done in shades of blue, yellow, and white. Labeled: Bigi at Bergdorf's. $40-50.

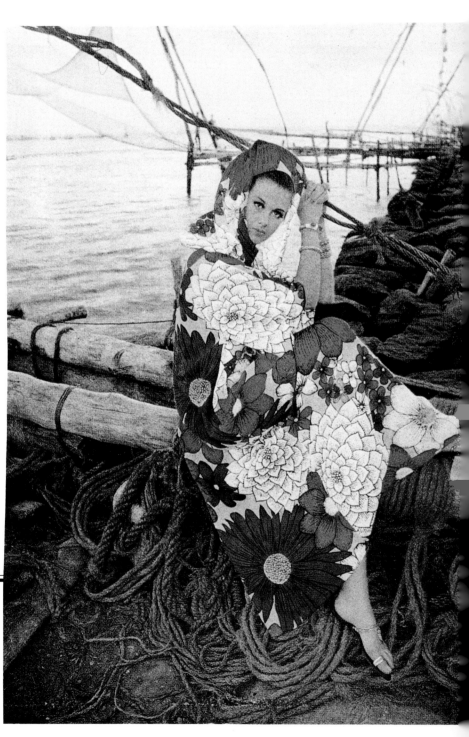

Hooded robe and matching bikini (not shown), designed with a gargantuan flower print. *McCall's*, 1966.

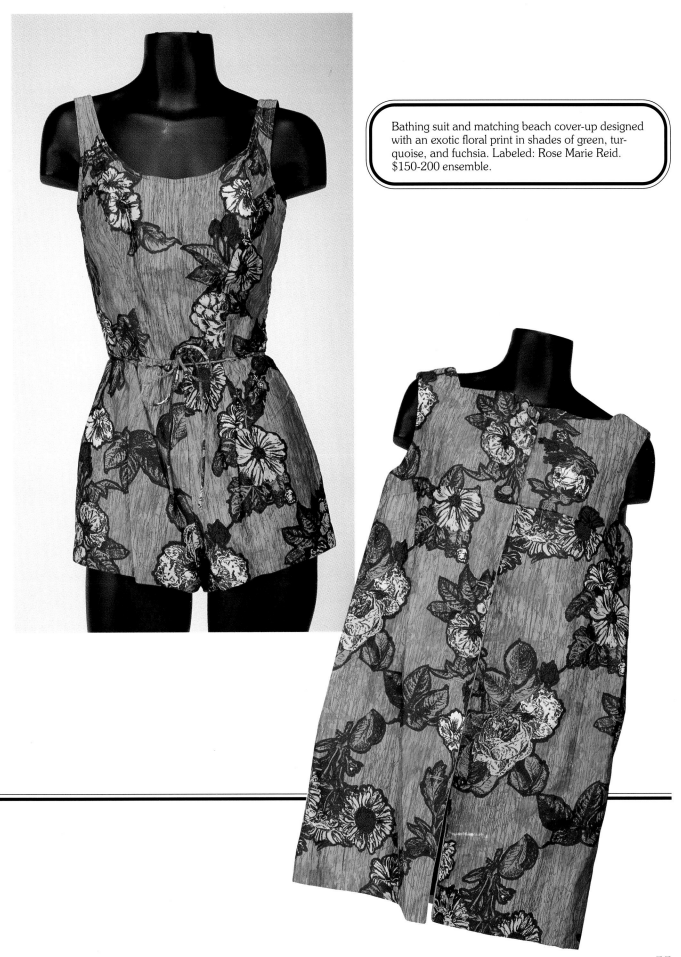

Bathing suit and matching beach cover-up designed with an exotic floral print in shades of green, turquoise, and fuchsia. Labeled: Rose Marie Reid. $150-200 ensemble.

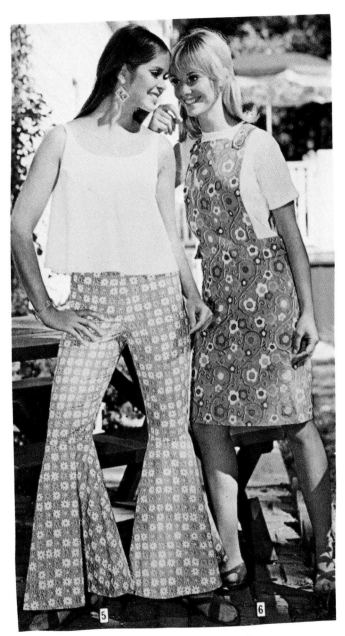

Ad for summer wear in funky floral
prints, popular in 1967.

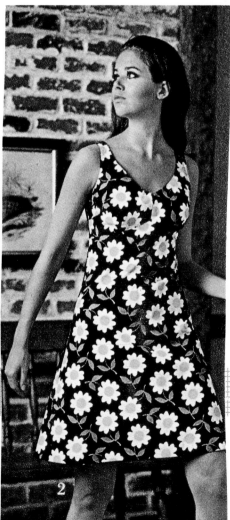

Ad for A-line shift with scooped
neckline in colorful daisy print, circa
1969.

Even the everyday housedresses were decked out with wild floral prints in psychedelic colors. This sleeveless shift made of cotton and avril is labeled Majestic Frocks. $15-20.

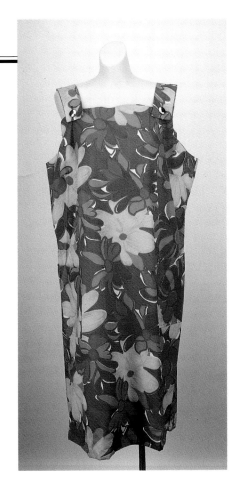

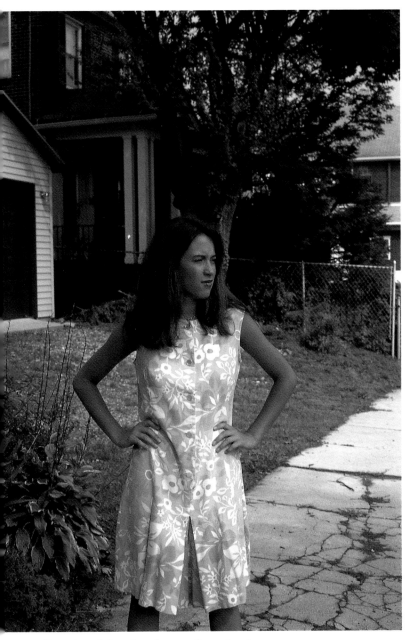

Sleeveless shift-style culotte outfit made of textured cotton with a large floral print done in shades of melon, periwinkle, apricot, and white on a chartreuse background. No label. $30-40.

Flower power combined with polka dots creates a funky print with a wild color scheme. Labeled: Replay. Made in Italy. $15-20.

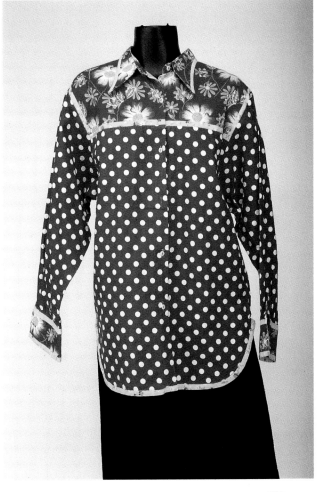

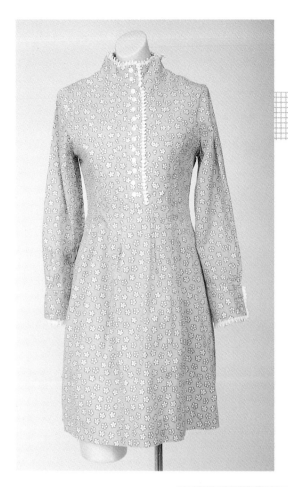

Left:
Shirtwaist dress made of cotton designed with long sleeves, slightly gathered skirt and stand-up collar. The granny print (small floral print) is further accented with lace edging. $20-30.

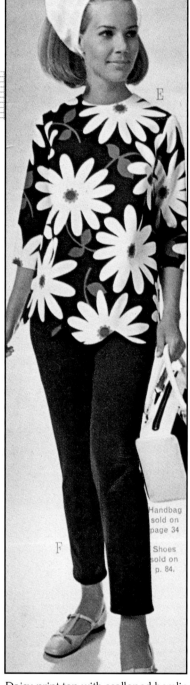

Daisy-print top with scalloped hemline designed as a maternity top and advertised in 1969.

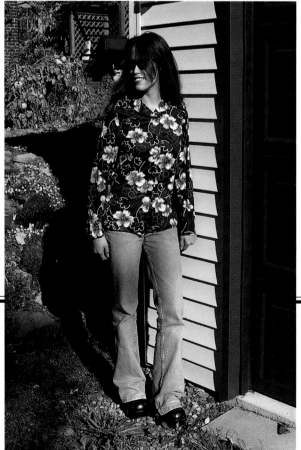

Long sleeve button-down blouse made of polyester with floral print executed in shades of pink, red, and white on a black ground. No label. $20-30.

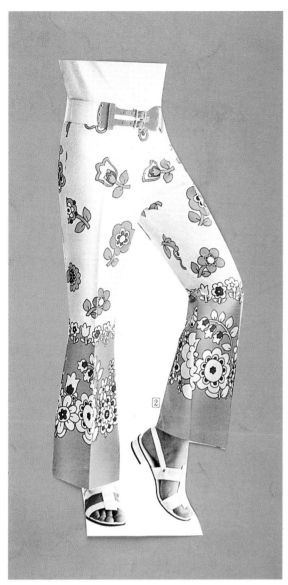

Permanent press, floral-printed pants with flared-legs and 2" vinyl belt, advertised in 1971.

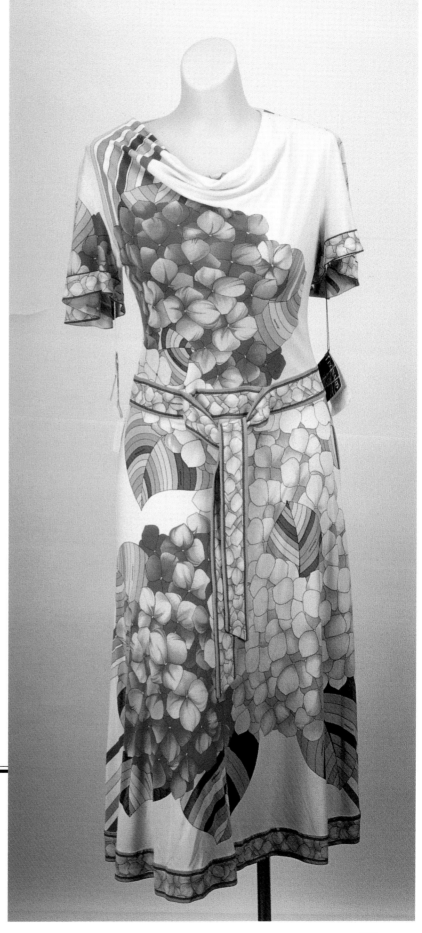

A charming palette of psychedelic colors decorates this floral printed silk jersey dress by "Leonard of Paris." The original tag reads: *Leonard presents their printed, knitted, pure silk dresses and sets in dazzling shades. Their lightness and compactness are the fore-runners of the smart women.* The original retail price of this exclusive dress, which was purchased at Bergdorf-Goodman in New York City was $450. $400 and up.

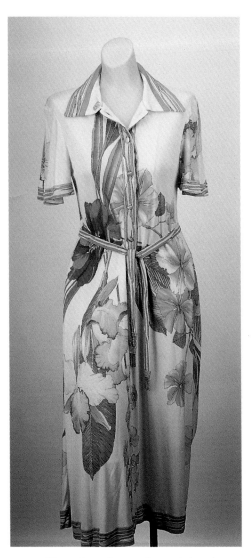

Short sleeve button-down shift with self-tied belt made of silk decorated with an oversized floral print in bright colors. Labeled: Leonard of Paris for Bergdorf-Goodman, New York. $300 and up.

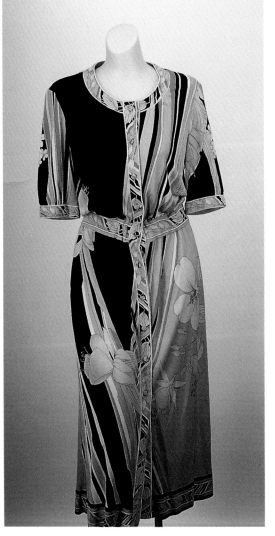

Pucci look-a-like by Leonard of Paris, made of silk jersey with a black, pink, and grey Art Nouveau style print. $300 and up.

Below:
Long sleeve button-down dress with self-tied belt made of silk, with an oversized floral print executed in shades of green and beige. Labeled: Leonard of Paris for Bergdorf-Goodman, New York. $300 and up.

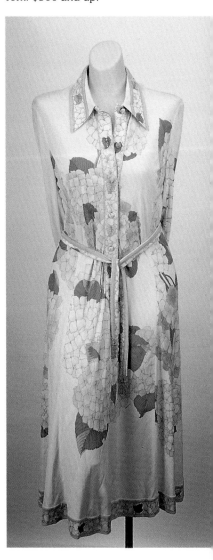

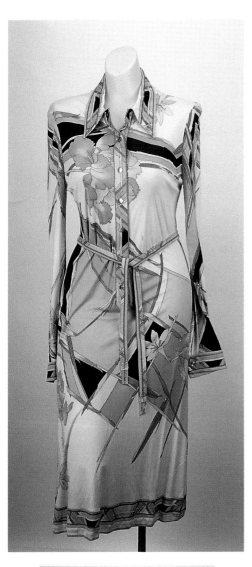

Another silk jersey dress by Leonard of Paris with a large floral print combined with geometric shapes in beige, brown, navy blue, and turquoise. Banded borders accentuate cuffs and hemline. $300 and up.

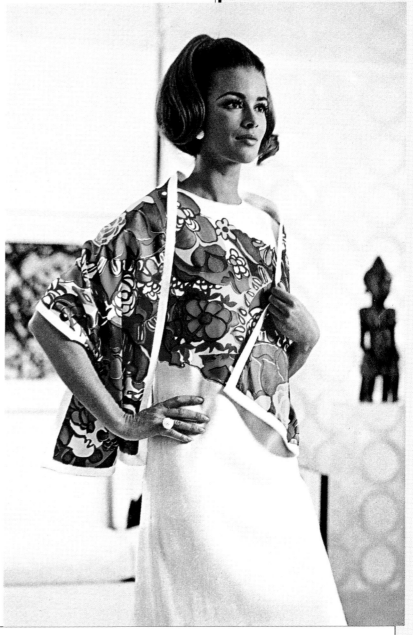

Two-piece ensemble consisting of an A-line dress with matching reversible stole. Even though the outfit is designed for the sophisticated lady, the funky floral print is rendered in psychedelic colors. Advertisement circa 1969.

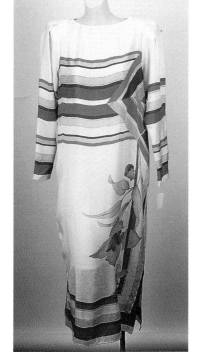

Elegant long sleeve shift made of imported silk woven in a checkerboard pattern with floral and geometric prints used in combination. Labeled: Brijo. $140-190.

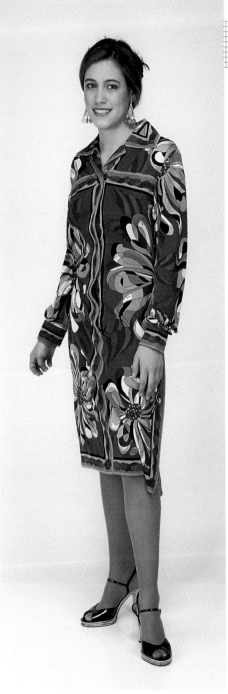

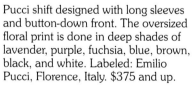

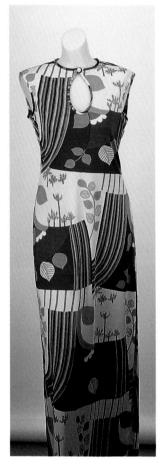

Sleeveless knit jersey dress with a combination print consisting of leaf patterns and stripes. Labeled: Don Luis. Made in Spain. $85-125.

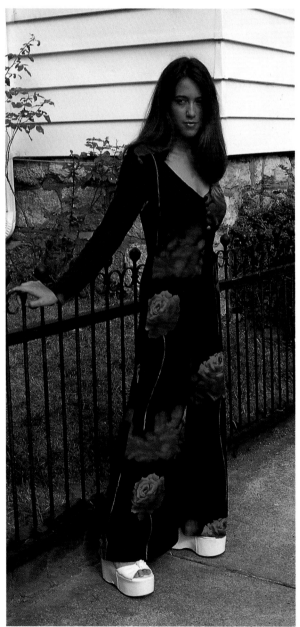

Pucci shift designed with long sleeves and button-down front. The oversized floral print is done in deep shades of lavender, purple, fuchsia, blue, brown, black, and white. Labeled: Emilio Pucci, Florence, Italy. $375 and up.

Jumpsuit designed with plunging neckline, made of jersey knit with a stunning oversized rose print executed in shades of pink and burgundy on a black ground. No label. $75-125.

Pucci two-piece outfit designed with a gathered skirt and matching top, made of silk jersey with a three-toned stylized floral print. Labeled: Emilio Pucci, Florence, Italy. $350 and up.

Long sleeve silk jersey dress designed with draped front and banding at the collar, cuffs, and hemline. Labeled: Leonard of Paris. Bergdorf-Goodman on the Plaza, New York. $400 and up.

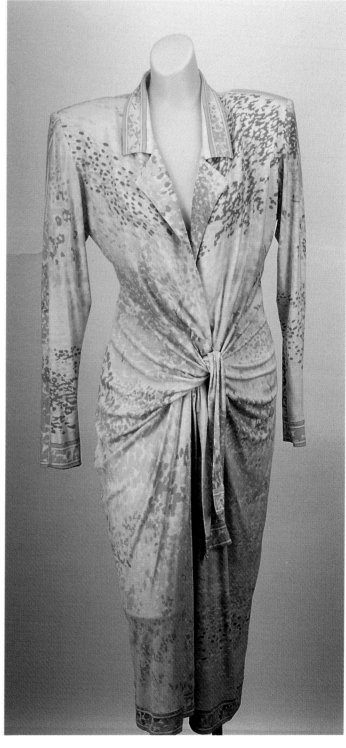

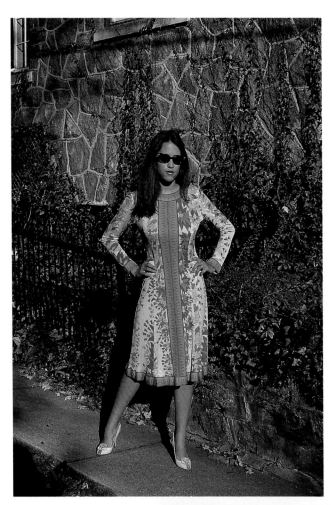

Pucci knock-off made of silk jersey with a stylized floral print in shades of pink, mauve, blue, turquoise, purple, and white. The signature "Bessi" is found throughout the design of the fabric. Banded borders accentuate the neckline, cuffs, and hemline. Labeled: Made in Italy for Bonwit Teller. $150-200.

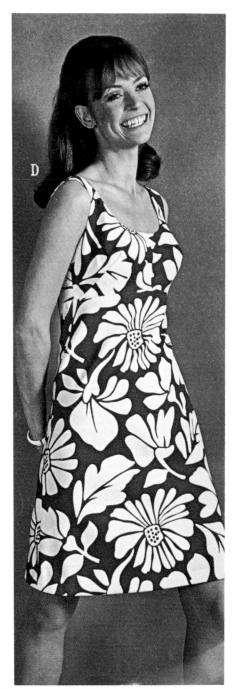

"Polynesian-style bra-shift" offered for sale in 1969.

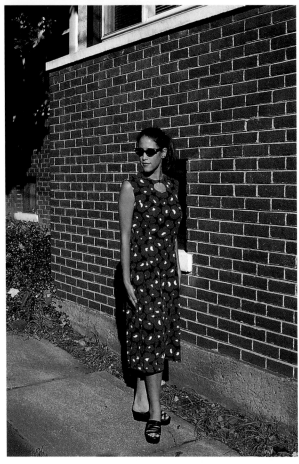

Sleeveless shift made of polyester with allover floral print rendered in red and white on a black ground. No label. $50-75.

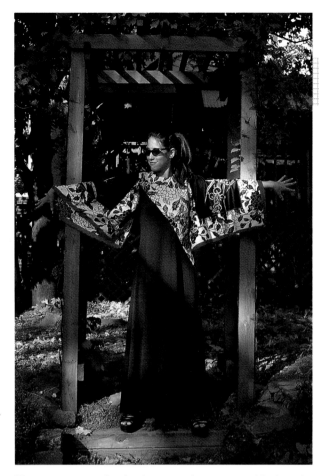

Hostess gown made of polyester with a stunning black and white floral print trimmed in red. No label. $75-100.

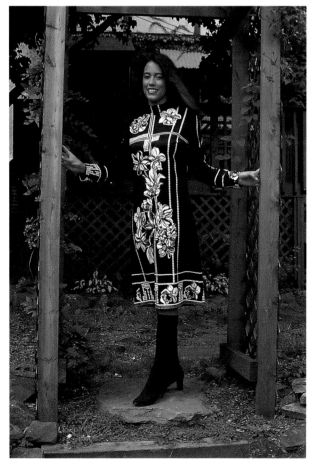

Elegant halter-style evening dress made of nylon with an allover floral print executed in psychedelic colors. Labeled: Estelle Peck, Lake Hiawatha, N.J. $125-150.

Panel print shift designed with long sleeves and stand up collar. The floral and geometric print is rendered in black and white. Labeled: Cirette, California. $70-95.

Chapter Five
Op Art Influence

In the Spring of 1965, a display of over 125 paintings created by 75 artists from 10 different countries was exhibited at the Museum of Modern Art in New York City. "The Responsive Eye," as the exhibit was titled, focused on an art movement known as *Op Art*. Op (short for optical) Art, is an art form which employs basic design elements such as circles, squares, checkerboards, spirals, and wavy lines to create designs which the eye interprets in various ways. The positioning of the patterns, which seem to display movement, creates optical illusions.

Shortly after the art exhibit in the Spring of 1965, textile designers began demonstrating their Op Art prints on textiles used for fashions and home furnishings. This was a continuation of the close tie that already existed between the artist and the textile designer. Years earlier, art and industry had influenced each other with the abstract art movement.

Pop Art also made its way into the fashion industry at that time. By the early 1960s, Pop Art had really blossomed with the works of Andy Warhol. His depiction of the Campbell's soup label in "monotonous repetition" created further impetus for other artists to create impressions of "popular culture."

By the Summer of 1965, *American Fabrics* reported on the "design phenomenon" of Op Art:

The almost instantaneous adoption of Op Art by the textile, fashion and home furnishings industries is a significant demonstration of the speed with which things move in today's fabric and fashion world. Simultaneous with the "Responsive Eye" Op Art exhibit at New York's Museum of Modern Art was the appearance of Op Art-inspired fabrics. Overnight, it seems a deep penetration into the fabric and fashion field took place. With electronic speed, the textile houses, cutters and retailers made contact with the public, and the consumers welcomed the whole idea with open arms.

We believe that there are a number of significant deductions to be made from this openhearted reception of Op Art. First, it proves that the consuming public is art-conscious to a degree surpassing theoretical speculation. Second, the public taste in response to well-designed fashion has been enormously underrated. Third, the American public is ready and eager for anything fresh and bold and new. Finally, fashion in every field and on every level has become a live and fascinating world where only what's boring is excluded. In ideas as well as clothing, nobody wants to wear "grandma's shoes." Op Art motifs in the design area are as convincing evidence of the desire area for freshness and newness as stretch and bonding and permanent press are in the area of technological advances in the effervescent fabric and fashion fields.

Opposite page:
Bathing suit and matching cover-up with wonderful Op Art print. Labeled: Tina Lesser Original. $300 and up.

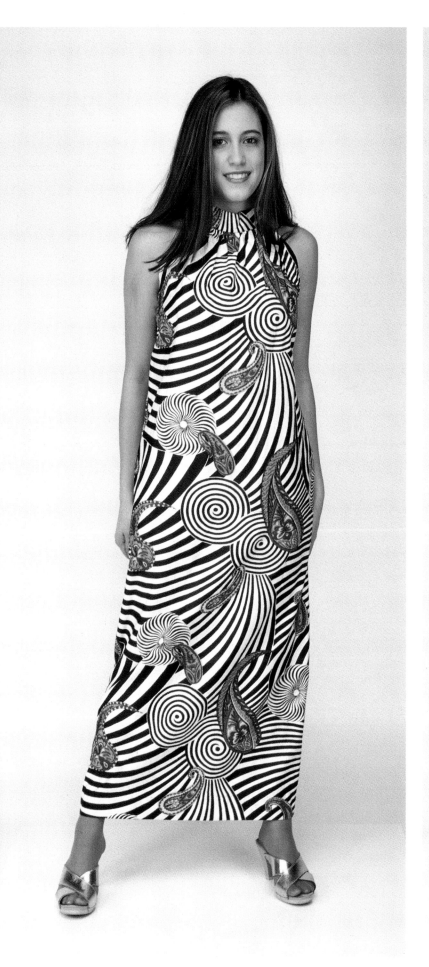
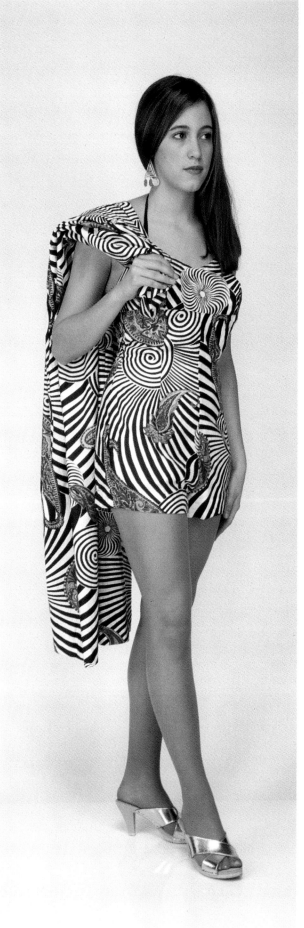

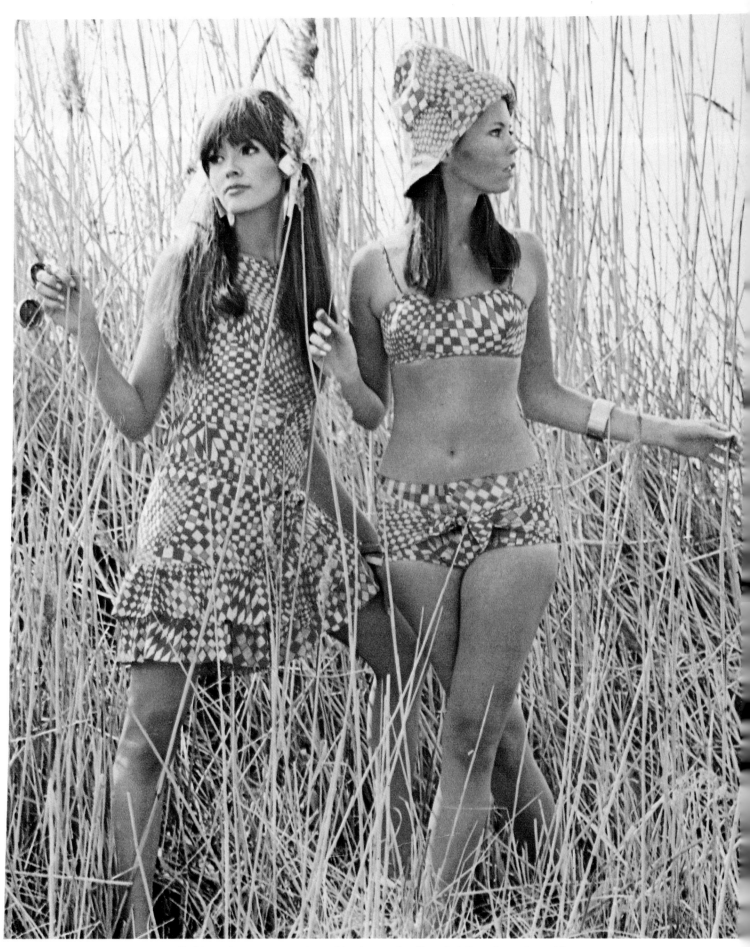

Bathing suit, cover-up, and matching hat made of bonded Caprolan nylon, with Op Art prints rendered in psychedelic colors. *Seventeen*, 1967.

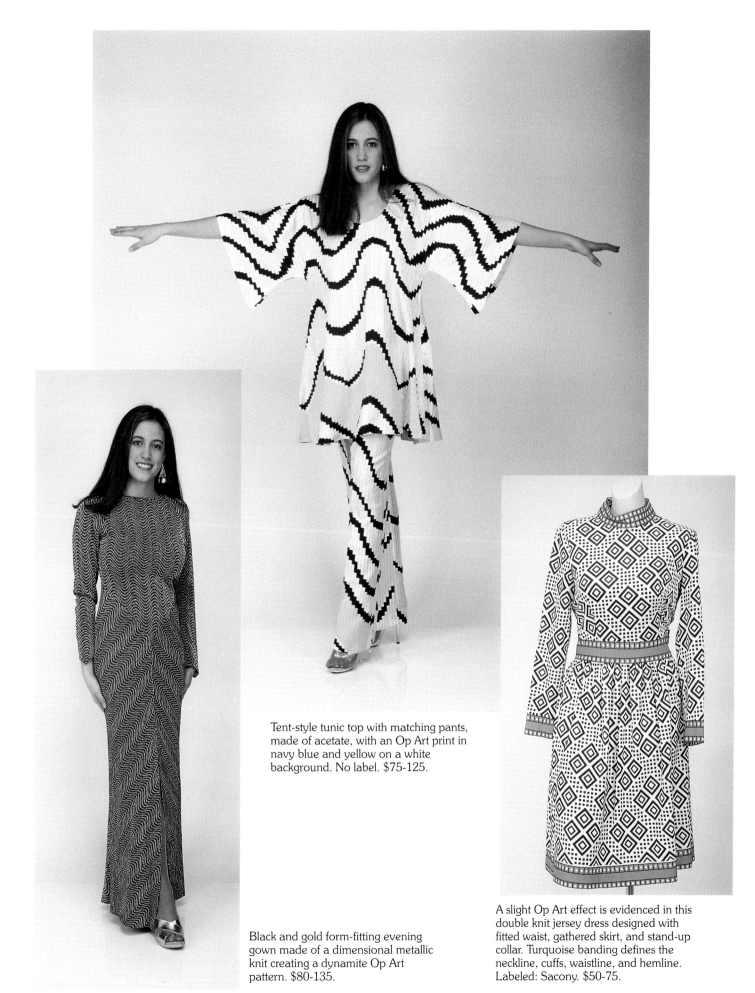

Tent-style tunic top with matching pants, made of acetate, with an Op Art print in navy blue and yellow on a white background. No label. $75-125.

Black and gold form-fitting evening gown made of a dimensional metallic knit creating a dynamite Op Art pattern. $80-135.

A slight Op Art effect is evidenced in this double knit jersey dress designed with fitted waist, gathered skirt, and stand-up collar. Turquoise banding defines the neckline, cuffs, waistline, and hemline. Labeled: Sacony. $50-75.

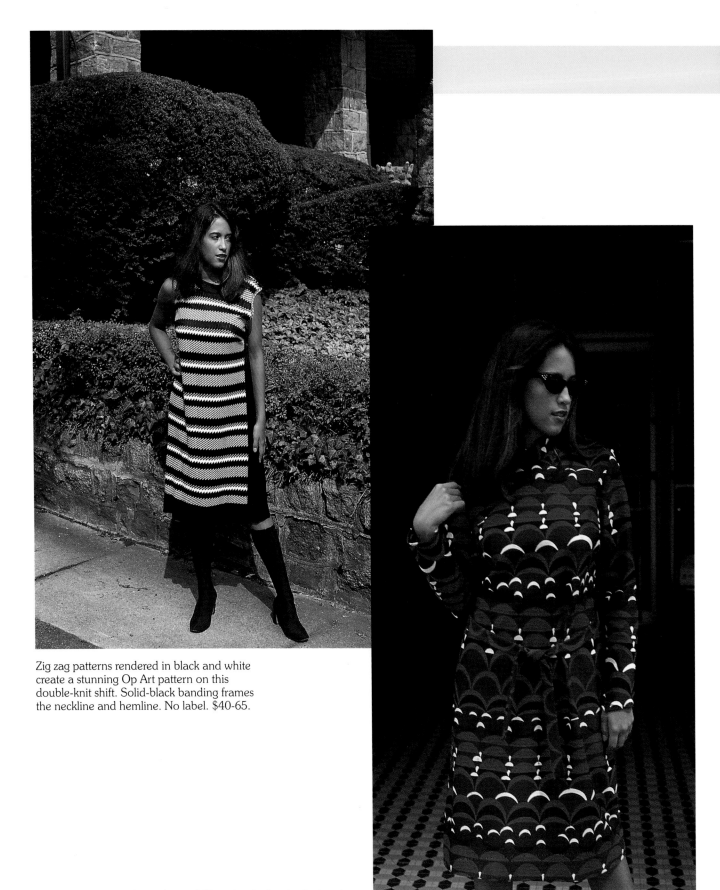

Zig zag patterns rendered in black and white create a stunning Op Art pattern on this double-knit shift. Solid-black banding frames the neckline and hemline. No label. $40-65.

Long sleeve shift made of polyester designed with a mandarin collar and self-tied belt. Geometric shapes in shades of brown, rust, black, and white create a slight Op Art pattern. No label. $60-80.

Sleeveless knit dress with Op Art print in burnt orange, chestnut brown, black, and white. Sears, 1971.

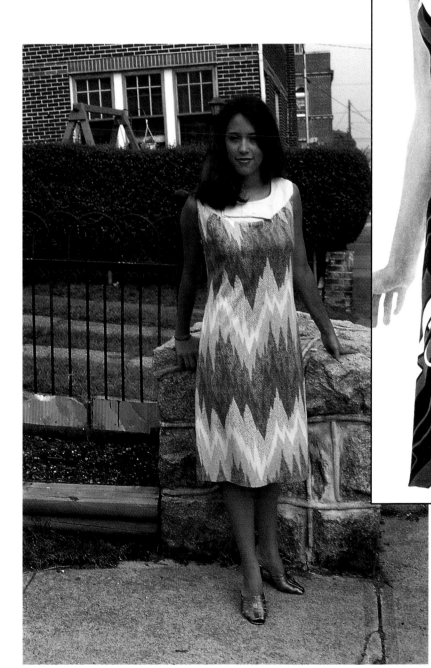

Sleeveless shift made of polyester with a zig zag pattern in shades of yellow, gold, orange, and olive green. A solid-color bow accentuates the neckline. No label. $40-60.

Short sleeve dress designed with stand-up collar, drop waist, and gathered skirt. The black and white abstract print creates a slight Op Art effect. Labeled: Leo Narducci. $100 and up.

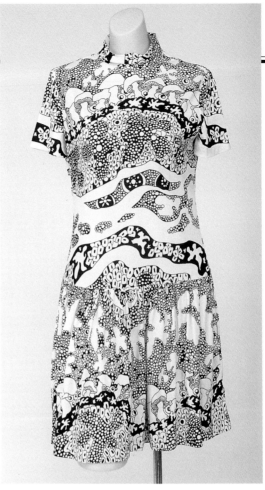

Velveteen evening skirt with exceptional Op Art pattern executed in shades of blue accented with black. Labeled: Mr. Dino. New York, Paris, Florence. $135 and up.

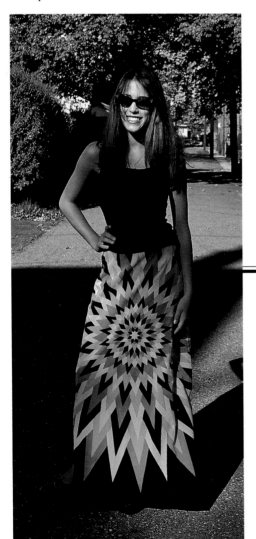

Right:
Matching four-piece ensemble consisting of a skirt, sleeveless top, jacket, and turban-style hat made of silk. The positioning and size of the multi-colored horizontal stripes creates a slight Op Art effect. Labeled: Atelier by Gayle Kirkpatrick. $150 and up.

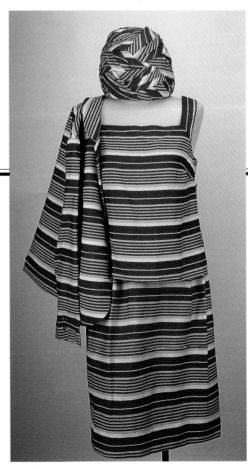

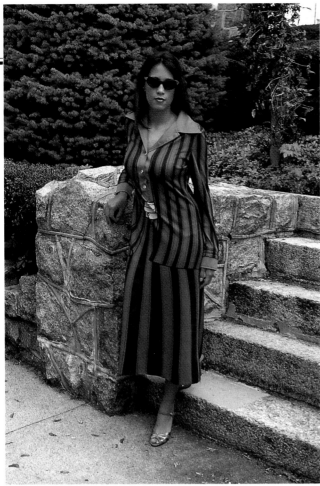

A very unusual dress made of polyester, printed with the illusion of being a two-piece ensemble. Labeled: 100% Polyester Fibre. $95 and up.

Another unusual polyester dress printed with the illusion of having a sash draped around the waist. No label. $95 and up.

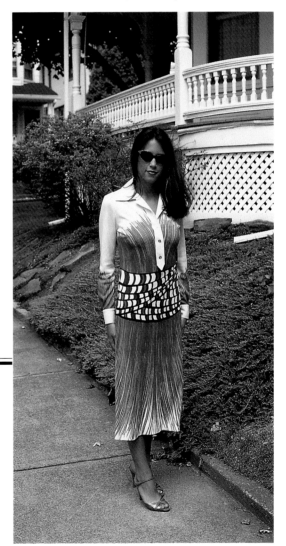

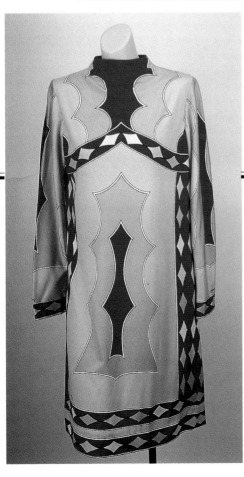

Long sleeve shift made of stretch knit with an abstract print in shades of pink, fuchsia, and grey. The fabric is signed "Artemis." Labeled: Artemis. $85-135.

Chapter Six
Pure Psychedelics

Young people of the 1960s popularized many of the print movements of the decade, thus creating newsworthy fashion trends. Art Nouveau prints, Art Deco prints, granny prints, Op Art prints and Pop Art prints were enthusiastically worn by Sixties' youth. Mods preferred stripes, checks, polka dots, and small floral prints. The anti-mods chose to wear turn of the century and Art Nouveau styles with a strong penchant for second-hand clothing. As each trend gathered momentum, more and more designers jumped on the band wagon, creating similar styles catering not only to the young person, but to the sophisticated "jet setter" as well. Established patterns of dress began changing for everyone.

The Sixties' youth movement was a revolt against social and political conformity. Young people rebelled against normal society. They refused to conform to their parents' beliefs, attitudes, and—most of all—their dress codes. Youth in the Sixties demanded their own individuality.

The Hippies, for example, were a psychedelic breed of modern-day Bohemians. Living in communes, belonging to cults, taking hallucinogenic drugs, practicing free sex, preaching peace, love and brotherhood, and studying Eastern religions, this breed of radicals had a dress code all their own. They preferred to wear jeans and t-shirts, long dresses and cloaks, all decorated with love beads, crosses, medallions, and Egyptian ankhs. Their hair was long and usually parted down the center. Most of the time, it was difficult to determine from the back if it was a male or a female.

Hippie heaven was the Haight-Ashbury district of San Francisco. This strange breed, fond of taking hallucinogenic drugs, hung around street corners preaching their beliefs and wandering in and out of psychedelic shops that reeked of burning incense. They read underground newspapers full of words written by Timothy Leary and far out drawings reminiscent of the Art Nouveau style.

Responding to the hallucinogenic suggestions of the drug-induced hippie—not to mention the Vietnam war, race riots, and acid rock—graphic artists began designing posters dealing with all the turbulence of that decade. Many shops opened up in San Francisco and other large cities to sell these posters, which displayed anti-war messages, advertised specific events, or were just elaborately designed with pure psychedelics. The posters were brilliantly colored in bright pink, purple, orange, and acid green, and they immediately caught the attention of the general public. Because of this, textile designers responded, and, like the graphic artist, created wonderful psychedelic prints for the fashion world. Again we find a close relationship existing between the world of art and the world of fabric and fashion.

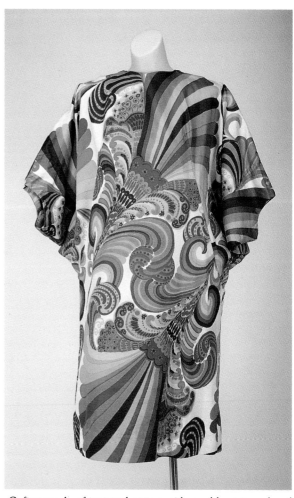

Caftan made of textured cotton with a wild print rendered in pure psychedelic colors. No label. $75-125.

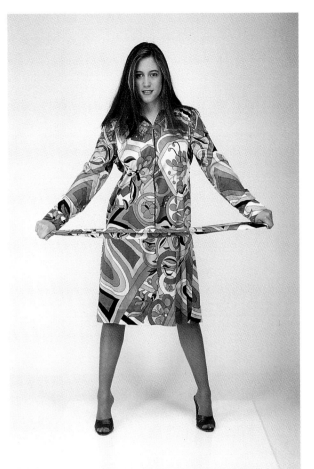

Long sleeve shift with zip front and self-tied belt, made of stretch knit polyester with an abstract print rendered in psyche-delic colors. No label. $70-95.

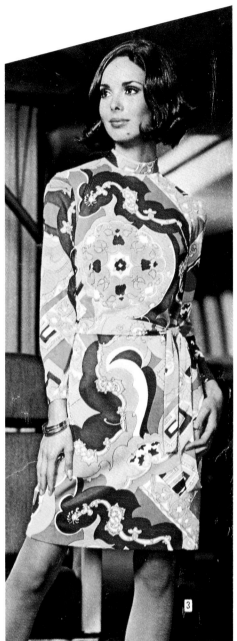

Long sleeve jersey knit dress with stand-up collar and self-tied belt. The psychedelic print is rendered in shades of yellow, tan, brown, orange, and white. Advertisement circa 1970.

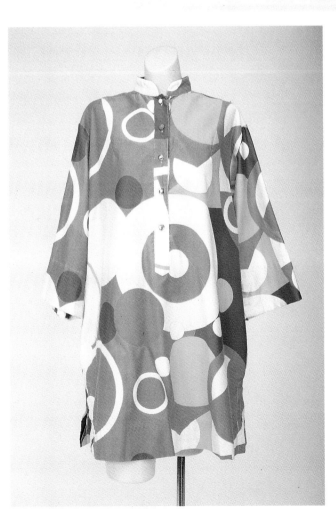

Long sleeve shift designed with Mandarin collar made of cotton. The wild geometrics are executed in psychedelic colors. Labeled: Catherine Ogust for Penthouse Gallery. $60-85.

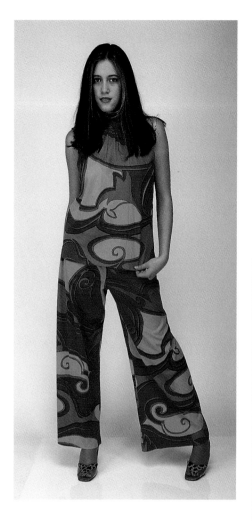

Bell-bottomed pants with matching
top made of stretch knit with a wild
abstract print rendered in psychedelic
colors. No label. $100-150.

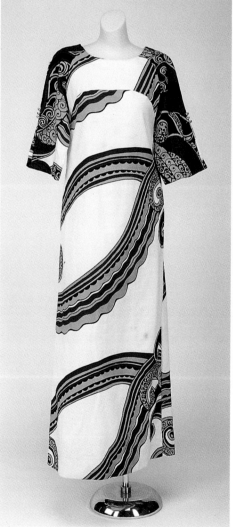

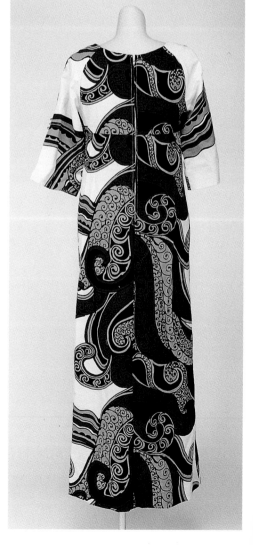

Above and right:
Hostess gown made of cotton with an abstract
print executed in deep purple, fluorescent
green, orange, and black on a white ground.
The print on the front is different than the print
on the back. Labeled: Created in Hawaii For
Surfside Sportswear, Waikiki, Hawaii.
$75-100.

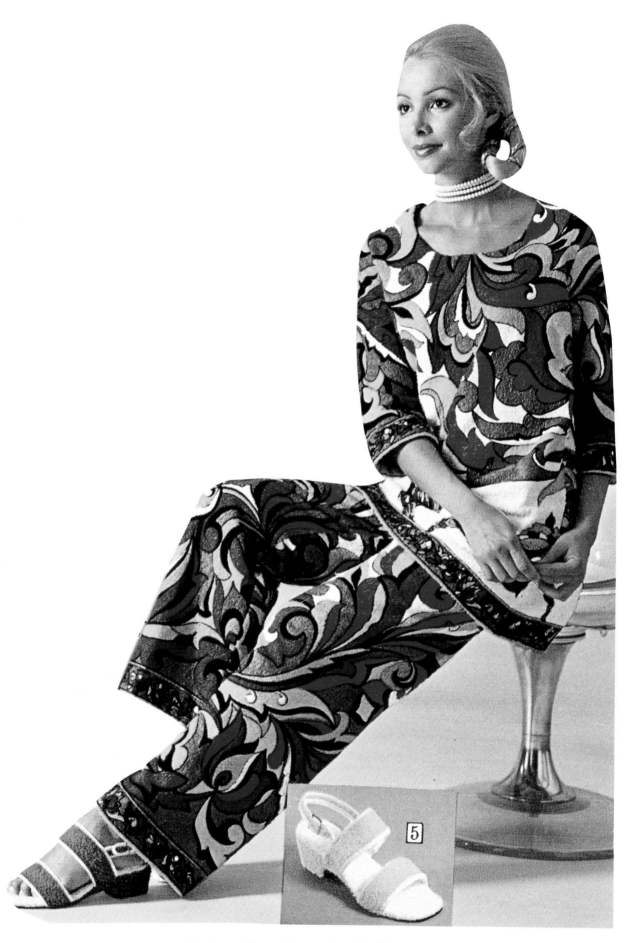

Tunic top with matching pants made of terry
cloth with colorful psychedelic print. Sears, 1971.

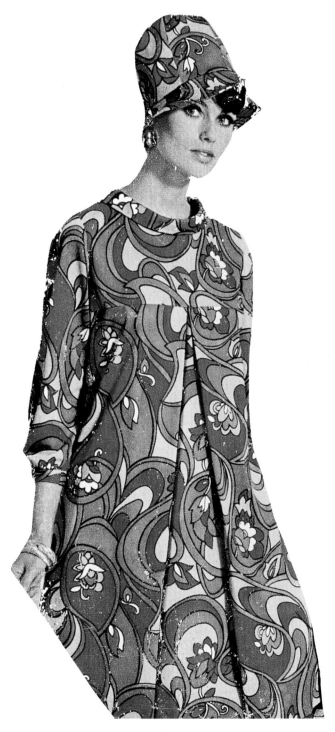

Tent dress with matching hat in an Art Nouveau style print rendered in psychedelic colors. Aldens, 1967.

Hawaiian muu-muu with an abstract print in pink and yellow. Labeled: Nalii, Honolulu. $50-75.

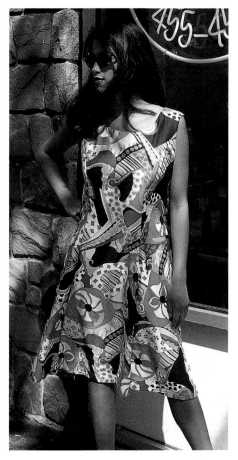

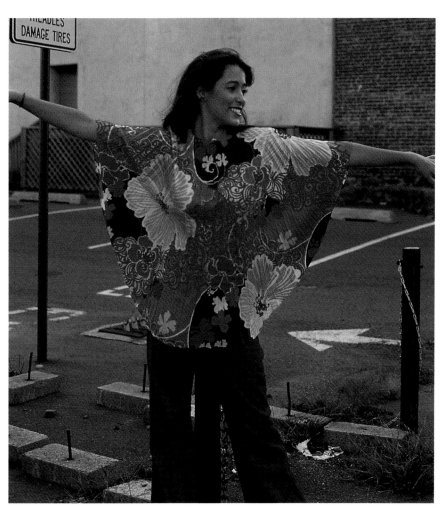

Sleeveless shift with rounded neckline made of 100% cotton with a psychedelic print. Labeled: Dash-About. $45-65.

Caftan-styled top designed with accordian pleats and drawstring neckline with an abstract floral print in psychedelic colors. No label. $35-50.

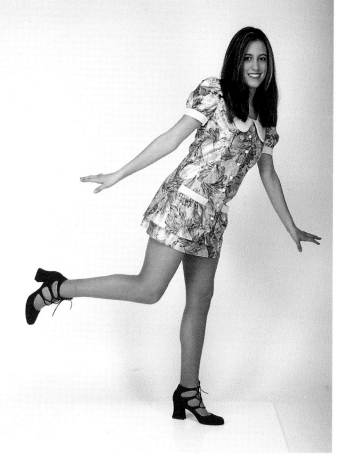

Two-piece suit made of polyester, consisting of mini-skirt and matching jacket with short baby doll sleeves. The colorful print is accented with solid-color trim. This suit was made in 1969. *Courtesy of Marlene Franchetti.* $75-100.

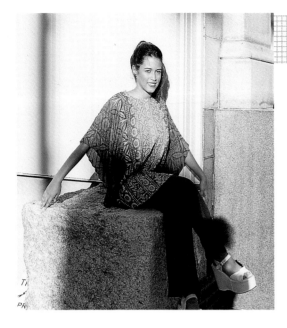

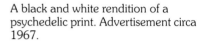

Caftan-styled top designed with accordian pleats and drawstring neckline with a Batik-style print in shades of green and yellow. No label. $35-50.

A black and white rendition of a psychedelic print. Advertisement circa 1967.

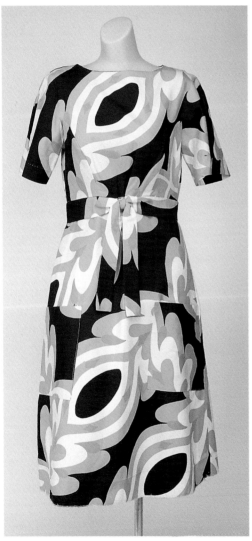

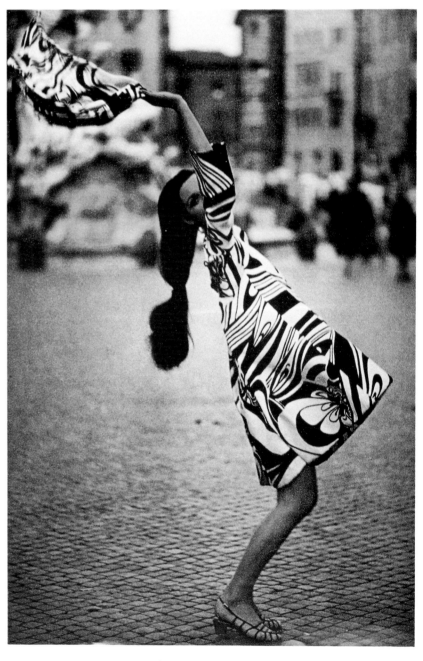

Structured day dress made of cotton designed with short sleeves, patch pockets, and self-tied belt. The abstract print is rendered in lime green, navy, and white. Labeled: Baba Kea, Honolulu For Peter Pan Swimwear, Inc. $40-50.

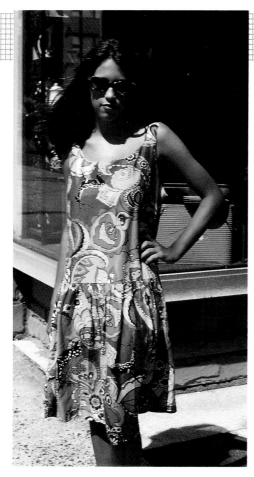

Sleeveless dress made of polished cotton designed with scoop neckline, dropped waist, and gathered skirt. Labeled: Styled by Kamore. $35-45.

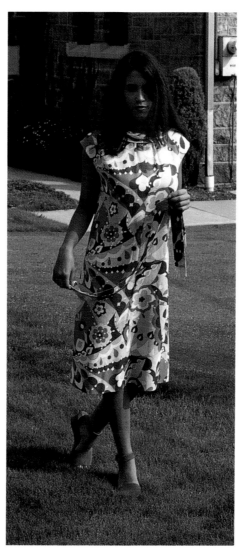

Sleeveless shift made of cotton with psychedelic print executed in shades of purple, lavender, green, blue, and white. No label. $35-45.

Sleeveless shift with self-tied belt made of crepe. The stylized print is executed in shades of pink, brown, and tan accented with white. No label. $35-50.

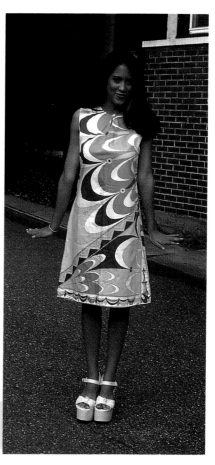

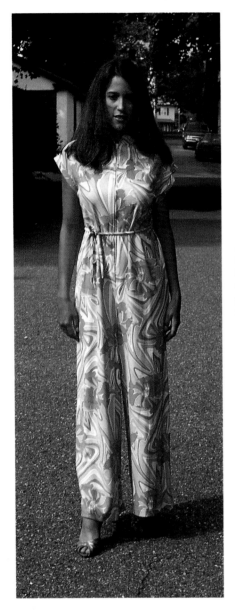

Jumpsuit made of 100% acetate designed with zip front, cap sleeves, and self-tied belt. The abstract floral print is rendered in shades of grey, brown, tan, orange, and white. $70-95.

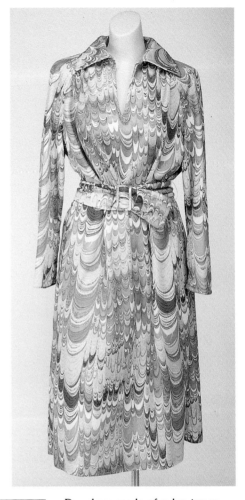

Day dress made of nylon jersey designed with long sleeves, v-neckline, and buckled sash. The wild print is done in shades of pink, burgundy, grey, gold, and white. Labeled: Leslie Fay Original. $30-45.

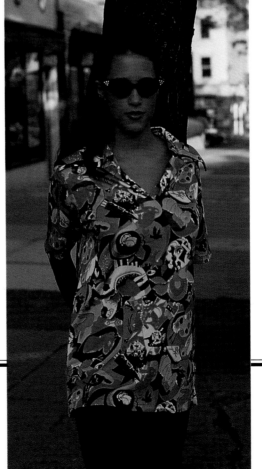

Pullover blouse with v-neckline made of double knit polyester with a colorful abstract print. No label. $20-30.

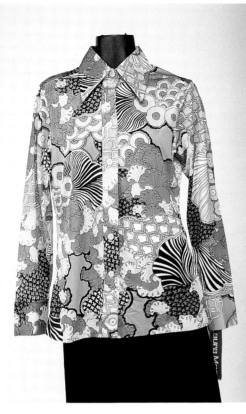

Button-down blouse made of acetate and nylon with abstract print in light blue, teal, orange, yellow, black, and white. Labeled: Laura Mae. $25-35.

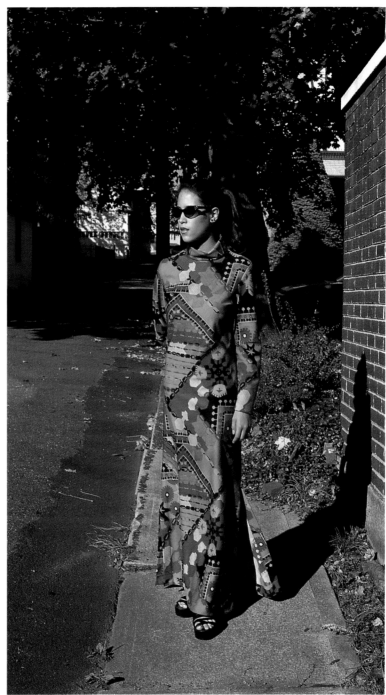

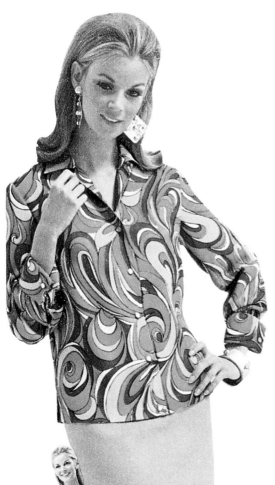

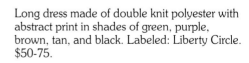

Long dress made of double knit polyester with abstract print in shades of green, purple, brown, tan, and black. Labeled: Liberty Circle. $50-75.

Ad for psychedelic print blouse teamed with a solid-color skirt; a popular look in 1967.

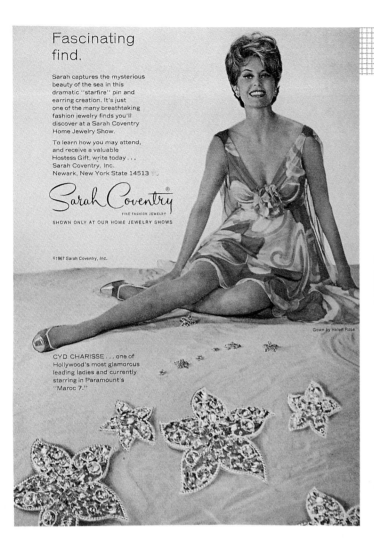

Cyd Charisse modeling a psychedelic print gown by Helen Rose in an ad for Sarah Coventry® jewelry in 1967.

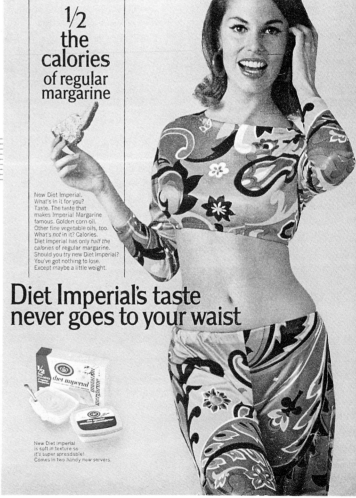

Margarine advertisement featuring a model wearing a two-piece psychedelic print outfit. Even the ads went psychedelic in the late 1960s. *McCall's*, 1967.

84

Chapter Seven
Eastern Influence

Whether the influence came from the Near East, the Far East, or the Middle East, the jet age of the 1960s created a tremendous impact for travel, which in turn provided the fabric and fashion designer with unlimited sources of inspiration from far-off places. Textile and art museums, with their many cultural exhibits, created even further impetus for designers.

The Eastern influence was displayed in fashion in the early 1960s and continued throughout the decade. Printed fashions were popular, as well as woven and knitted garments displaying the ornate and lavish look associated with Eastern cultures. Sculptured jacquards and metallic brocades were extremely fashionable.

The Near East or Islamic influence consisted of designs that were richly colored, very intricate, and extremely symmetrical. In addition to stylized flowers or animals, the use of geometric shapes was extremely common. The two most popular design motifs included renderings of mosaic tiles or Persian rug designs. This intricate subject matter was a great source of inspiration for modern day fabric designers.

The "Tiraz," or banded border, was a characteristic of authentic Near Eastern textiles. It consisted of a border decorated with detailed designs that were sometimes in sharp contrast to the print on the rest of the fabric. This particular influence was seen quite often in the 1960s and was especially strong in the works of Emilio Pucci.

The most popular Eastern influence found in textile design was the paisley. Although the name *paisley* comes from the weaving town of Paisley, Scotland, the origins of the design are found in the Himalayan mountains of Kashmir, India. The original Kashmir shawls, intricately woven with elaborate designs in rich color combinations, were worn by royalty in the fourteenth century. Because they were considered a precious commodity, they became the perfect item used for trading. Through bartering, the shawl made its way from Kashmir into Persia, then Egypt, and finally to the European continent via Napoleon's army.

The Kashmir shawls became increasingly desirable. Because of the time and the intense labor spent in mak-

ing the shawls (sometimes up to three years), the cost was extremely high. Around 1800, a man in Paisley, Scotland, tried to reproduce the shawls at a much lower price; thus the term paisley shawl was used from that time on.

The first paisley shawls were not exactly like the original Kashmir or Persian shawls, but there was a good resemblance. As time went on, the weaving became more intricate. It took the Paisley weavers one week to make a shawl. Cost was still a factor. The average person could not yet afford one. As a result, printed paisley designs became the next alternative to the actual weaving. The cost was lowered, but so was the durability of the shawl. Sadly, the desirability of the shawl waned as they were marketed for all levels of income. There became no class distinction between those who wore a paisley shawl and those who did not: the well-to-do no longer wanted them since the lower class were able to buy copies of the more expensive originals. By the 1880s, the paisley shawl business in Scotland came to an end.

In the 1950s, the paisley print entered the fashion scene once again. By the early 1960s, Persian influences for new print directions were found on fabric for fashion as well as for home furnishings. The new paisley renditions were not as elaborate as the original designs, but they were "loosely articulated and...inspired by the original Persian sources," reported *American Fabrics*.

By 1964, fabrics made by Boussoc of France featured "giant paisleys in new colors and combinations." This new fabric was used for dresses and sportswear. In 1965, "Marc Bohan, of Christian Dior, showed remarkable prescience by the strong Indian influence in the Dior Haute Couture Collection," according to *American Fabrics*. In 1966, *American Fabrics* also reported that "The perennial paisley is truly astonishing. Most design motifs come and go, but paisleys continue unabated in customer favor from season to season, year in and year out." A year later, wool prints by Gene Siebert and Leon Hecht featured feathered paisleys and confetti paisley prints.

The paisley motif has been described as having "a mysterious and ageless appeal," which makes perfect sense since the design motif has been around for a few thousand years. This curved figure, sometimes referred to as an elongated teardrop, a cone, or a pine, offered so much potential for the designer and will continue to do so in the future. A classic never dies.

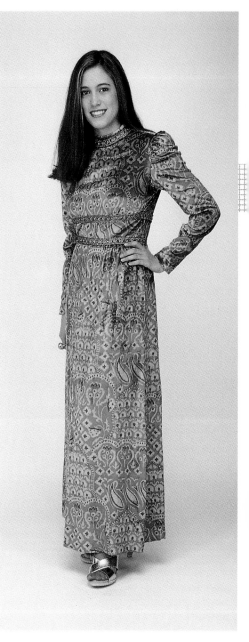

Empire evening gown designed with a black velvet bodice and multi-colored metallic brocade skirt. Braid and spangles accentuate the waist. No label. $65-85.

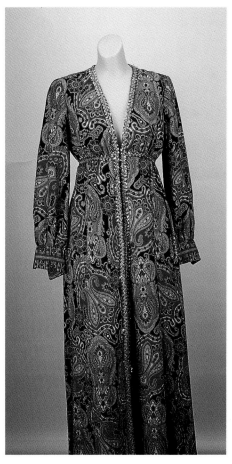

This stunning hostess gown with Empire waist is made of wool jersey with a colorful paisley print. The v-neckline is embellished with gold metallic braid and sequins. No label. $75-125.

Velveteen evening gown with an exotic turquoise, gold, and orange paisley print further embellished with gold braid and topaz-colored stones. Labeled: Jayna, New York. $95-135.

Hostess skirt made of acetate jersey with an oversized paisley print rendered in psychedelic colors. No label. The cotton jersey top is labeled "Yves Saint Laurent, Paris." $45-85 each.

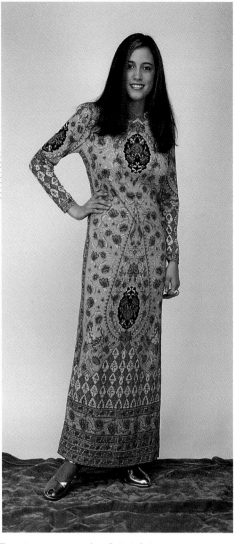

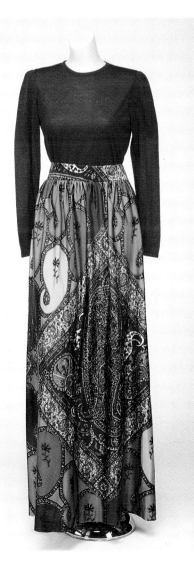

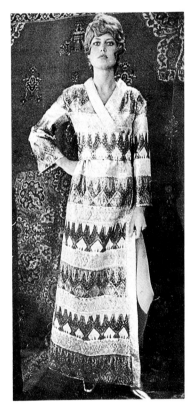

Persian print evening gown designed by Bill Blass. *McCall's*, September, 1970.

Evening gown made of stretch jersey designed with long sleeves and v-neckline. The Persian print is executed in hot pink, red, turquoise, green, and black. Labeled: Mr. Dino, New York, Paris, Florence. $150 and up.

Long sleeve shift made of double-knit polyester with colorful Persian print. No label. The large-brimmed hat is unmarked; the pink vinyl purse is contemporary. $20-50 each.

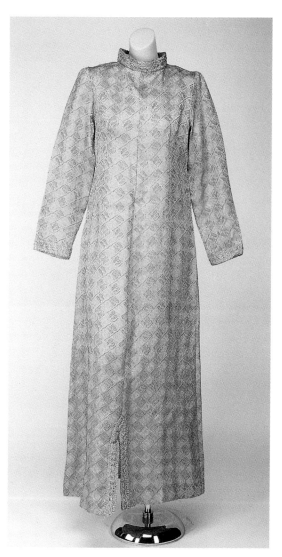

A glittering brocade was used to create this hostess gown trimmed with gold metallic braid. No label. $40-60.

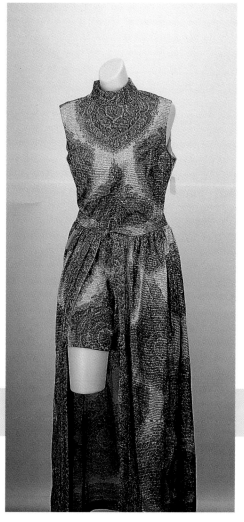

A sleeveless, one-piece shorts outfit designed with stand-up collar is teamed with a long skirt made of metallic brocade with a wonderful Persian print. No label. $80-120.

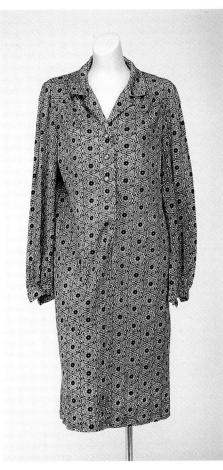

Button-down shift designed with long sleeves and man-tailored collar made of cotton jersey with a Persian print in orange, gold, beige, and blue. Labeled: R & K Originals. $30-40.

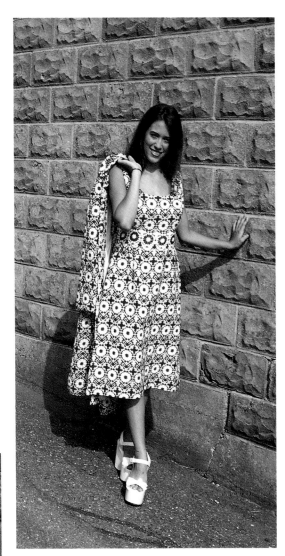

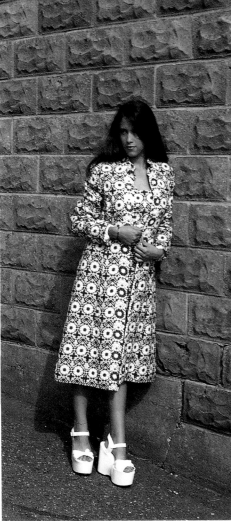

Left and above:
Two-piece ensemble consisting of sleeveless dress and matching coat with a wonderful jacquard weave forming a Persian design in red, metallic gold, and white. No label. $95-145 ensemble.

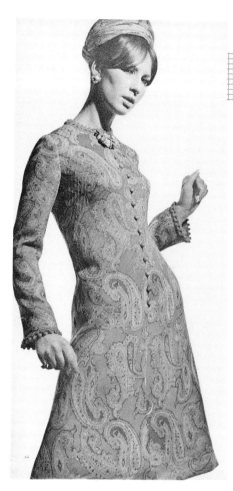

A-line dress made of wool with matching turban-style hat. The large woven paisley pattern is done in coral and turquoise. *McCall's*, 1965.

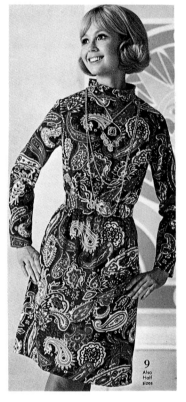

A-line dress with matching jacket made of a heavy jacquard fabric woven with a Middle Eastern design. *Courtesy of Marlene Franchetti.* $60-85 ensemble.

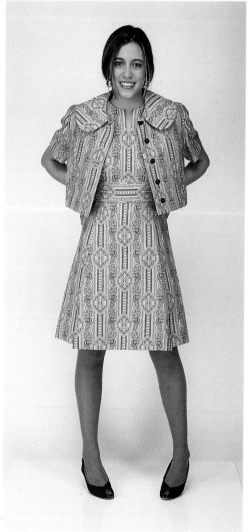

A bold paisley print is found on this belted shift dress with stand-up collar, fashionable in 1970.

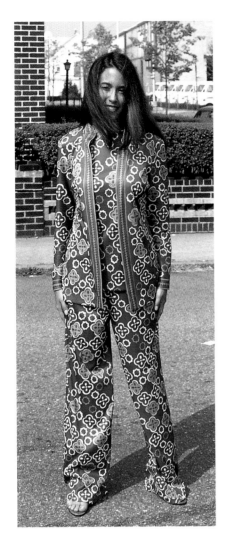

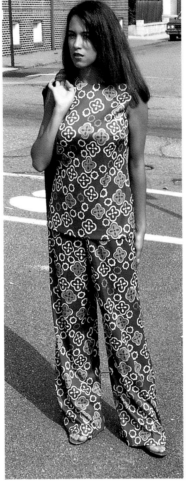

A Far Eastern influence is found on this nylon dress designed with Mandarin collar and frog closures. The stylized floral print is rendered in shades of blue and grey. No label. $65-95.

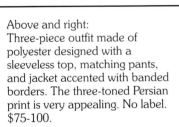

Above and right:
Three-piece outfit made of polyester designed with a sleeveless top, matching pants, and jacket accented with banded borders. The three-toned Persian print is very appealing. No label. $75-100.

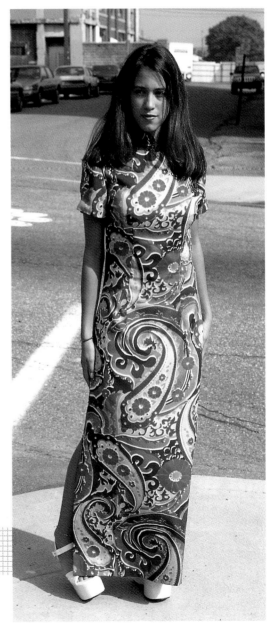

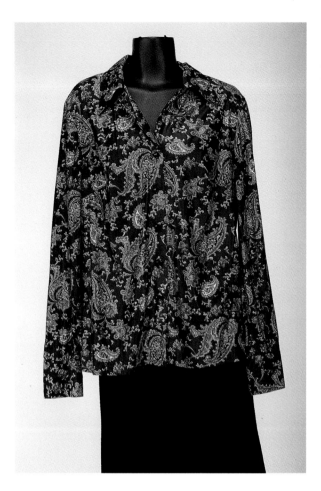

Long sleeve blouse with button-down front made of ribbed jersey with a paisley print in shades of orange, green, gold, and brown on a deep blue background. No label. $25-35.

Sleeveless shift made of cotton with a colorful paisley print. Labeled: Made in Hong Kong. $30-45.

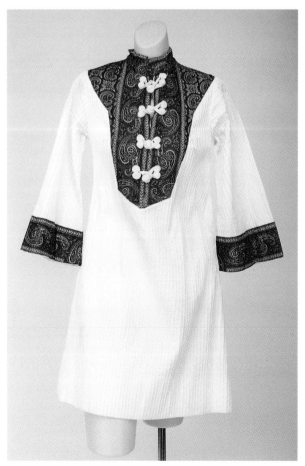

White mini-dress designed with rows of tucks accented with paisley print and frog closures. Labeled: Vendome, Acapulco. $40-55.

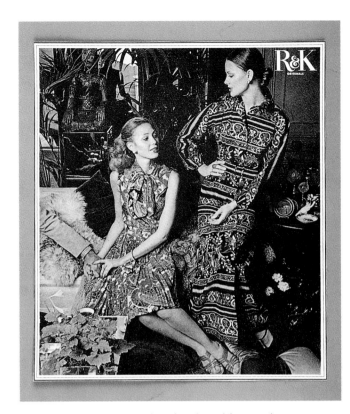

Eastern influences are displayed in this ad for two dresses made of Qiana nylon by R & K Originals.

Two-piece ensemble designed with sleeveless tunic top and matching pants made of sculptured cotton. The tunic is embellished with gold braid and faux coral and turquoise beads. No label. $95-135.

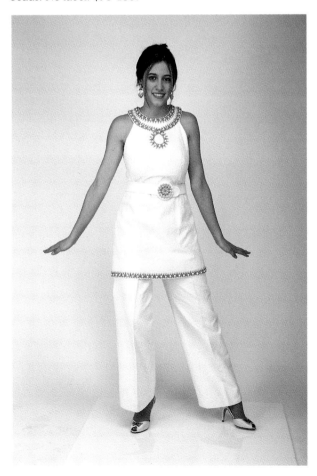

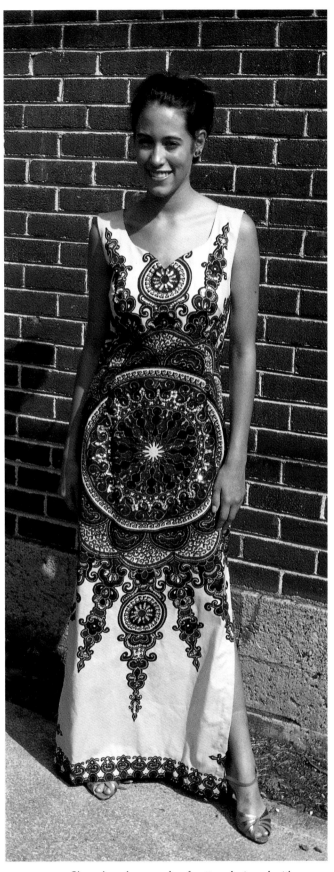

Sleeveless dress made of cotton designed with sculptured neckline and side slits. The exceptional print is further enhanced by sequin decoration. Labeled: Bou Boudima. Exclusively Made by Euopean Fashions, Kingston, Jamaica. $75-110.

93

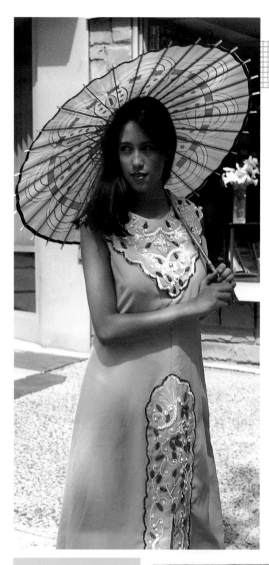

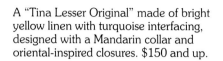

A "Tina Lesser Original" made of bright yellow linen with turquoise interfacing, designed with a Mandarin collar and oriental-inspired closures. $150 and up.

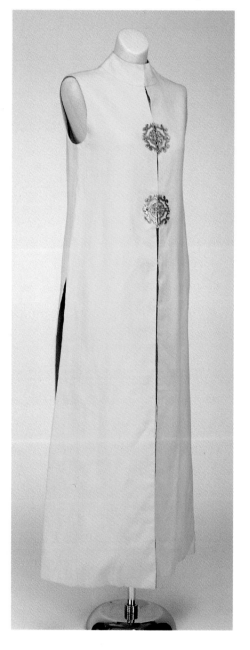

Left:
Sleeveless evening dress made of turquoise polyester embellished with beads, pearls, and sequins accenting the bodice and the front split. No label. $70-90.

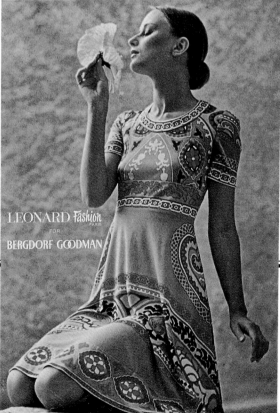

Similar to Pucci dresses, fashions by Leonard of Paris were also exclusive to major department stores. This advertisement dates back to the early 1970s. The print displays Eastern influences.

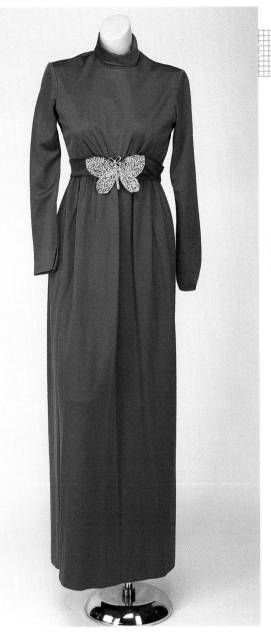

Royal blue polyester evening gown designed with Empire waist, gathered skirt, long sleeves, and turtleneck. A large goldtone butterfly decorates the solid-color dress. No label. $50-75.

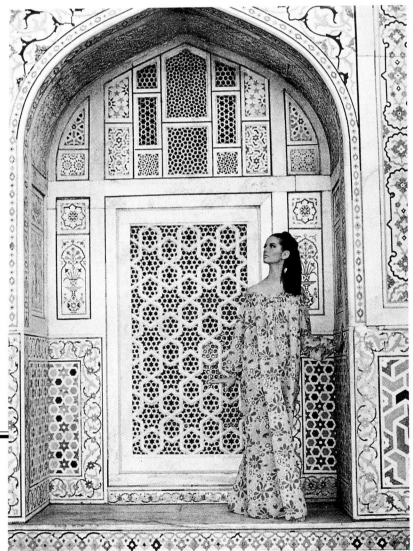

Although the print on the chiffon robe is floral, the background of white marble is a perfect example of some of the Eastern influences that designers utilized to create the wonderful prints of the late 1960s. *McCall's*, 1966.

Native-Inspired Influences

Batik

Beginning in the late 1950s, fashions specifically designed for resort wear were becoming increasingly popular as a direct result of the jet age. Winter vacations were becoming longer. Millions of people packed their bags and hopped on airplanes to visit exotic lands. The island influence created a sensation in resort wear apparel for men and women. The consumer needed the correct attire for visiting these far-off places.

One influence in particular that became extremely popular in the 1960s was batik. The art of batik has been around for centuries, and has been found in places like Indonesia, Japan, Northern China, India, and parts of Africa. It was the people of Java, however, who perfected this technique.

Batik is a process by which patterns or designs of different colors are applied to fabric. The execution of the technique is time consuming. The first step is drawing the design or pattern on paper. When this is accomplished, the pattern is traced in wax on the fabric with a special tool called a *tjanting*. The tjanting is a small container made of copper. It is designed with a spout and serves as a reservoir for the hot wax. After applying the design, the fabric is placed in a dye solution—the unwaxed areas then pick up the color while the waxed areas do not. Afterwards, the wax is removed by dipping the fabric in boiling water. Depending on the desired effect, the fabric may be redipped in different dyes several times to produce a multitude of colors.

Creating two yards of a good batik sometimes took over a month to prepare. Because of this time-consuming and extremely tedious process, around 1850 the Javanese introduced an easier way of producing batik fabric, by a method of stamping called *tjap-printing*. This method consisted of waxing with blocks. The blocks, constructed of thin strips of copper arranged into specific patterns and soldered to a copper base with a handle, form the actual stamper. When this stamper is dipped into hot wax, it transfers the design onto the fabric.

Javanese batik consisted of many patterns ranging from stylized animals to plants and flowers, all artistically arranged and full of symmetry. Abstract and geometric designs were also common and occasionally placed in diagonal patterns and vertical stripes.

As with any other influence, the fabric designers of the 1960s appreciated age-old inspirations and applied them to the contemporary needs and wants of the consumer. Renewed interest in batiks began around 1960. The early batiks were executed in basic earth tones or browns and blues highlighted with white. By 1962, they had become more colorful, using burgundy and red. By the late 1960s, psychedelic pinks and purples were found in batik prints.

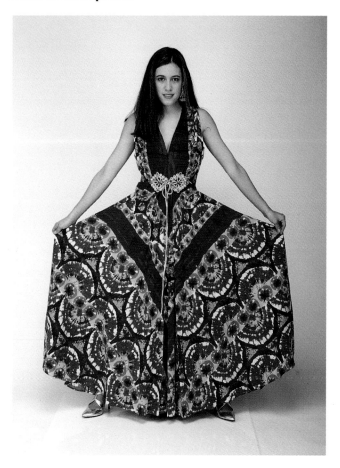

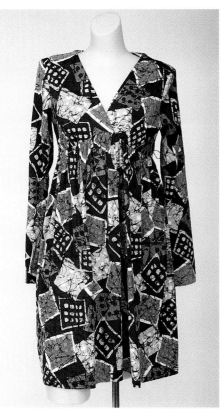

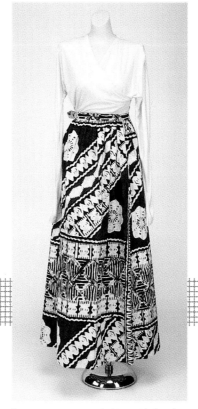

Day dress made of jersey knit designed with an Empire waist, v-neckline, and long sleeves. The batik print is executed in shades of brown, beige, and hot pink. Labeled: Anika, New York, Stockholm. $50-75.

A batik-style print is found on this hippie-style top made of cotton and polyester. $25-35.

Zip front top made of double knit polyester with a batik print in psychedelic colors. No label. $20-30.

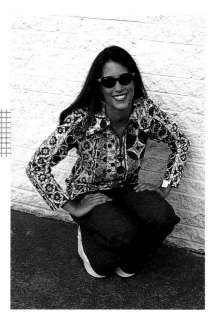

Opposite page:
Culotte-style, v-necked evening dress made of cotton with a colorful batik print. The fitted waist is decorated with gold braid and colored rhinestones. No label. *Courtesy of Marlene Franchetti.* $100 and up.

Long wrap-around skirt with batik print in shades of brown and beige. No label. The off-white rayon top is labeled Nancy Heller. $30-60 each.

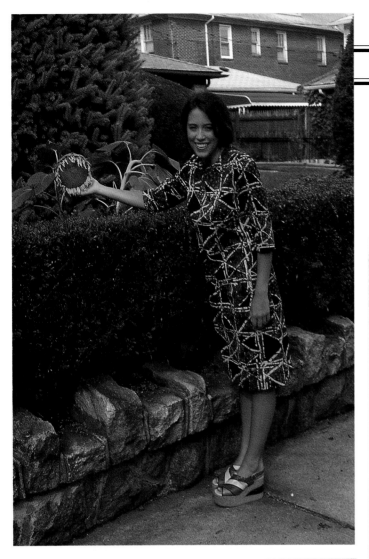

Long sleeve shift made of polyester
with batik print in shades of brown,
tan, black, turquoise, and olive green.
No label. $35-45.

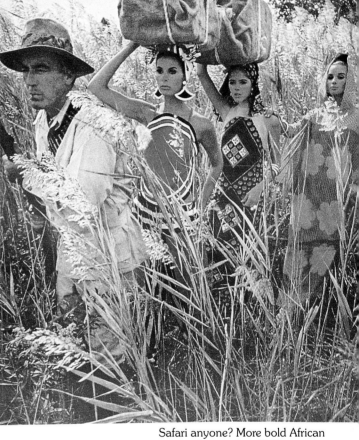

Safari anyone? More bold African
prints advertised in 1967.

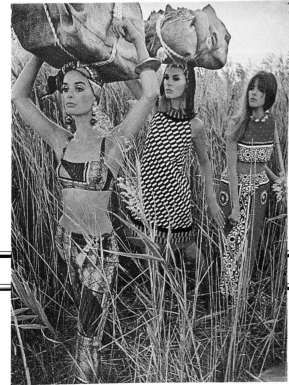

Bold African prints advertised in
McCall's in 1967.

Animal Prints

Around 1966, the vogue for animal prints was at an all time high. Designers were "spending time at the zoo" and gaining inspiration from the colorations and striations of nature's beasts. Everything from sportswear to evening wear, outerwear, and lingerie was decorated with leopard, ocelot, cheetah, zebra, and giraffe prints. Occasionally, animal prints were combined with checks, stripes, and floral designs to create a more unusual look with some extra color. This new print direction was popular in the late 1960s.

Basic interest in African prints also became top fashion news due to the "rise of new nations on the African continent," according to *American Fabrics* in 1966. Bright, bold, native prints created a sensation in the American fashion market at that time. The African culture produced a variety of print options for the American designer to emulate.

In Tanzania, wood blocking on barkcloth was one method used to achieve desirable prints. Originally, this method was done by hand with vegetable dyes, producing what was called "Khanga" prints. In

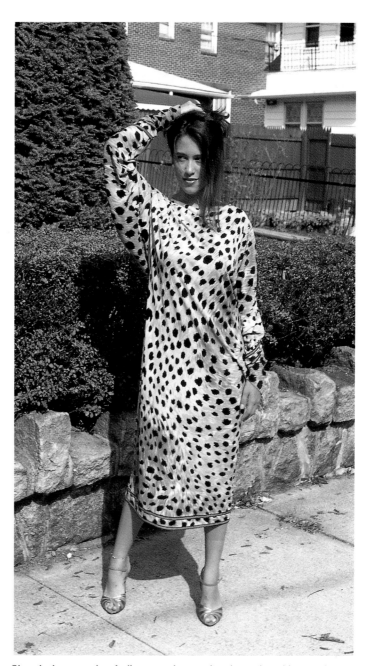

Sheath dress made of silk jersey designed with cowl-neckline and draped and tapered sleeves. The allover leopard print is accentuated with banding at the hemline. Labeled: Leonard Studio, Paris, France. Bergdorf-Goodman On The Plaza, New York. $400 and up.

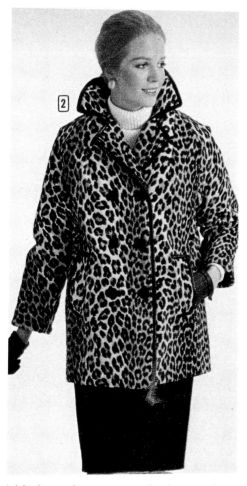

Ad for leopard print coat made of rayon pile trimmed with black vinyl, fashionable in 1968.

Ghana, stamp printing with a calabash gourd produced desirable effects on cloth using brown and black bark dyes. Abstract and geometric prints were achieved using this method. Tie-dying was another African method of producing colorful designs on cloth, one original to the people of Nigeria. The Nigerian people also used a wax-resist method of decorating cloth that was similar to batik and produced desirable effects.

Africa was full of inspirations for the 1960s textile and fashion designer. Fashion magazines and mail-order houses offered a wide variety of native-inspired fashions for the mass market.

Conversation print blouse made of nylon with wild animal motif. Labeled: Knit Editions. Ship 'n Shore. $25-35.

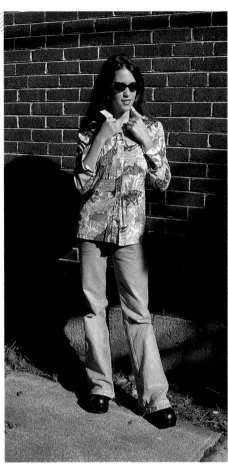

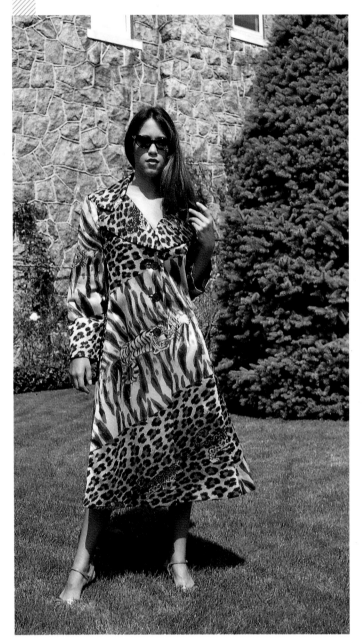

Fitted coat designed with large notched collar. The animal print was applied to the fabric in a diagonal fashion creating further excitement. Labeled: MAIN STREET by Tom Fallon. $150 and up.

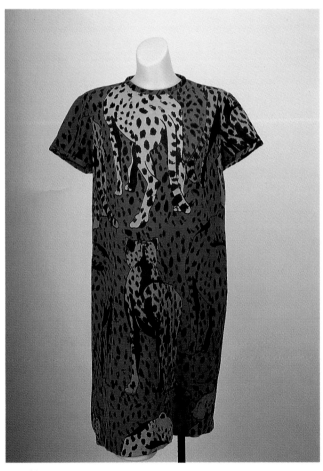

Short sleeve shift made of stretch knit with animal print in psychedelic colors. Labeled: Gerald Pierce. $30-40.

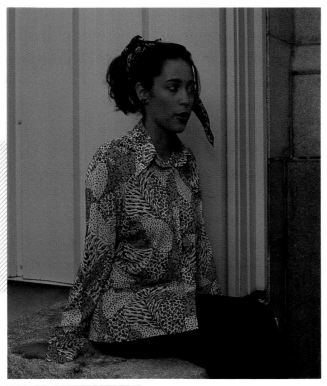

Ladies' blouse made of nylon with assorted animal prints. Labeled: Knit Editions. Ship 'n Shore. $25-35.

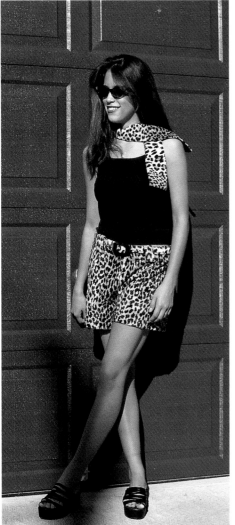

Left:
Fake fur hot pants decorated with leopard print. $40-50.

Right:
Bra, girdle, and half slip designed with leopard print, offered for sale in 1967.

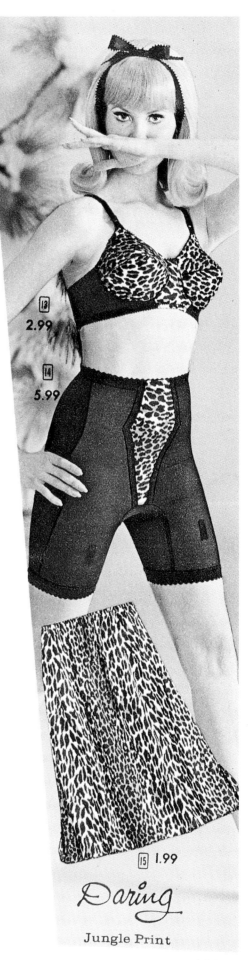

2.99

5.99

1.99

Daring

Jungle Print

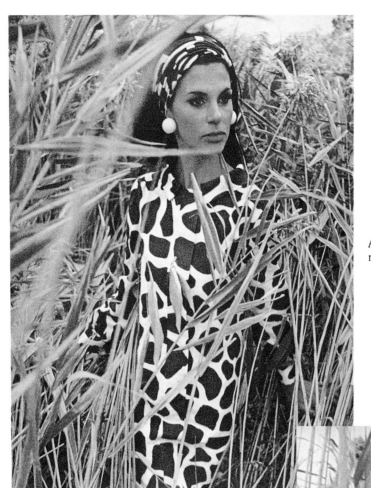

Ad for giraffe print dress with matching scarf, popular in 1967.

Ad for cheetah-print jacket and zebra-striped dress, also fashionable in 1967.

Intimate Apparel

Emilio Pucci became very famous in the 1950s for his fabulous designs, especially the ladies' tight-fitting Capri pants, also called Pucci pants. Women in that decade were accustomed to wearing girdles, but they were not acceptable under these skin tight pants. In 1957, Pucci teamed up with a Chicago firm called Formfit-Rogers to produce a panty girdle made of a thin, stretch material that basically molded the derrière without leaving panty lines. This girdle, which was called *Viva*, marked the beginning of a new era in less constrictive undergarments for American women. Pucci also designed bras that created a more natural look, which he advised women to wear under his sleek silk jersey creations. The days of the 1950s bullet bras were coming to an end.

Just like the fabulous prints found on his outerwear, Pucci designed wild and colorful prints for his lingerie lines, which were all made and marketed by Formfit-Rogers. The fabric was printed in Italy and then sent to the United States to be made into the intimate apparel.

The lingerie was made of nylon tricot and the initials "EPFR" (Emilio Pucci for Formfit-Rogers) are found within each design. Bikini pants, matching bras, slips, nightgowns, and robes were made of nylon and decorated with wonderful Pucci prints.

Pucci also designed printed tights and body stockings, which were to be worn under revealing or see-through clothing of the period.

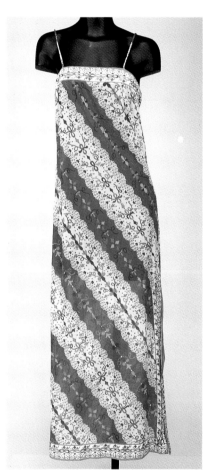

Pucci nightgown made of nylon with bow and flower print set into lacy diagonal stripes. Labeled: Emilio Pucci for Formfit Rogers. $125 and up.

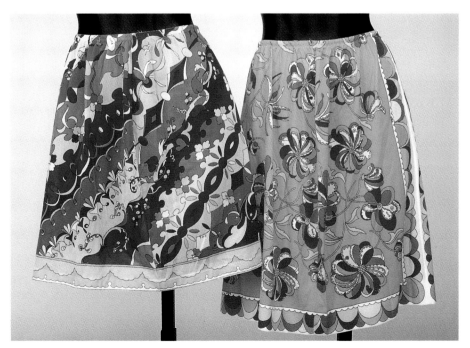

Two Pucci half slips made of nylon with abstract floral prints. Labeled: Emilio Pucci For Formfit Rogers. $75 and up each.

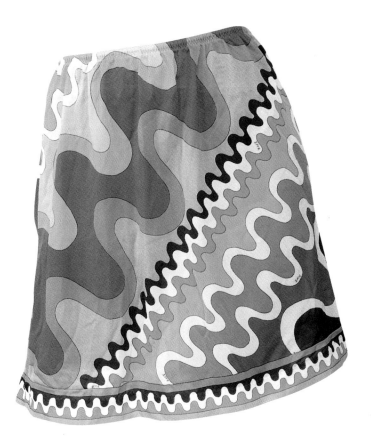

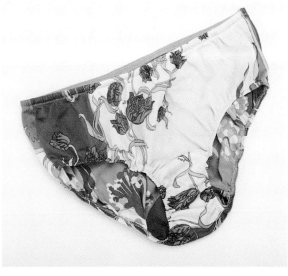

Pucci panties made of nylon with Art Nouveau style floral print. Labeled: Emilio Pucci For Formfit Rogers. $35 and up.

Pucci half slip made of nylon with wave-like print in blue, turquoise, lavender, purple, and white. Labeled: Emilio Pucci For Formfit Rogers. $75 and up.

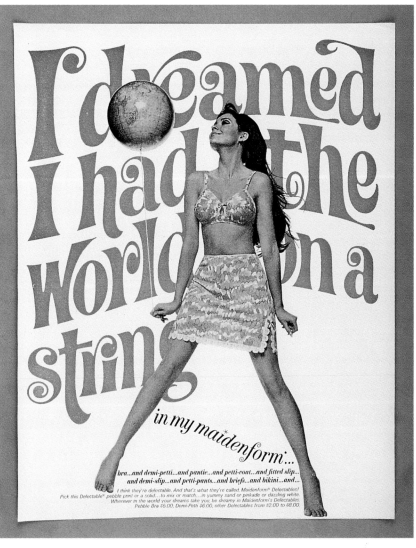

"Pebble Print" lingerie by Maidenform, advertised in *McCall's* in 1967.

Below:
An assortment of printed and solid-color
lingerie designed by top manufacturers in
popular colors and prints. *McCall's*, 1967.

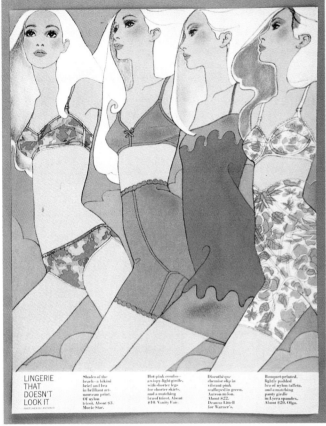

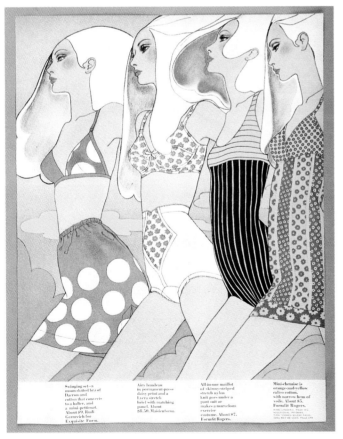

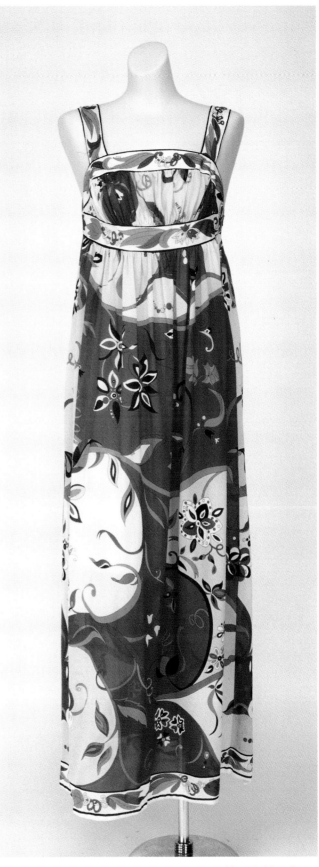

Pucci nightgown designed with Empire waist and banded borders
accentuating the bodice and forming the straps. The stylized floral
print is rendered in shades of pink, fuchsia, orchid, grey, black,
and white. The initials "EPFR," which are found throughout the
design on the fabric, stand for "Emilio Pucci For Formfit Rogers."
$150 and up.

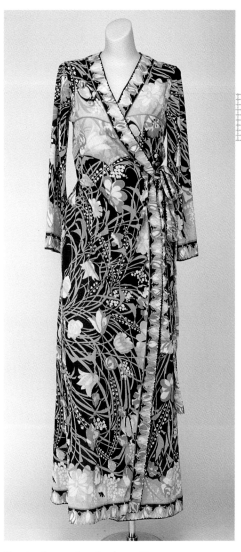

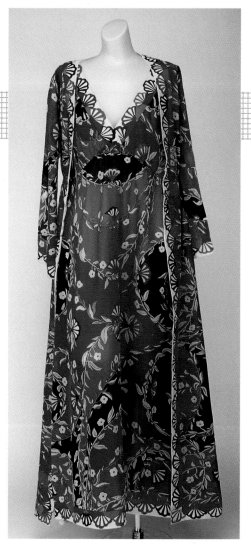

Pucci peignoir set made of silk in a six-toned floral print. Banded borders accentuate both garments. Labeled: Emilio Pucci For Formfit Rogers. $295 and up.

Pucci robe made of nylon with lovely floral print in shades of pink and blue on a black ground. Banded borders add extra interest. Labeled: Emilio Pucci For Formfit Rogers. $175 and up.

Pucci leotards designed with a geometric print in shades of green, burgandy, fuchsia, and black. Labeled: Emilio Pucci, Florence, Italy. 100% Helanca. $100 and up.

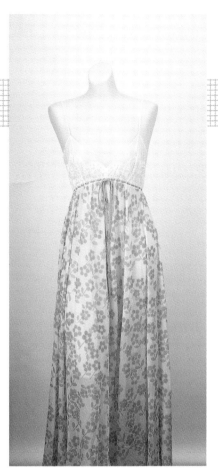

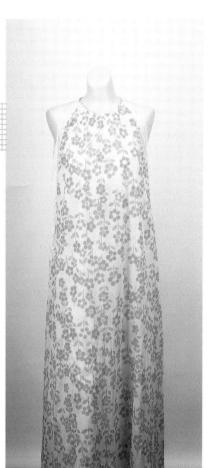

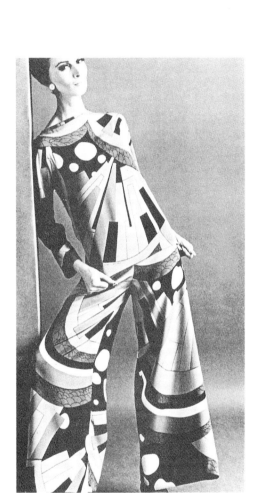

Pajamas by Donald Brooks made of crepe de chine with a wonderful geometric print. *American Fabrics*, Summer, 1966.

Above two photos:
Two piece peignoir set made of nylon and lace with pink and green floral print. $50-75 set.

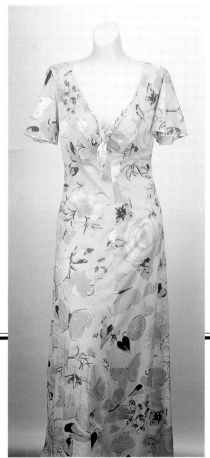

This colorful floral printed nightgown was designed by Ken Scott and is made of 100% nylon. $75 and up.

Chapter Ten

Accessories

Scarves

The use of scarves, which were made in all shapes and sizes, became a great way to create a fashion statement in the 1960s. Just like the many influences and exciting print directions found on the clothing, the same wild designs and psychedelic color schemes were found on the scarves of the period. The large format—the yard-square scarf—was a perfect medium with which fabric designers expressed themselves. The women who wore the scarves became equally expressive, not only by choosing the right print, but also by the many creative ways in which the scarf could be worn. In the 1960s, there was little distinction between "art and textiles." The scarf became the print designer's canvas.

The fashion designer element played a big role in scarf manufacture. Top of the line designers created exciting printed scarves, usually made of silk and signed by the designer. Christian Dior, Oscar de la Renta, Yves Saint Laurent, Rudi Gernreich, and Emilio Pucci were a few of the most famous. The signature scarf was the perfect vehicle for women of the 1960s to flaunt their wealth and social status. Scarves were also perfect for gift-giving. Today, designer scarves are extremely collectible.

Vera Neumann, an American print designer of the 1960s, created a dynamic impact in the scarf industry. Fortunately for her, she was married to the head of a textile screen printing plant called "Printex," located in Ossining, New York. With her talent in design and her husband's "encouragement," Vera prints became sought after worldwide in a short period of time. Besides her artistic scarves, Vera also created dresses, blouses, ascots, aprons, draperies, table linens, and towels. Vera prints are always signed "Vera" and accompanied by her signature ladybug.

Original Peter Max scarf, 20" square, with an Art Nouveau style butterfly print. *Courtesy of Marlene Franchetti.* $60 and up.

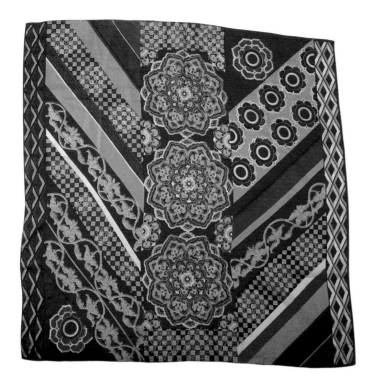

Square scarf made of pure silk with Eastern influences rendered in a five-toned color scheme. Labeled: Triangle, Made in the People's Republic of China. $15-25.

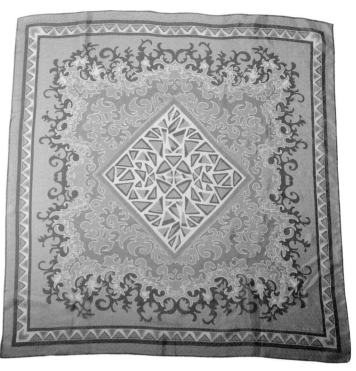

Square scarf made of pure silk with hand-rolled edges, decorated with an abstract print in shades of lavender and peach. Labeled: Oscar de la Renta for Accessory Street. $30-40.

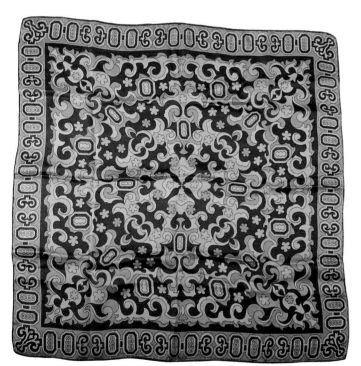

Square scarf made of acetate with Middle Eastern print in pink, mint green, gold, beige, and brown. $15-25.

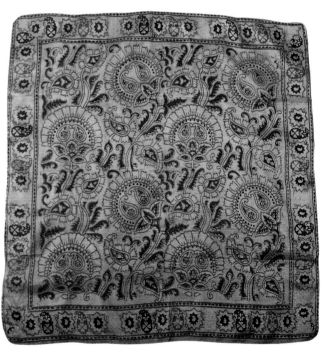

Square scarf made of pure silk with hand-rolled edges in a paisley print. $15-25.

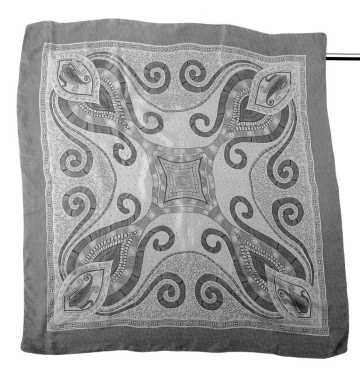

Square scarf made of pure silk with hand-rolled edges. Pretty pastel colors form an unusual paisley print. $15-25.

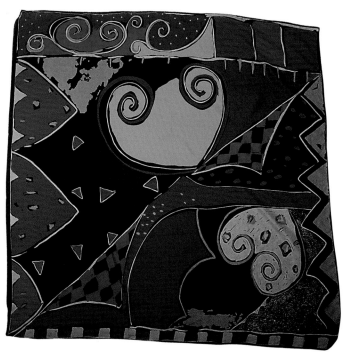

Square scarf made of silk with hand-rolled edges and a multi-colored abstract print. $15-25.

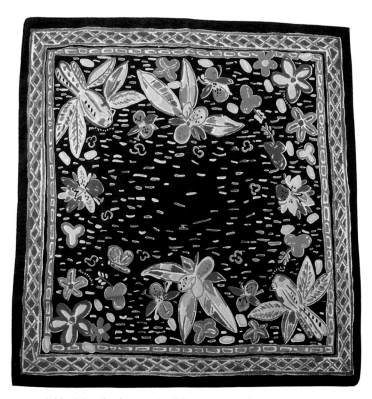

A black border frames this 27" square scarf made of acetate with a brightly colored floral print. $15-25.

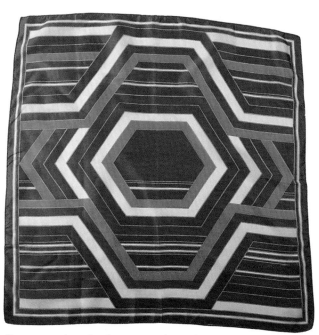

Square scarf made of acetate with machine-stitched edges in a five-toned geometric print. $15-25.

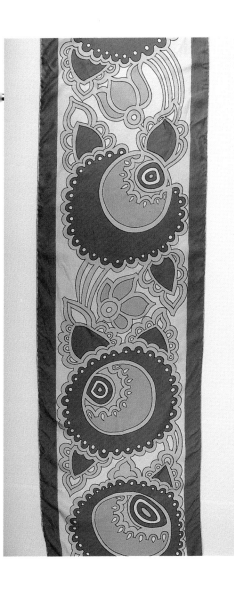

Oblong scarf made of silk chiffon with an Art Nouveau style floral print. $35-45.

Oblong scarf made of silk with hand-rolled edges in an abstract print signed Ostinelli. Labeled: Pia Piccini, Made in Italy. $35-45.

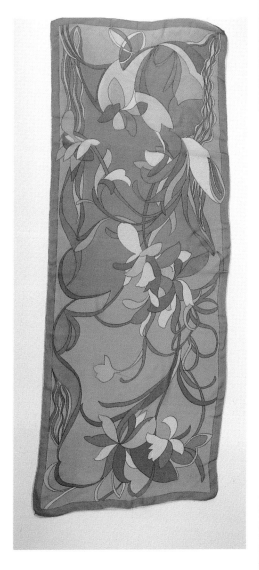

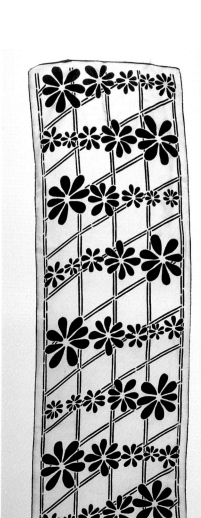

Oblong scarf made of silk with a floral print rendered in black and white. $30-40.

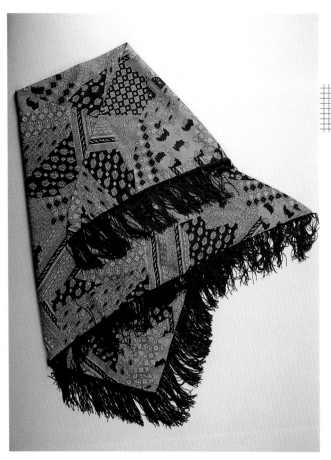

Triangular-shaped fringed shawl made of acetate with Persian-style print in navy, orange, green, yellow, and white. $35-50.

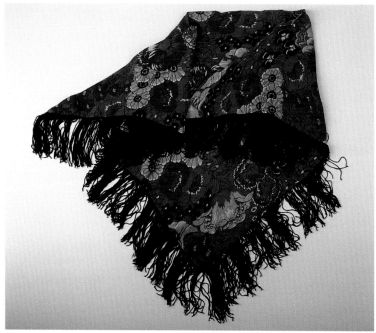

Triangular shawl made of wool jersey decorated with a multi-colored floral print and trimmed with black fringe. $35-50.

Oblong fringed shawl made of rayon and acetate with cute daisy print in yellow and white. $35-50.

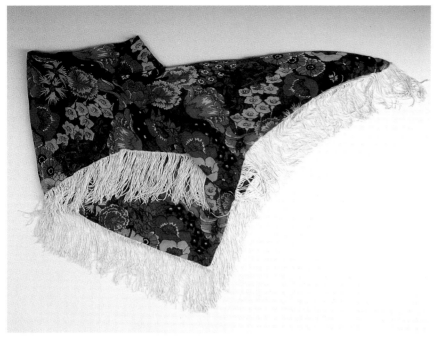

Triangular shawl made of wool jersey decorated with a multi-colored floral print and trimmed with white fringe. $35-50.

Below:
"Vera," a print designer of the 1960s, was famous for her fabulous printed scarves but also created printed dresses, blouses, and domestics for the home. This stretch knit mini-dress with turtleneck collar and self-tied belt was designed by "Vera." Her signature is found throughout the print. Labeled: Vera. $75-100.

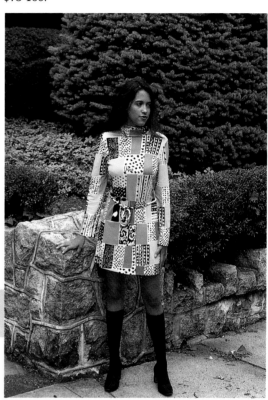

Two colorful sashes made of acetate with psychedelic prints. $6-10 each.

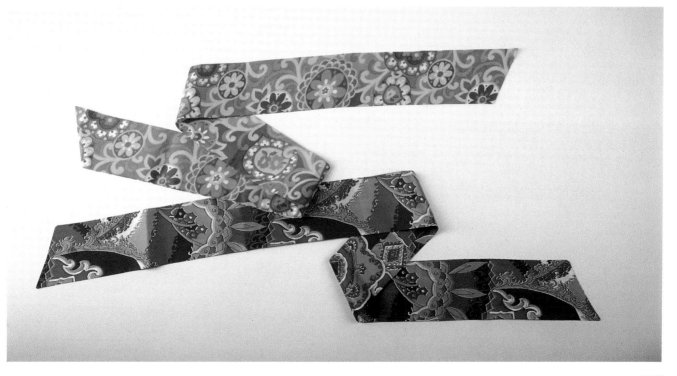

Pucci Accessories

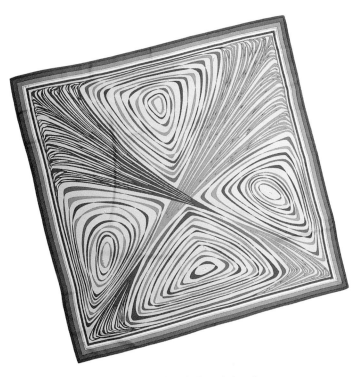

Pucci scarf, 36" square, made of silk with hand-rolled edges, in an abstract print rendered in shades of beige, brown, and tan. Labeled: Emilio Pucci, Florence, Italy. $75 and up.

Pucci scarf, 36" square, made of silk with hand-rolled edges. The geometric print is rendered in shades of pink, mauve, acid green, black, and white. Labeled: Emilio Pucci, Florence, Italy. $85 and up.

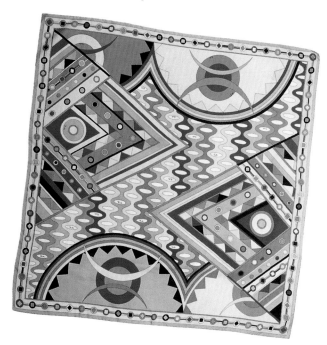

Pucci scarf, 36" square, made of silk with hand-rolled edges. The kaleidescope-type print is executed in shades of pink, grey, black, and white. The label is missing but the signature fabric tells it all. $75 and up.

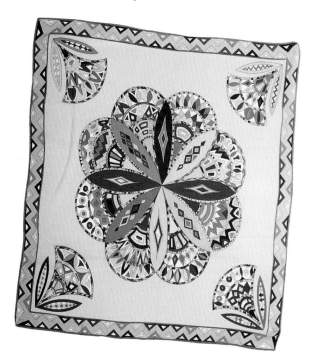

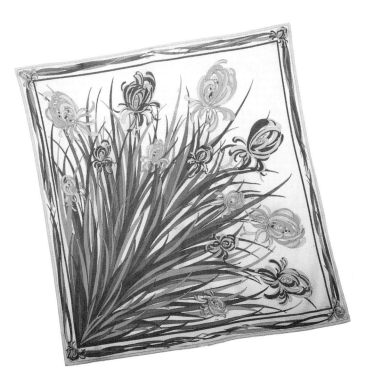

Pucci scarf, 34" square, made of cotton with machine stitched edges and decorated with a lovely floral print. Labeled: Emilio Pucci, Florence, Italy. $75 and up.

114

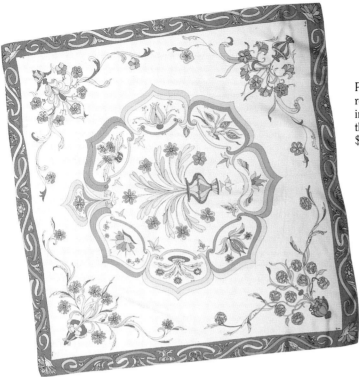

Pucci scarf, 34" square, made of silk with hand-rolled edges. The stylized floral print is rendered in pastel colors. The word "Emilio" is found throughout the design on the fabric. No label. $75 and up.

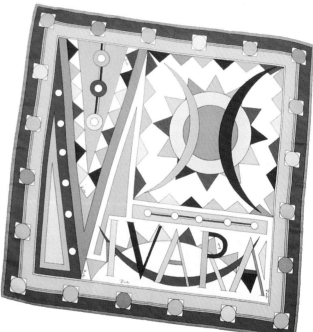

Pucci scarf made of silk with hand-rolled edges. The popular "Vivara" print is executed in shades of green, brown, aqua, black, and white. Labeled: Emilio Pucci, Florence, Italy. $85 and up.

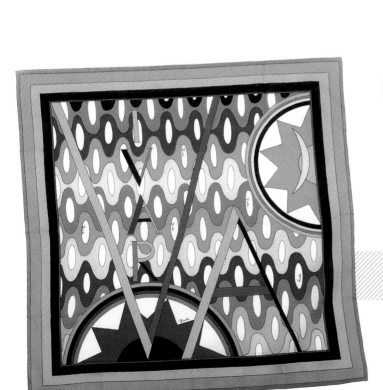

Pucci handkerchief made of cotton in popular "Vivara" print. $50 and up.

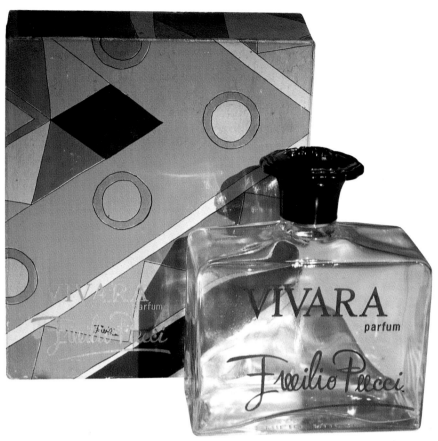

"Vivara" perfume bottle with original box decorated with the print of the same name. Vivara was the first perfume introduced by Pucci in 1965. $125 and up.

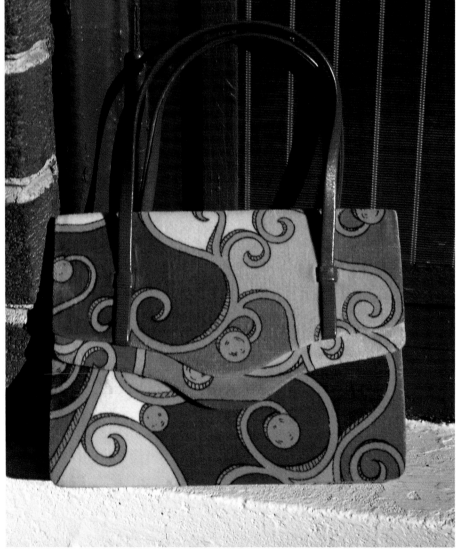

Vibrant shades of blue, purple, gold, and yellow decorate this velveteen handbag signed "Emilio." Labeled: Emilio Pucci Bags. Made in Italy. $250 and up.

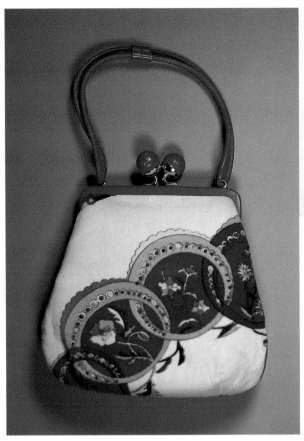

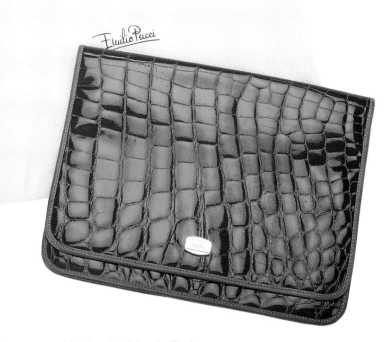

Alligator grained leather clutch bag by Emilio Pucci. The bag is accompanied by its original cloth pouch. $250 and up.

Printed velvet and leather handbag signed "Emilio." Labeled: Emilio Pucci by Jana. Made in Italy. *Courtesy of Anita Davis.* $175 and up.

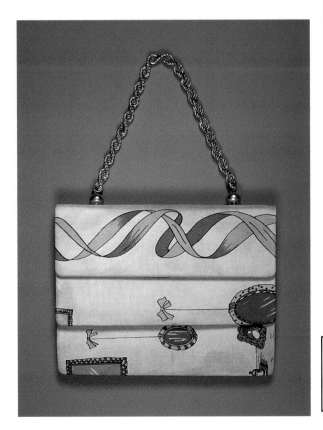

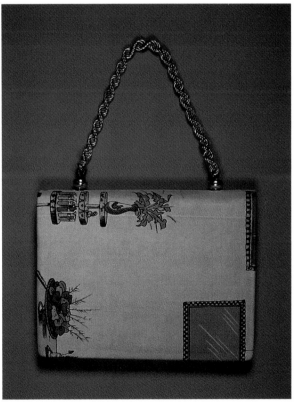

Front and back view of printed Pucci purse with gold-plated chain handle. Labeled: Emilio Pucci Bags. Made in Italy. *Courtesy of Lee Herling.* $175 and up.

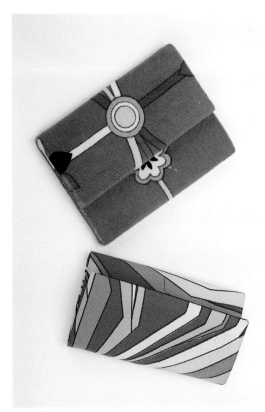

Pucci velveteen coin purse with abstract floral design. Lining labeled: Emilio Pucci, Florence, Italy. Pucci key case made of silk with an abstract print. Labeled: Emilio Pucci. Made in Italy. $75 and up each.

Pucci fabric designs lent themselves very well to other products. The stationery shown here entitled "Zadig" by Emilio Pucci was marketed by Eaton for the Haute Scripture Collection. Zadig was also the name of another Pucci fragrance for women. $75 and up.

Pucci bath towel made of cotton with a geometric print in orange, pink, yellow, black, and white. Labeled: Emilio Pucci for Springmaid. In 1968, Springmaid won first award in the 23rd Annual International Design Awards Program for domestic linens. The towel which placed first was one designed by Emilio Pucci called "Della." According to *American Fabrics*, it was "considered unique because of its large-scale abstract pattern and its totally new way of being printed in intense fast color dyes." Pucci towels also highlighted the Nikolais Ballet performed at the George Albott Theater in New York in 1967. Emilio Pucci, already extremely famous at that time for his "jet age" fashions for women, designed a line of towels for Springmaid featuring his "startling geometrics." The ballet company combined "avant garde art and avant garde industrial design," and performed to electronic music against a "background of frenzied film images." According to *American Fabrics*, "...all was designed to convey fresh colors, patterns, texture and sensuous quality of the new Pucci towels."

Pair of monogrammed pillow cases with the initials EPS (Emilio Pucci for Springmaid) found throughout the design. The label reads: Wondercale by SPRINGMAID, Designer Collection. $35 and up.

Hand-shaped ring holder, stationery box, pillow, make-up cases, head-shaped wig stand, and postcards, all colorfully decorated with floral, geometric, abstract, and psychedelic motifs. $20-75 each.

Shoes

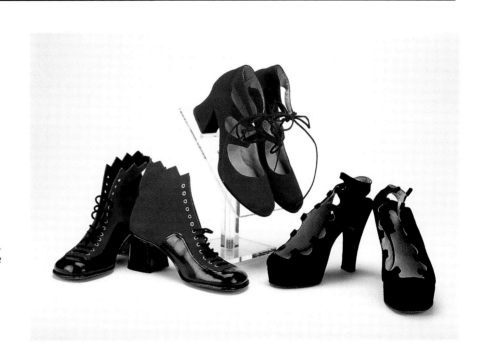

Tie-up boots made of black vinyl and purple suede with chunky heel. Platform sling back shoes made of black suede with lace-up fronts. ANSONIA Custom Group. Tie-up shoes made of purple suede with chunky heel. Trosconini. $65-125 each pair.

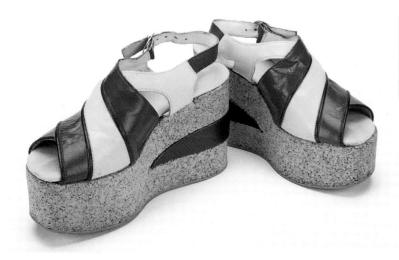

Platform sandals made of multi-colored leather and cork. Made Exclusively For Di Orsini. Made in Italy. $75-100.

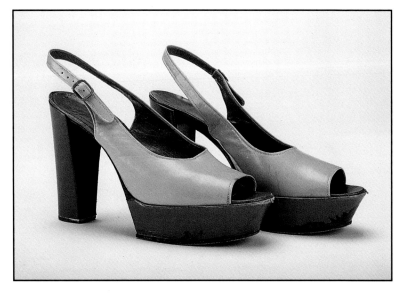

Two-toned leather sling back heels designed with open toes and platform soles. Charles Jourdan, Paris. $85-100.

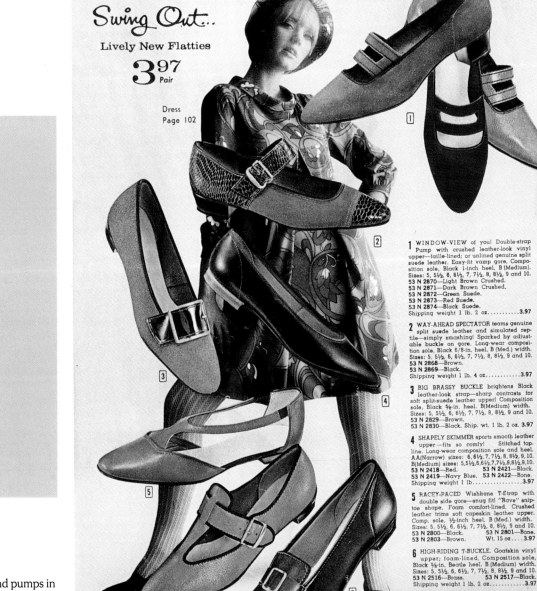

Assortment of flats and pumps in the popular styles of 1967, offered for sale from Aldens.

Swing Out...

Lively New Flatties

3 **97** Pair

Dress
Page 102

1 WINDOW-VIEW of you! Double-strap Pump with crushed leather-look vinyl upper—faille-lined; or unlined genuine split suede leather. Easy-fit vamp gore. Composition sole. Black 1-inch heel. B (Medium). Sizes: 5, 5½, 6, 6½, 7, 7½, 8, 8½, 9 and 10.
53 N 2870—Light Brown Crushed.
53 N 2871—Dark Brown Crushed.
53 N 2872—Green Suede.
53 N 2873—Red Suede.
53 N 2874—Black Suede.
Shipping weight 1 lb. 2 oz...........**3.97**

2 WAY-AHEAD SPECTATOR teams genuine split suede leather and simulated reptile—simply smashing! Sparked by adjustable buckle on gore. Long-wear composition sole. Black 5/8-in. heel. B (Med.) width. Sizes: 5, 5½, 6, 6½, 7, 7½, 8, 8½, 9 and 10.
53 N 2868—Brown.
53 N 2869—Black.
Shipping weight 1 lb. 4 oz...........**3.97**

3 BIG BRASSY BUCKLE brightens Black leather-look strap—sharp contrasts for soft split-suede leather upper! Composition sole. Black ⅝-in. heel. B(Medium) width. Sizes: 5, 5½, 6, 6½, 7, 7½, 8, 8½, 9 and 10.
53 N 2829—Brown.
53 N 2830—Black. Ship. wt. 1 lb, 2 oz. **3.97**

4 SHAPELY SKIMMER sports smooth leather upper—fits so comfy! Stitched topline. Long-wear composition sole and heel. AA(Narrow) sizes: 6, 6½, 7, 7½, 8, 8½, 9,10. B(Medium) sizes: 5,5½,6,6½,7,7½,8,8½,9,10.
53 N 2418—Red. 53 N 2421—Black.
53 N 2419—Navy Blue. 53 N 2422—Bone.
Shipping weight 1 lb.................**3.97**

5 RACEY-PACED Wishbone T-Strap with double side gore—snug fit! "Rave" snip-toe shape. Foam comfort-lined. Crushed leather trims soft capeskin leather upper. Comp. sole, ½-inch heel. B (Med.) width. Sizes: 5, 5½, 6, 6½, 7, 7½, 8, 8½, 9 and 10.
53 N 2800—Black. 53 N 2801—Bone.
53 N 2803—Brown. Wt. 15 oz....**3.97**

6 HIGH-RIDING T-BUCKLE. Goatskin vinyl upper; foam-lined. Composition sole. Black ⅝-in. Beatle heel. B (Medium) width. Sizes: 5, 5½, 6, 6½, 7, 7½, 8, 8½, 9 and 10.
53 N 2516—Brass.
53 N 2517—Black.
Shipping weight 1 lb. 2 oz...........**3.97**

7 BUCKLE 'N STRAP accent crushed simulated leather upper. Foam-lined. Composition sole. Black 4/8-in. heel. B(Med.) width. Sizes: 5, 5½, 6, 6½, 7, 7½, 8, 8½, 9 and 10.
53 N 2864—Antique Dark Brown.
53 N 2866—Black.
53 N 2865—Ceylon Tan. Wt. 1 lb. 1 oz. **3.97**

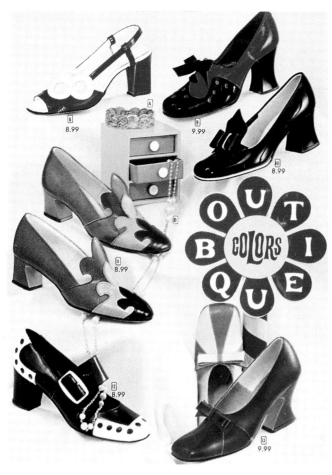

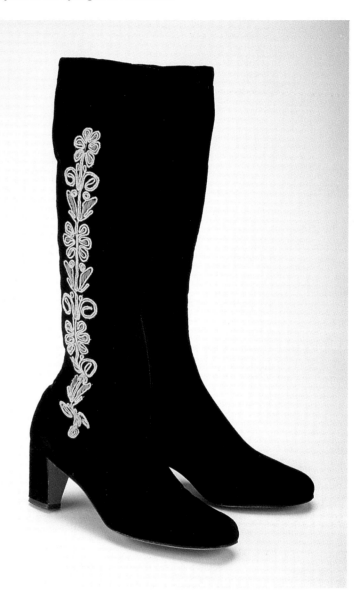

Sling-backs and pumps with shaped heels in two-toned color combinations popular in the Spring of 1970. Aldens.

Black velvet go-go boots accented with gold braidwork and colored embroidery. Sak's Fifth Avenue. $125 and up.

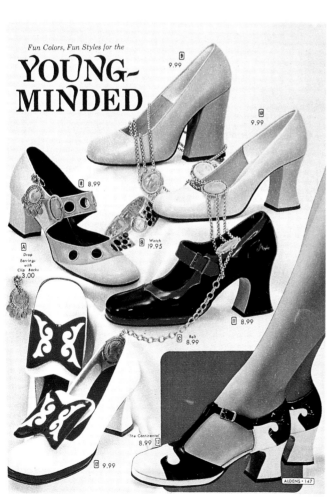

Shoes designed for the "Young-Minded," with chunky-shaped heels in bright colors and two-toned color combinations. Aldens, 1970.

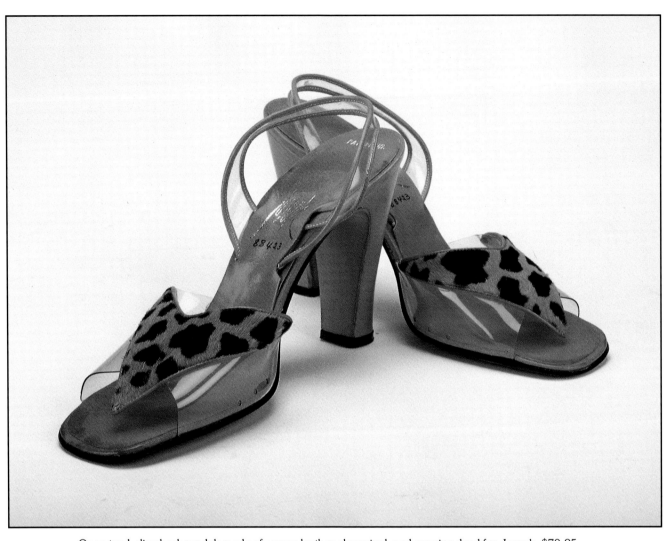

Open-toed, sling back sandals made of orange leather, clear vinyl, and genuine dyed fur. Joseph. $70-95.

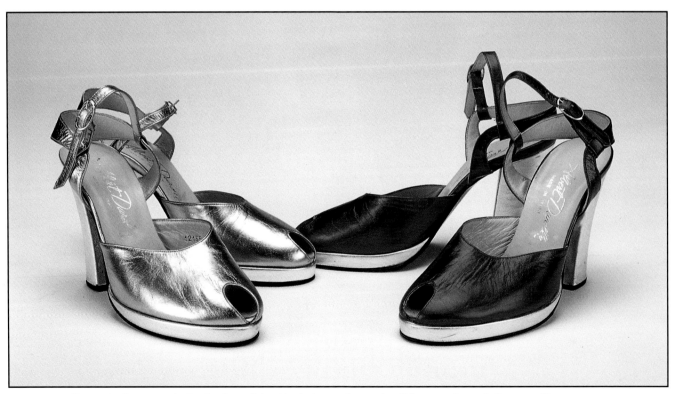

Two pair of open-toed, sling back sandals with platform soles made of blue, purple, and silver metallic leather. Albert Durelle. Made in Italy. $85-100 each pair.

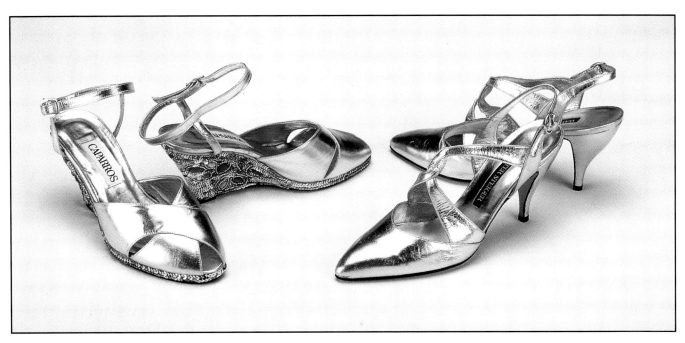

Gold leather wedgies with ankle straps and jeweled soles. CAPARROS. Sling back heels made of gold leather with overlapping straps. Walter Steiger. Hand Made in Italy. $55-80 each pair.

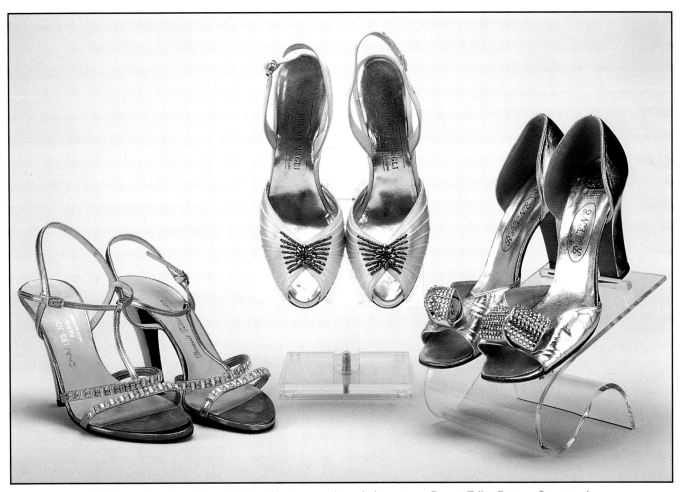

High-heeled sandals designed with ankle straps and jeweled toe straps. Bonwit Teller, Boston. Open-toed, sling back high-heeled sandals made of ivory-colored silk and decorated with bronze-colored glass beads. Bruno Magli. Made in Italy. Open-toed pumps made of gold leather with rhinestone decoration. RAVNE. By Appointment To Her Majesty The Queen Shoemakers. $75-100 each pair.

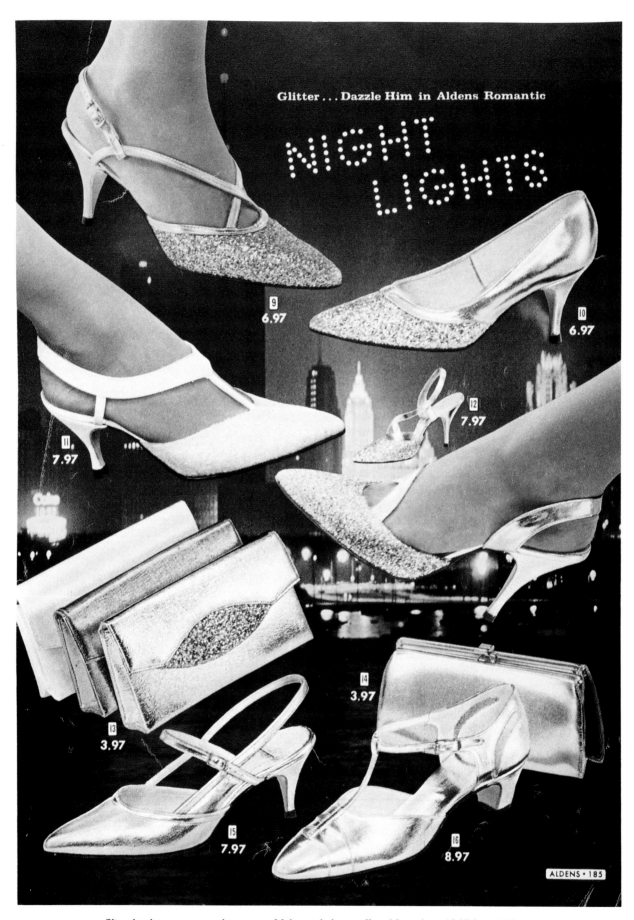

Sling-backs, t-straps, and pumps in Mylar and glitter, offered for sale in 1967 from Aldens.

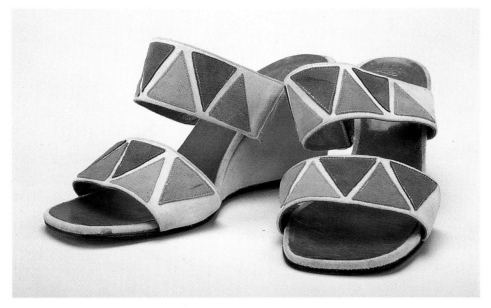

Cream-colored suede wedgies accented with multi-colored suede geometrics on toe straps and ankle straps. Made in Italy. $45-70.

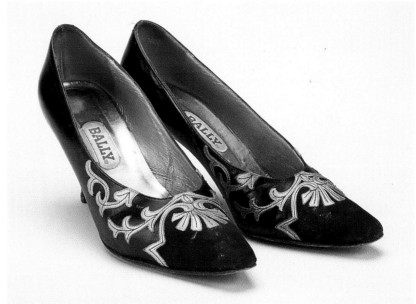

Black leather pumps accented with fancy gold leather decoration. Bally. Made in Italy. $60-90.

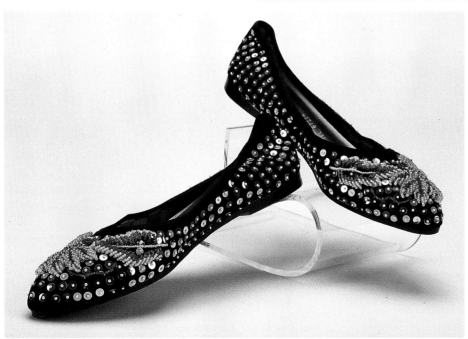

Velvet slippers decorated with sequins and beadwork applied in floral patterns. Chow Hang Kee. $40-55.

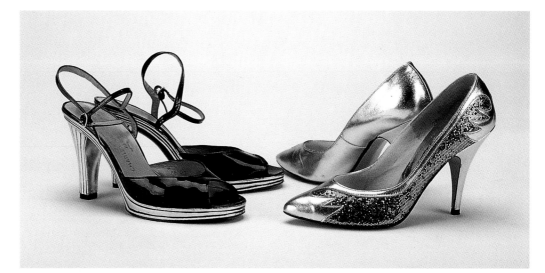

High-heeled sandals designed with black patent leather uppers and gold platform soles and heels. Charles Jourdan, Paris. Made in France. Stiletto heels in gold accented with glitter. Imperial. $45-95 each pair.

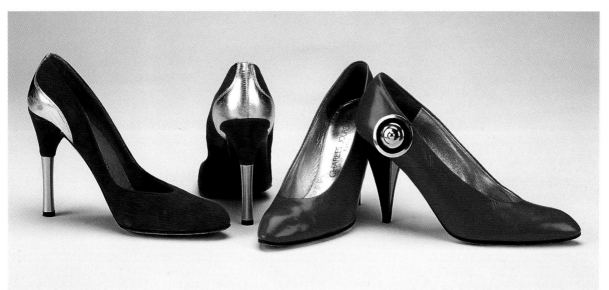

Stiletto heels made of burgundy suede and gold leather. The heels are gold-plated. Christian Dior. Sak's Fifth Avenue. High-heeled pumps made of red leather with black heels. A silver-plated disk, decorated with black suede, further accents the shoe. Charles Jourdan, Paris. Made in France. $100 and up each pair.

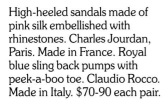

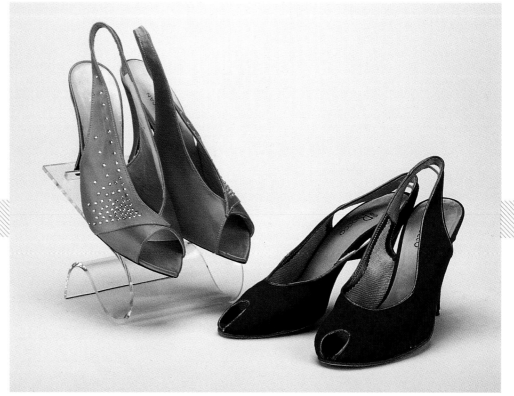

High-heeled sandals made of pink silk embellished with rhinestones. Charles Jourdan, Paris. Made in France. Royal blue sling back pumps with peek-a-boo toe. Claudio Rocco. Made in Italy. $70-90 each pair.

126

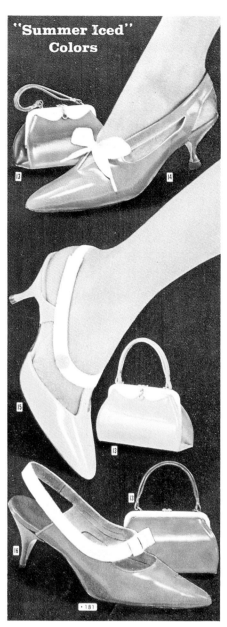

"Summer Iced" Colors

Bright-colored "Patenlite" sling-back shoes with matching bags popular in 1967. Aldens.

"Hot Shades" in colored pantyhose popular in the late 1960s and early 1970s. $3-5 each.

Assortment of fishnet stockings spanning the 1960s, the 1970s, and the 1980s. $4-8 each.

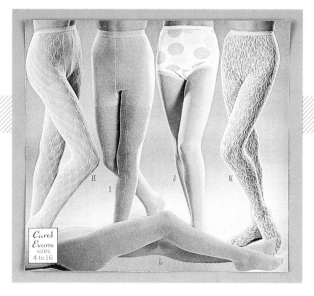

Textured tights and colored pantyhose, popular in 1969.

Men's Fashions

Fashions for men rarely changed as dramatically as those for women. With the exception of jacket lapels, shirt collars, and neckties either increasing or decreasing in size, the basic look for men remained pretty standard over the first half of the twentieth century.

In the latter half of the 1960s, however, men's fashions went through some radical changes. Veering away from established patterns of the past, a large percentage of men from the turbulent Sixties became "proud as peacocks." At the other end of the fashion spectrum, the anti-establishment dress code flourished.

In the animal kingdom, the male of the species is almost always the most colorful. This is definitely the case for the peacock, so as Sixties' men began proudly strutting their stuff, the phrase "The Peacock Revolution" was coined.

The Peacock Revolution of the late 1960s and early 1970s allowed men to express their personality via the clothes they wore. In the past, it had always been women who were allowed to do this while the men stood in the background. But with the social revolution of the times, men were now allowed the same gratification in dress as women. Age-old barriers on what was acceptable dress for men of different age groups was diminishing. The idea that expensive clothing "made the man" was becoming a thing of the past. Even the men's hairstyles during that period became radical. Men grew their hair long; if they could not grow their own hair, they were able to "buy it," along with false beards, moustaches, and sideburns. Salons for men were opening up in major department stores across the country.

Men wore velvet, brocade and silk moiré dinner jackets and blazers. Nehru jackets made of iridescent fabric were extremely popular, as were brightly colored polyester leisure suits. Although leisure suits became fashionable for men in the late 1930s and early 1940s, they were revamped in the Sixties and became more popular due to the technological advances of polyester. Belted vest suits were also popular.

Dress shirts were adorned with lace, ruffles, and embroidery. They were made of silk and satin and offered in a wide spectrum of colors. Previously, these extravagances were limited to women's fashions—but times were definitely changing. Qiana nylon became popular, and shirts designed with colorful floral prints were extremely common for men. India madras shirts were also being worn by men in the 1960s. By the latter part of the decade, the colors became almost psychedelic. Men also wore gold pendants and medallions, lots of chains, bracelets, and finger rings.

Sport jackets were designed with very wide lapels and patch pockets. Bright plaids and checks were popular. Colors like beige, orange, and blue were common and used in combination to form glen plaids. Tri-col-

Sharkskin Nehru jacket advertised in Spiegel in 1969.

ored stripes and checks were common for pants, with flared or bell-bottomed legs.

Although the "knit explosion" was a 1960s phenomenon, it wasn't until the late 1960s that knit clothing for men made top fashion news. In 1968, knit suits for men were available in England. In America, doubleknit fabrics were making their way to manufacturers. By 1969, knit clothing for men became extremely desirable, especially pants and suits. Up to that point, knits for men were basically limited to sport shirts. Now men wanted to be comfortable not only in their casual wear, but while wearing business suits as well. They declared their independence from the conformity of the past, an action made possible through the combined elements of technology and social revolution. Knit clothing filled the needs of the consumer looking for comfort, durability, and easy care. Knits became the perfect travel garments of the jet setter.

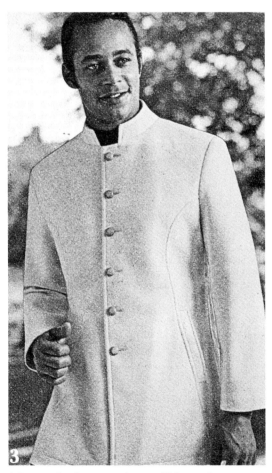

Advertised as being similar to a Nehru jacket, this "bonded knit long-line tunic top with stand-up collar" was offered for sale in 1969.

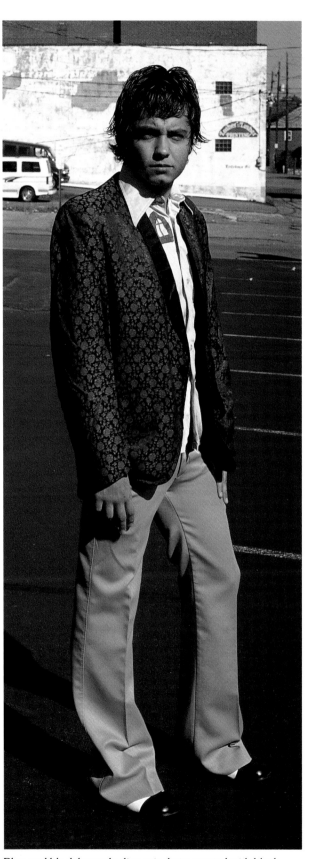

Blue and black brocade dinner jacket accented with black satin lapels. No label. Light blue polyester bell-bottomed slacks. Labeled: Farah. Modeled by the author's son, Clint Ettinger. 25-75 each.

Deep green velveteen sport jacket designed with oversized lapels and large patch pockets. No label. $60-75.

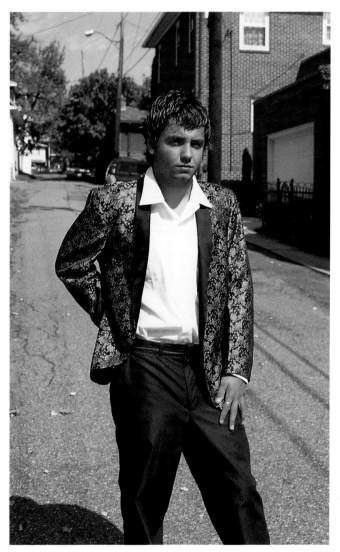

Black and gold brocade dinner jacket accented with black satin lapels. Labeled: First Nighter Formals, New York City. $60-75.

Sport jacket made of 100% cotton with batik print in shades of red, burgundy, melon, and black. Labeled: Made in British Hong Kong. Sandwich Isles, Hawaii. $40-55.

Belted tunic, pullover sweater, printed polyester shirts, and solid-colored flared-leg jeans, offered for sale in 1971 by Sears, Roebuck & Company.

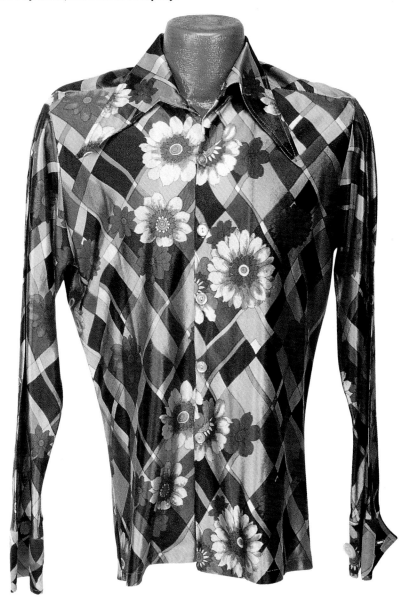

Long sleeve shirt made of nylon with a combination floral and geometric print rendered in psychedelic colors. Labeled: Flair, California. $30-40.

Vest suits and printed shirts made of Dacron polyester, fashionable in the early 1970s.

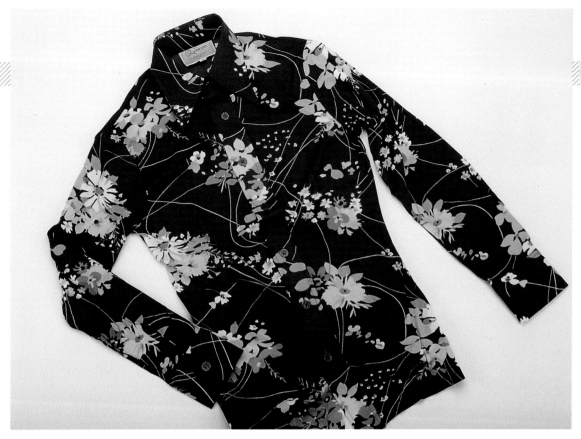

Long sleeve shirt made of nylon stretch knit with a colorful floral print. Labeled: New Quiessa Fabric, Permanent Press. $25-35.

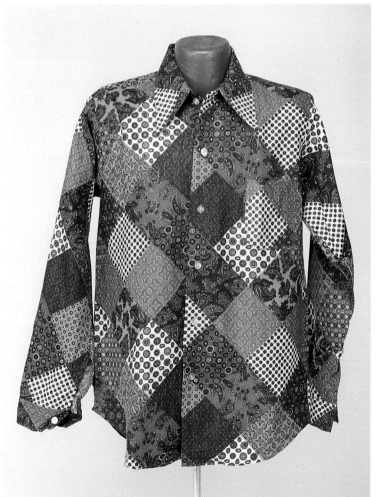

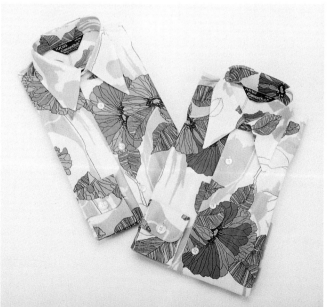

Two long sleeve shirts designed with oversized floral prints, made of 80% acetate and 20% nylon. Labeled: Focus. Career Club. $20-30 each.

Long sleeve shirt with patchwork paisley print made of permanent press cotton. $20-30.

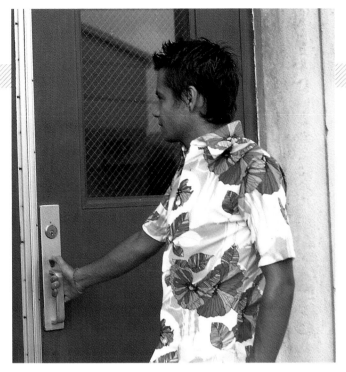

Short sleeve nylon shirt with oversized floral print. Labeled: Focus. Career Club. $18-25.

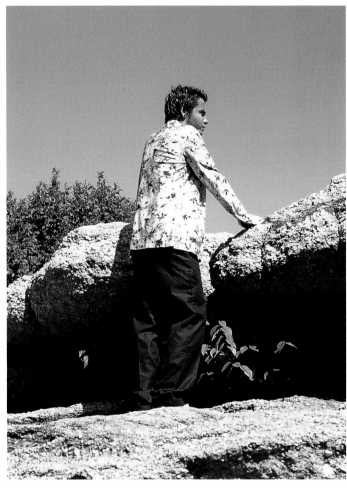

Long sleeve shirt made of 65% acetate and 35% nylon. The floral print is rendered in black, white, and grey on a sky blue background. No label. $20-30.

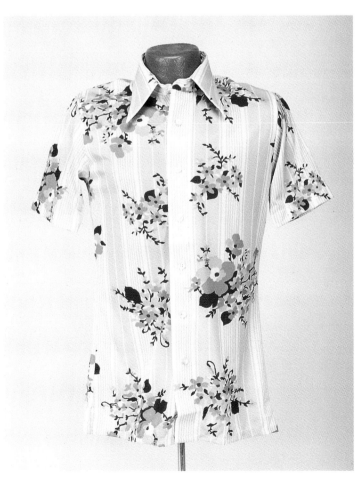

Short sleeve shirt made of 70% Arnel Triacetate and 30% Fortrel Polyester. The floral print is coupled with vertical stripes. Labeled: Focus. Career Club. $18-25.

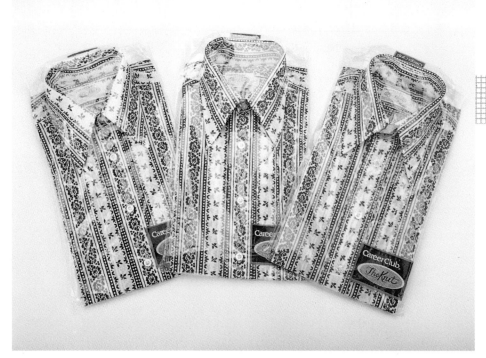

Three identical shirts made of polyester and nylon with different color combinations. The floral prints are coupled with vertical stripes. Labeled: The Knit. Career Club. $18-25 each.

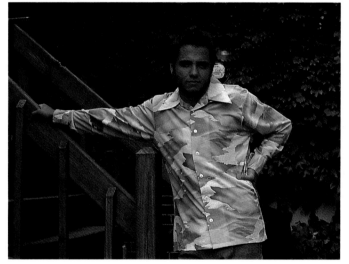

Long sleeve shirt made of acetate and nylon with an abstract print in shades of green, melon, and white. Labeled: Shirt # 1. $20-30.

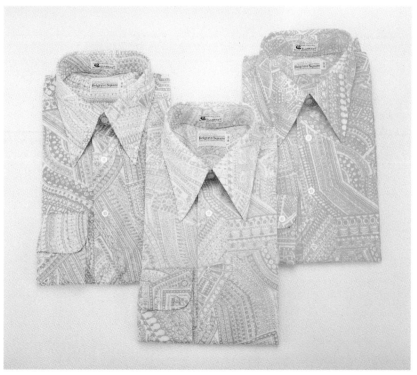

Trio of long sleeve shirts made of 100% Arnel Triacetate. The abstract designs are rendered in pastel colors. Labeled: Career Club. Belgrave Square. Permanent Press. $20-30 each.

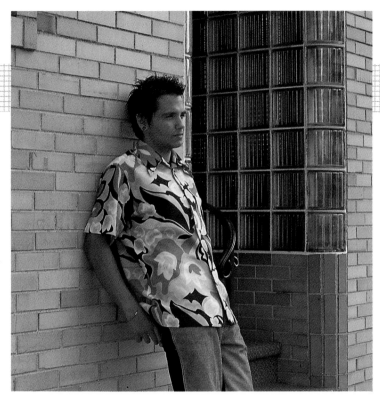

Short sleeve polyester button-down shirt with abstract floral print executed in shades of yellow, orange, tan, and brown. No label. Tight fitting two-toned flared-leg jeans. Labeled: Chardon, Paris. $35-50 each.

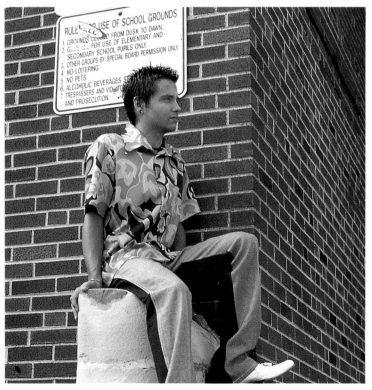

Another abstract floral printed shirt modeled by Clint. This time the print is executed in shades of blue and tan. $35-50.

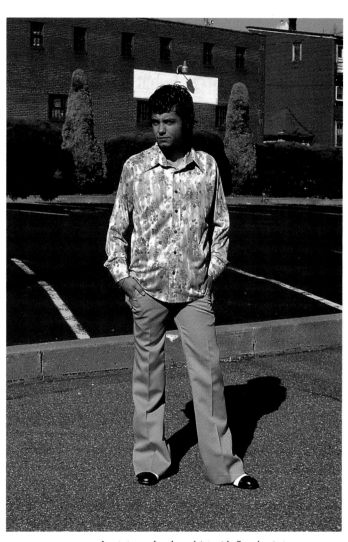

Acetate and nylon shirt with floral print on a lavender background. No label. $20-30.

135

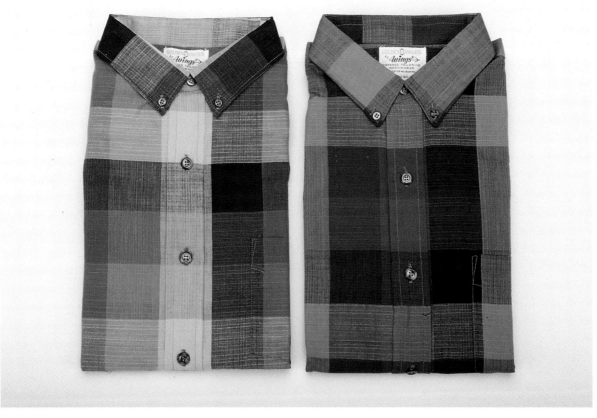

Authentic India Madras shirts were still being worn in the late 1960s. These two examples were woven in psychedelic colors. Labeled: Golden Award by Wings. $25-35 each.

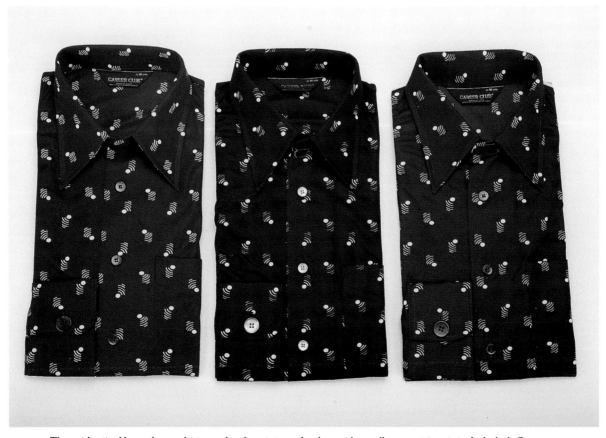

Three identical long sleeve shirts made of acetate and nylon with small geometric prints. Labeled: Career Club. $20-30 each.

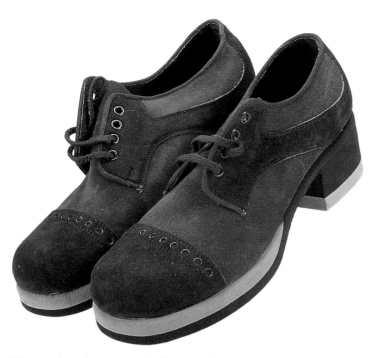

Platform shoes for men made of two-toned suede. Hampton Imperials. Made in Poland. $45-75.

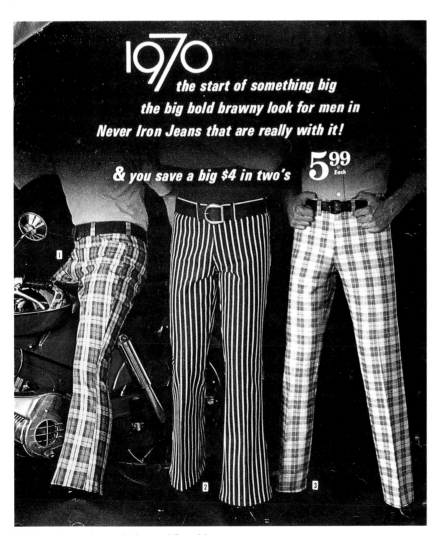

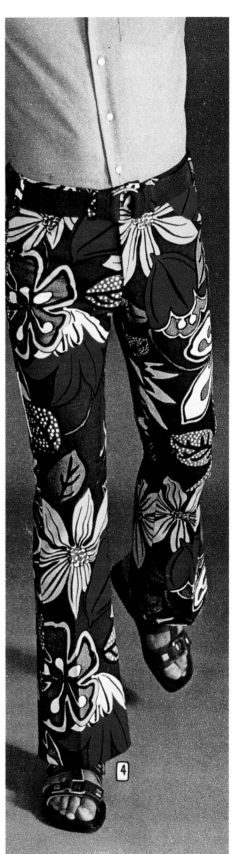

Men's flared-leg pants, designed with oversized floral prints, were offered for sale from Aldens in 1970. They were advertised as "Styled for the Big Swinger."

Plaid and striped straight-leg and flared-leg jeans, offered for sale from Aldens in 1970.

Pucci Menswear

Emilio Pucci not only designed clothes for women, but for men as well. Initially, his menswear—particularly his silk shirts—was sold only in Europe. By 1970, however, it became available in the United States. Pucci designed suits and sport jackets that were made of silk, wool, and linen. They were usually lined with the colorful printed silk he became so famous for. In the early 1970s, Pucci designed striped and checked double-breasted sport jackets with wide lapels. His designs ranged from very trendy to extremely classic. His famous silk prints were made into tailored shirts for men with $85 price tags. They attracted royalty, celebrities, jet setters, and status seekers.

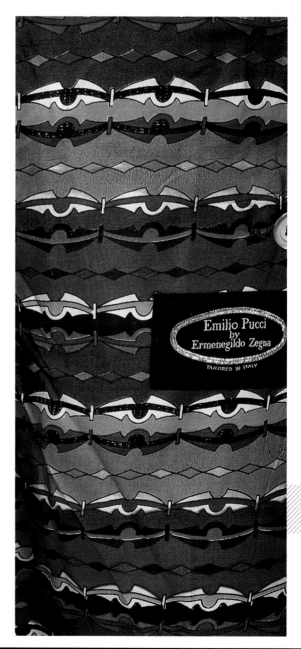

BOYS AND GIRLS TOGETHER

Ruffled Shirts 7⁹⁹ Ea.

6 Unisex is here to stay—4 rows of ruffles win the day! 3-button long sleeves, long point collar, taper 'n tails. 50% Kodel® polyester, 50% cotton. Never iron! Machine wash. HIS: S(14-14½), M(15-15½), L(16-16½). Color: Dk. Brown. M61 B 5607—Ship. wt. 14 oz. 7.99 HERS. 10, 12, 14, 16. Dk. Brown. M61 B 5608—Ship. wt. 12 oz. 7.99

Lace Pullovers 8⁹⁹ Ea.

8 Luxurious acetate lace shirts – tricot bonded back, high-style puffed sleeves. 3-button wide cuffs. V-neck collar with stays. Rounded hemmed bottom worn in or out. HIS: S(14-14½), M(15-15½), L(16-16½). Color: Blue. Dry clean. M61 B 5665—Ship. wt. 12 oz. 8.99 HERS. 10, 12, 14, 16. Color: Blue. M61 B 5666—Ship. wt. 9 oz. 8.99

Flare Denims 6⁹⁹ Ea.

7 No-iron striped flare-bottom denim jeans in coordinating Brown. Yoke back, hip patch pockets. 50% Dacron® polyester, 50% cotton. Machine wash and dry. HIS: Waist 29,30 (Ins. 29,30,31,32). W.: 32,34,36 (Ins. 29,30,31,32,33). M63 B 6410—Wt. 1 lb. 2 oz...6.99 HERS. 8, 10, 12, 14, 16. M63 B 6411—Wt. 1 lb. 1 oz...6.99

Sheer Foral Print 6⁹⁹ Ea.

9 Black and White floral print shirt of sheer voile! Taper 'n tails. long point collar, collar stays. Pleated yoke backs, large pearlized buttons, puffed sleeves, wide cuffs. HIS: S(14-14½), M(15-15½), L(16-16½). Machine wash. M61 B 5662—Ship. wt. 10 oz. 6.99 HERS. 10, 12, 14, 16. M61 B 5663—Ship. wt. 8 oz...6.99

ALDENS • 367

"Unisex" clothing became very fashionable in the late 1960s; the trend continued well into the 1970s. This display from Aldens is dated 1970.

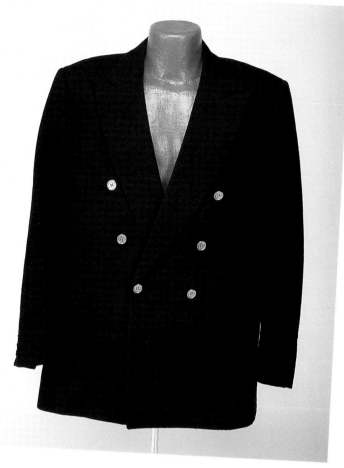

Pucci double-breasted sport jacket of navy blue wool with signature fabric lining. Labeled: Emilio Pucci by Ermenegildo Zegna. Tailored in Italy. Sak's Fifth Avenue. Made in Italy. $350 and up.

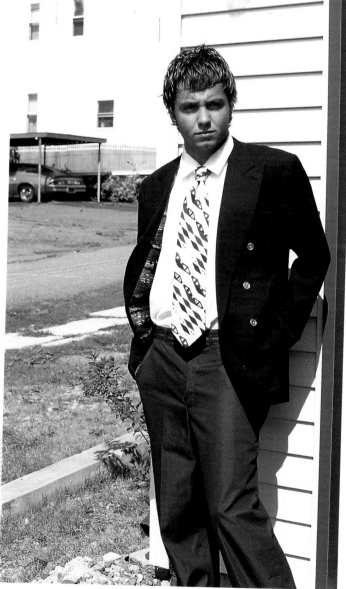

Clint modeling the Pucci sport jacket with a Pucci necktie.

Opposite page, bottom:
Close-up of Pucci wool sport jacket showing signature fabric lining and label.

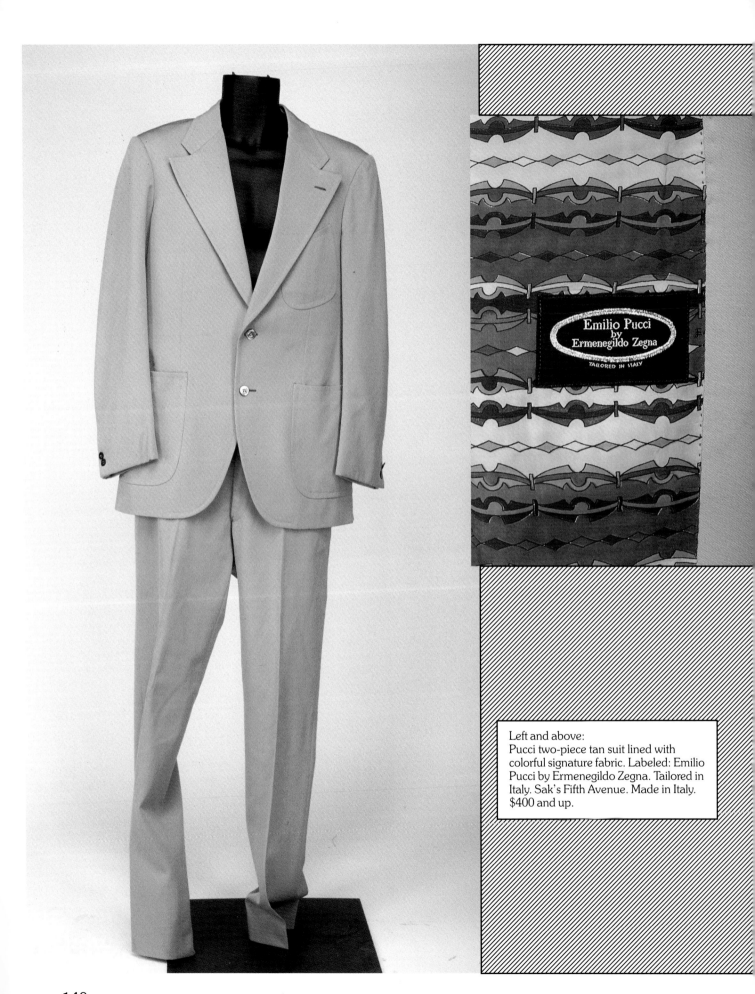

Left and above:
Pucci two-piece tan suit lined with colorful signature fabric. Labeled: Emilio Pucci by Ermenegildo Zegna. Tailored in Italy. Sak's Fifth Avenue. Made in Italy. $400 and up.

Clint modeling the Pucci tan suit
jacket with a Pucci necktie.

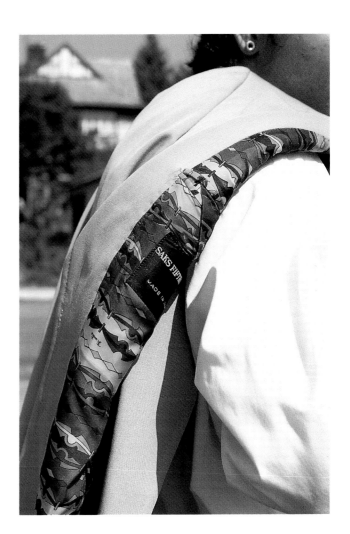

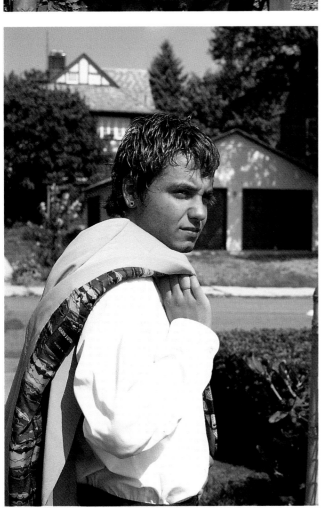

Left and above:
Close-up of Pucci jacket and signature
fabric lining.

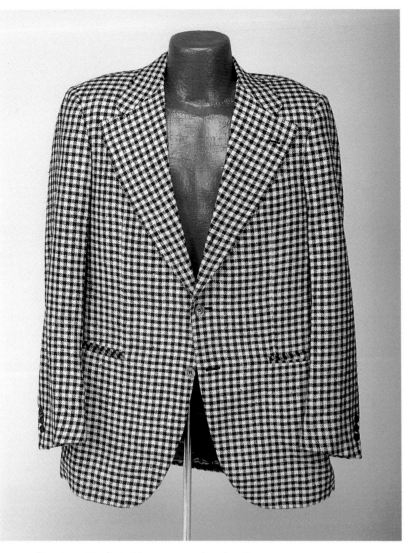

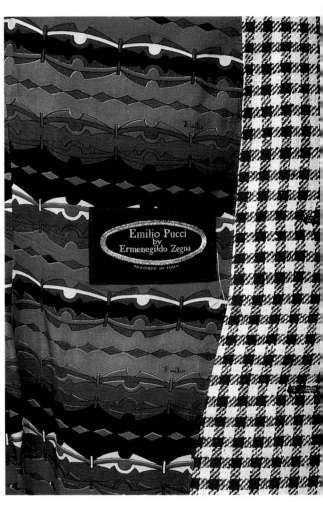

Pucci sport jacket with a cream-colored and burgundy checked pattern. Signature fabric lines the jacket. Labeled: Emilio Pucci by Ermenegildo Zegna. Tailored in Italy. Sak's Fifth Avenue. Made in Italy. $275 and up.

Close-up of Pucci checked sport jacket showing signature fabric lining and label.

Pucci Ties

Choosing the correct tie was a great way for a well-dressed man to express his personality, individuality, and status—and the late 1960s and early 1970s provided men with a large variety of ties from which to choose. With The Peacock Revolution in full swing, wide polyester Kipper ties were extremely popular; the designs on these ran the gamut from florals to Persian prints to embellished diagonal stripes to psychedelics. Solid color ties were also popular because the weaves were becoming extremely elaborate, thus adding intricacy and dimension to the tie.

Designer or signature ties became extremely chic at that time. Top designers like Pierre Cardin, Christian Dior, Oscar de la Renta, Oleg Cassini, Yves St. Laurent, and Guy Laroche were creating wonderful ties with designer labels or embroidered signatures. From the early 1960s, this trend gained momentum and became increasingly popular by the 1980s.

Emilio Pucci designed a wonderful assortment of silk ties with his brightly-colored artistic prints. Just like the women's silk jersey prints, which were signed with the word "Emilio" within the design, Pucci's ties were also signed and labeled on the back. Pucci also created solid color signature ties with his initials "EP" embroidered on the front.

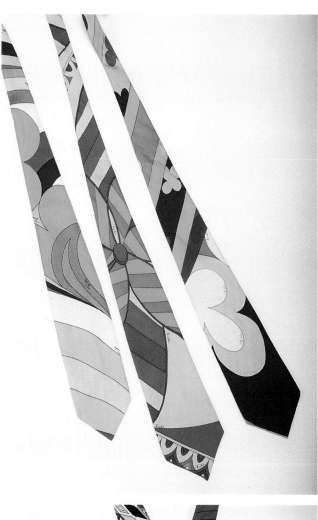

Three Pucci neckties made of silk with abstract prints in psychedelic colors. Each labeled: Emilio Pucci, Florence, Made in Italy. 100% Silk. Made in Italy for Sak's Fifth Avenue. $75 and up each.

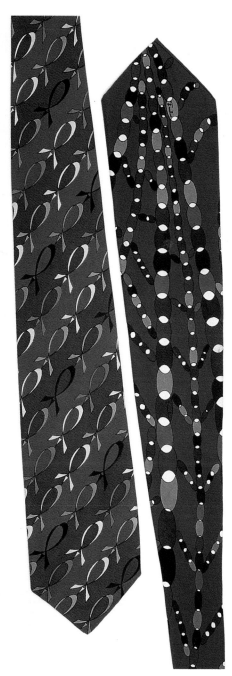

Two Pucci neckties made of silk with abstract and diagonal-striped patterns. Labeled: Emilio Pucci, Florence, Italy. $65 and up each.

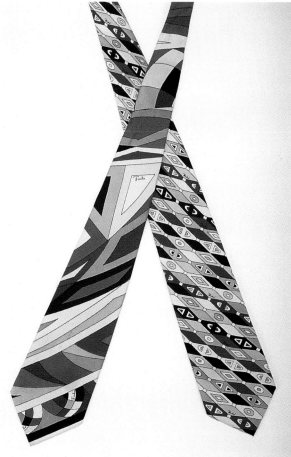

Two Pucci neckties made of silk with abstract and geometric patterns in shades of pink, purple, fuchsia, grey, black, and white. Labeled: Emilio Pucci, Florence, Italy. $65 and up each.

143

Two Pucci neckties with abstract
prints in psychedelic colors. Labeled:
Florence. Made in Italy. Emilio Pucci.
100% Pure Silk. $75 and up each.

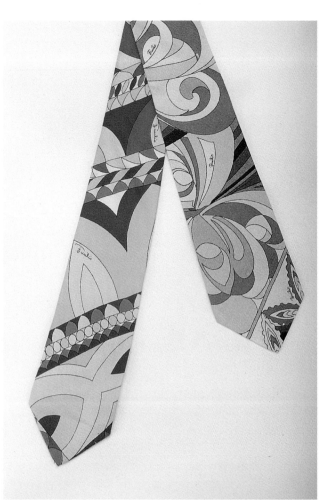

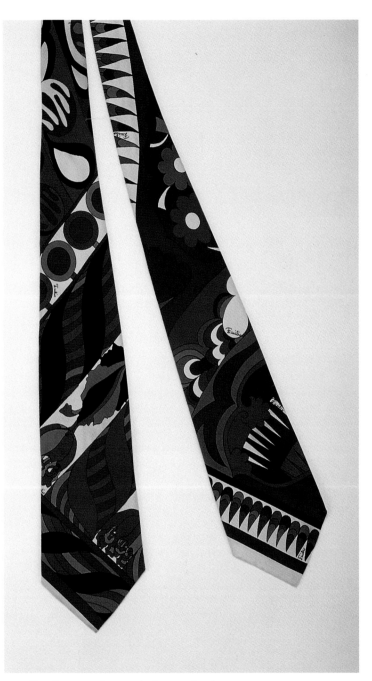

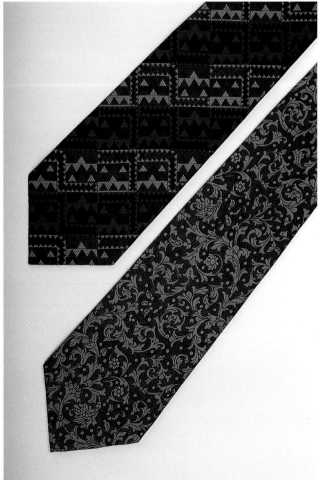

Two Pucci neckties with abstract floral prints in
shades of pink, fuchsia, magenta, burgundy,
brown, black, and white. Labeled: Florence.
Made in Italy. Emilio Pucci. 100% Silk. Made in
Italy for Sak's Fifth Avenue. $65 and up each.

Two Pucci ties with allover patterns
rendered in vibrant color schemes.
Both labeled: Made in Italy. Emilio
Pucci. 100% Pure Silk. $45 and up
each.

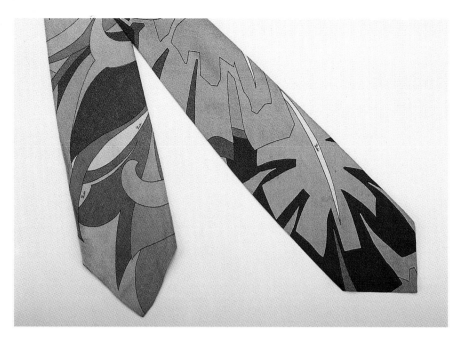

Similar color schemes were utilized in these two ties by Emilio Pucci. Both labeled: Made in Italy Expressly for Bergdorf-Goodman Men's Shop. $50 and up each.

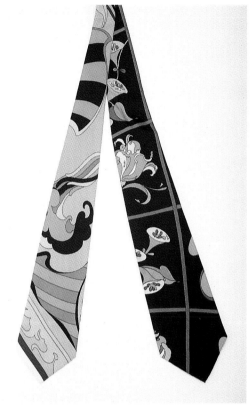

Two Pucci neckties with floral and abstract prints in shades of blue and green accented with black. Both labeled: Florence. Made in Italy. Emilio Pucci. 100% Pure Silk. $75 and up each.

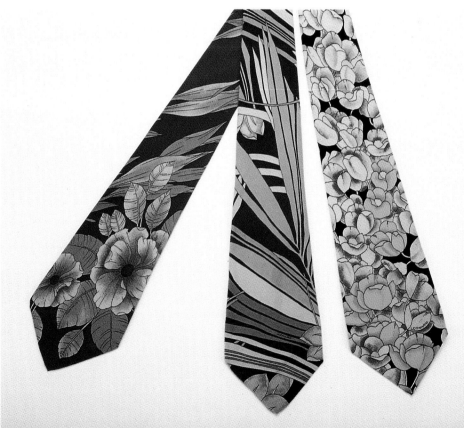

Signature ties made of silk with floral prints. Labeled: Leonard of Paris. Made in Italy. $65 and up each.

Conversation Prints

In the late 1940s, men began wearing bold print shirts at resort areas. In Palm Beach, it has been said, men were purchasing women's dress fabrics and having shirts custom-made for themselves with these fabrics. The most popular print at that time was the pineapple print. This led to the penchant for Hawaiian shirts, which became increasingly popular throughout the 1950s. This movement quieted down for a brief period in the late 1950s, but began gathering momentum again in the early 1960s. By 1967, the bold look had returned to the fashion scene with a vengeance.

By the late 1960s and early 1970s, shirts for men were designed in all shapes, styles, and colors. Technological advances created a broad fabric range. The performance of the fabric was an important factor and having qualities such as "wrinkle-resistance and ease of care" became top priorities. As a result of these and many other factors, polyester became the predominant fiber in the textile industry. In 1967, *American Fabrics* reported that there were over one hundred chemical plants worldwide producing polyester fiber. Most of these plants had not even existed in the late 1950s—nearly all were newly established only in the early 1960s. In 1966, it was also reported, these plants "produced over 1,300,000,000 pounds of polyester." According to *American Fabrics,* polyester became "the most dramatic symbol of the revolution which has transformed the whole textile complex in less than a generation."

Long sleeve polyester shirt with conversation print of a man day dreaming in his bed. Labeled: Printed in Italy. $35-45.

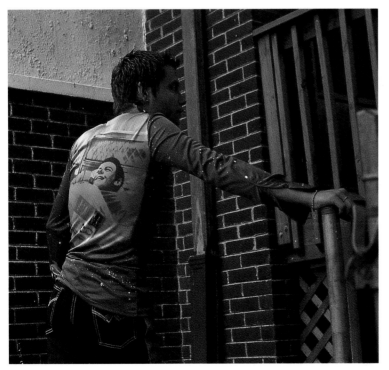

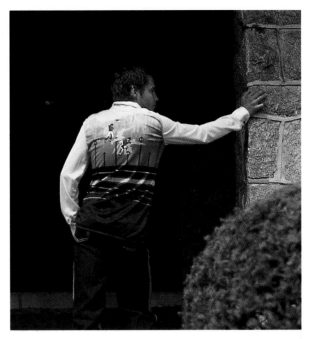

Long sleeve shirt made of 100% Antron nylon with sport motif. Labeled: Pinwinnie. $30-40.

Polyester was extremely versatile. It could be used alone or blended with other synthetic or natural fibers. It was used not only for apparel but for home furnishings and dozens of other items ranging from lightweight luggage to car tires.

Printed polyester shirts, designed for men and women in the late 1960s and early 1970s, became extremely fashionable. With the advent of automatic screen printing, roller printing, and heat transfer processes, the task of creating these unusual prints became much easier than in the past. The fabric designer could now let his imagination run wild.

Conversation prints ran the gamut from celebrity profiles to hot TV programs. In addition to space exploration, sports figures and events were common. Trains, planes, boats, and automobiles were featured. Scenic prints featuring far-off places were found on these shirts, as were desert, ocean, and mountain scenes. Western themes, street themes, and floral themes were all popular design motifs. Colorful renditions of Roman gladiators, Greek Gods, and Egyptian warriors were also prevalent. Men's shirts were printed with Victorian women, Colonial women, and Flapper women. Conversation prints became merchandising gimmicks to advertise new products. They were newspaper prints and comic strips. They became the artist's canvas, displaying Op Art and Pop Art designs.

Conversation prints made a statement and told a story. They were colorful and full of humor. Today, these polyester shirts are becoming extremely collectible for their artistic merit. They painted a picture of a revolution in fashion for both men and women.

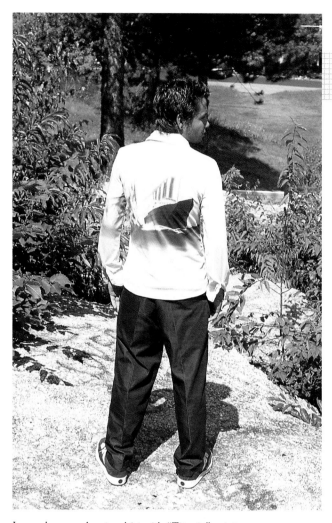

Long sleeve polyester shirt with "Titanic" print.
Fabric signed: Hutspah Shirts. $35-45.

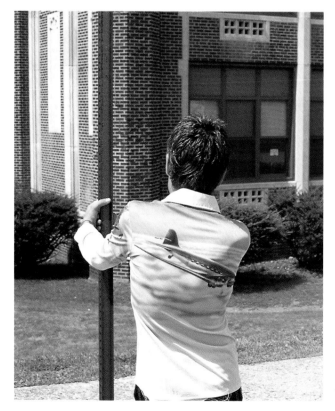

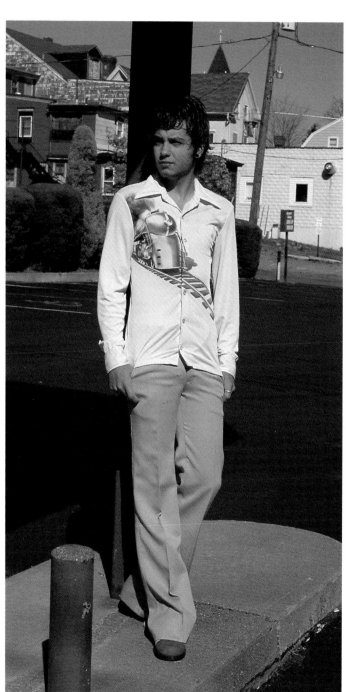

Long sleeve polyester shirt with
locomotive print. Labeled: Hutspah. A
Grouping. $35-45.

Long sleeve polyester shirt with
airplane print. Fabric signed: Hutspah
Shirts. $35-45.

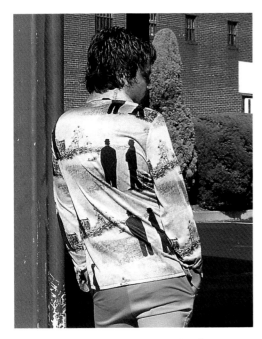

Long sleeve polyester shirt with male silhouette print. Labeled: Hutspah. A Grouping. $30-40.

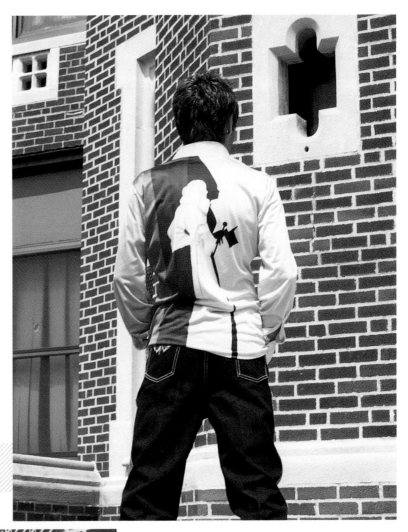

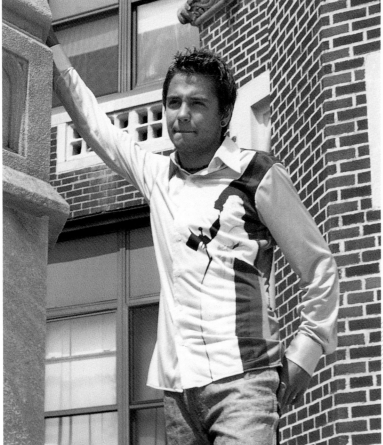

Left and above:
Clint modeling a nylon conversation print shirt with the silhouettes of a man and woman dressed in evening attire. Front and back views are shown. Labeled: Nik-Nik. $30-40.

Left and below:
The background in these two photos matches the conversation print on this polyester knit shirt. Labeled: MFD. by Dutchmaid. Ephrata, Pa. $30-35.

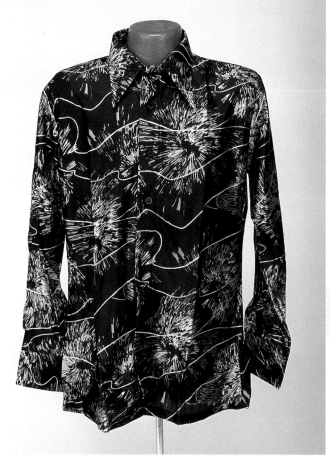

Long sleeve shirt made of acetate and nylon with a fireworks display.
Labeled: Focus. Career Club. $30-35.

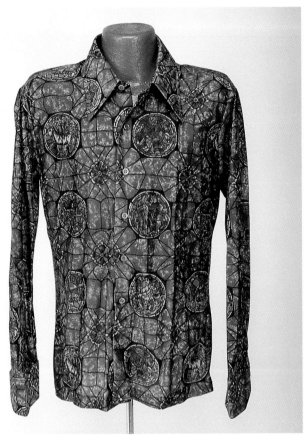

Long sleeve shirt made of nylon with a
stained glass window print. Labeled: West
Side. $30-40.

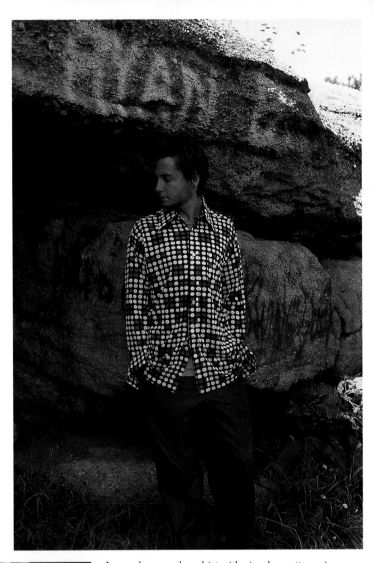

Long sleeve nylon shirt with circular patterns in
brown and white on a black ground. Labeled:
Designed by David Hamson. $25-35.

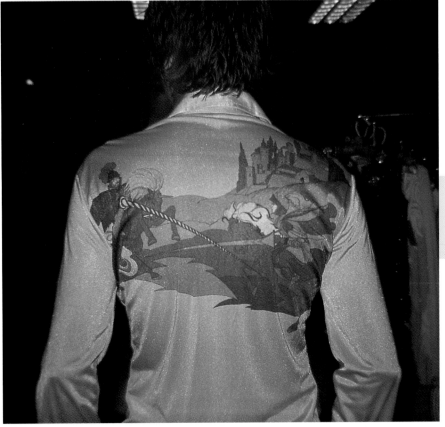

Long sleeve shirt made of acetate and nylon
with jousting motif. Labeled: Citta. Made in
Italy by Europe Craft. $25-30.

Short sleeve nylon shirt with a geometric print in red, black, and grey on a white ground. Labeled: Prince Igor by Burma. $30-35.

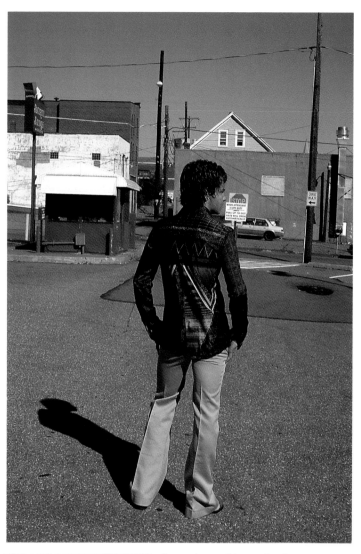

Long sleeve shirt made of acetate and nylon with geometric print in shades of brown, tan, blue, and white. $30-35.

Long sleeve polyester shirt with geometric print in red and blue. Labeled: Oscar de la Renta for After Six. $40-45.

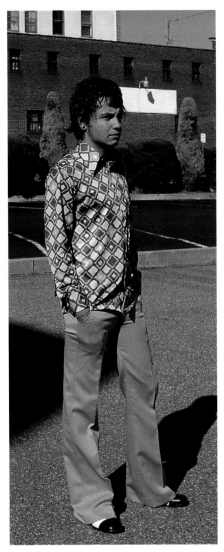

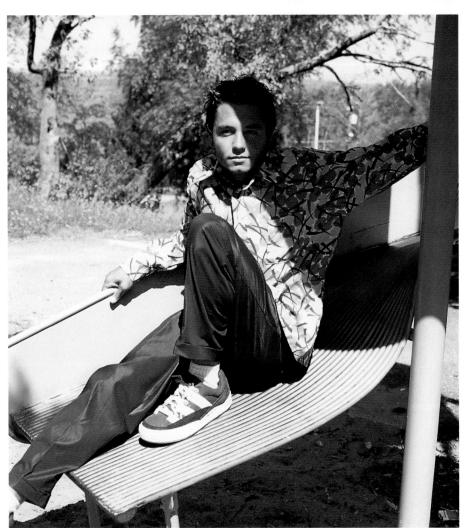

Long sleeve shirt made of polyester with geometric print in green, blue, and tan. Labeled: Puritan. $30-35.

Above right:
Long sleeve polyester shirt with abstract print in shades of brown, tan, and rust. Labeled: King's Road. Sears. The Men's Shop. $30-35.

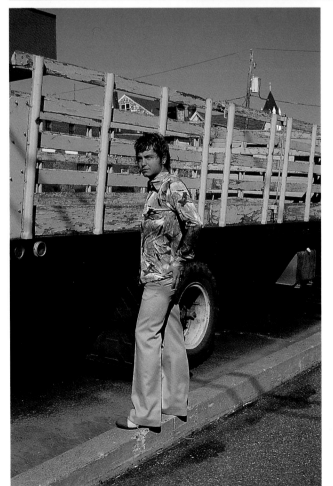

Long sleeve polyester shirt with flying geese motif. Labeled: Custom Casual. $30-35.

Chapter Twelve

Miscellaneous

Throwaway Chic—Paper Dresses

"Here today and gone tomorrow" was a popular phrase which became a Sixties' phenomenon. In the realm of fashion, anything became acceptable; nothing was to be taken seriously. Clothing was not meant to be worn for more than one season. Impulse shopping was the way to go.

In the home, for instance, women were growing accustomed to using paper plates, napkins, and table covers. With this new, fast-paced society, who had time to launder cloth napkins and tablecloths anymore? As a result, Scott Paper Company came up with a marketing tactic for selling fancy paper goods. They created a paper dress which could be purchased through the mail for $1.00 plus $.25 shipping and handling. The response was enormous, with over a half a million dresses ordered. The prints encompassed the whole spectrum of Sixties' mania from Op Art to Pop Art, prints and florals to stripes.

These disposable dresses, however, were not made of the kind of paper one might think. They were made of "non-woven fabrics," also described as a "web or continuous mat of fibers without benefit of spinning," according to *American Fabrics* in 1967. Other names used in association with non-woven fabrics were "short life textiles," used by the British, and "web textiles," coined by *American Fabrics* as early as 1960.

By 1967, boutiques selling only paper fashions were sprouting up in big cities; major department stores had paper boutiques as well. Trendy fashion was supposed to be short-lived, and throwaway apparel fit the bill for the constantly changing trendy society of the 1960s.

Besides the basic shift, web textiles were made into bathing suits, culottes, saris, caftans, raincoats, lingerie, and hats. Women's evening dresses made of a silver foil by Kimberly-Stevens called "Kaycel" sold for $9.00 each. In 1967, even a paper wedding dress was advertised, selling for $35.00. Paper pin-afores and frocks with floral prints were offered for little girls. For men, ties, handkerchiefs, bathing trunks, and underwear were made of non-woven fabrics. The men's bathing trunks were made of "Tyvek," a spun-bonded plastic polyolefin material from DuPont that was water resistant.

Besides the colorful table linens, plates, cups, and centerpieces that were offered for the home, curtains, sheets, and bedspreads were made of these revolutionary non-woven fibers. In 1967, there were sixty companies in the United States producing web textiles. Because the draping quality of the web textile used for apparel was not as good as that of a woven material, the trend did not last too long. Very few paper fashions survived over the last thirty years. Because of this, they are extremely collectible today, especially those with Pop Art prints.

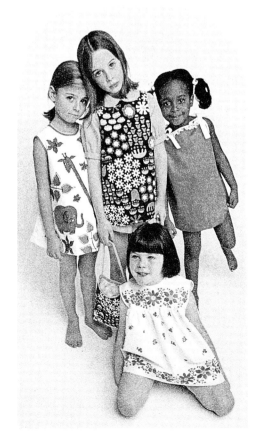

Pinafores, shifts and frocks, made of non-woven textiles, designed for little girls. *McCall's*, 1967.

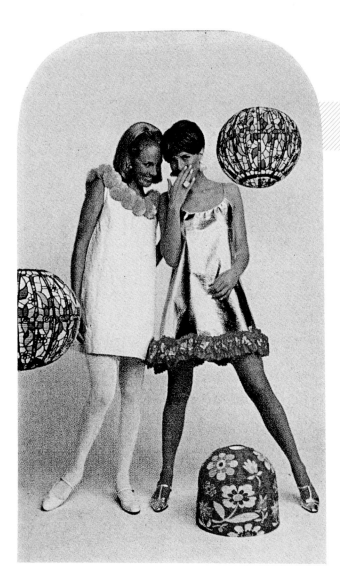

Paper party dresses by Miss Paper and Tiger Morse. *McCall's*, April, 1967.

Paper shifts and dresses designed with floral print, animal print, and two-toned print. *McCall's*, April, 1967.

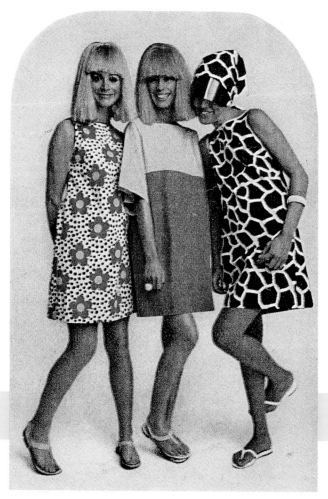

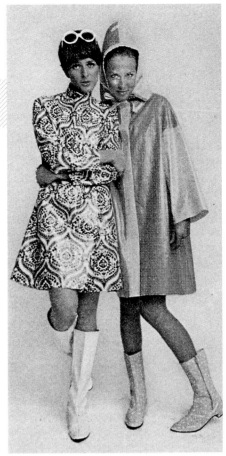

These paper raincoats were specially treated to provide "many wearings." The Persian print coat was designed by Veronica Marsh of London. Original price: $13. The two-toned example with matching hat retailed for $8.50 in 1967.

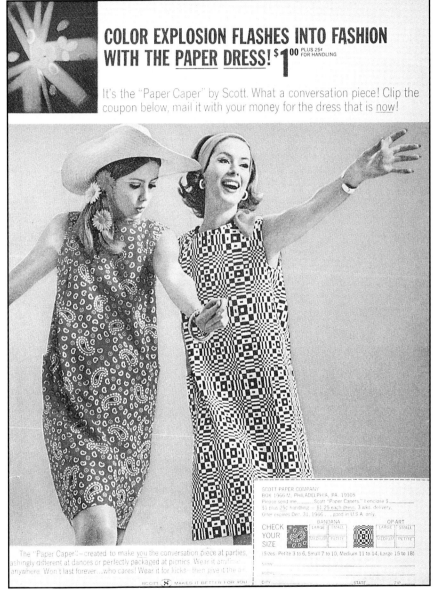

COLOR EXPLOSION FLASHES INTO FASHION
WITH THE PAPER DRESS! $1 00 PLUS 25¢ FOR HANDLING

It's the "Paper Caper" by Scott. What a conversation piece! Clip the coupon below, mail it with your money for the dress that is _now_!

The "Paper Caper"—created to make you the conversation piece at parties, dashingly different at dances or perfectly packaged at picnics. Wear it anytime, anywhere. Won't last forever...who cares! Wear it for kicks...then give it the air. SCOTT Ⓢ MAKES IT BETTER FOR YOU

SCOTT PAPER COMPANY
BOX 1966 M, PHILADELPHIA, PA. 19105
Please send me.........Scott "Paper Capers." I enclose $____.
$1 plus 25¢ handling = $1.25 each dress. 3 wks. delivery.
Offer expires Dec. 31, 1966.... good in U.S.A. only.

CHECK YOUR SIZE — BANDANA | OP ART
(Sizes: Petite 3 to 6, Small 7 to 10, Medium 11 to 14, Large 15 to 18)

Original advertisement from Scott Paper Company in 1966 promoting paper dresses in Op Art and bandana (paisley) prints. *McCall's*, June, 1966.

Paper wedding dress advertised in *McCall's* in April of 1967. The original retail price was $35.

155

Paper shift by Hallmark and a "party to match!" *McCall's*, March, 1967.

Gallery of Pucci Prints

The following pages show close-ups of some of the wonderful Pucci garments found throughout this book, each showcasing the the artistic nature of Pucci prints and the profusion of color for which he became famous. Silk jerseys, velvets, and cottons are shown. The signature "Emilio" is also displayed on many of the photographs.

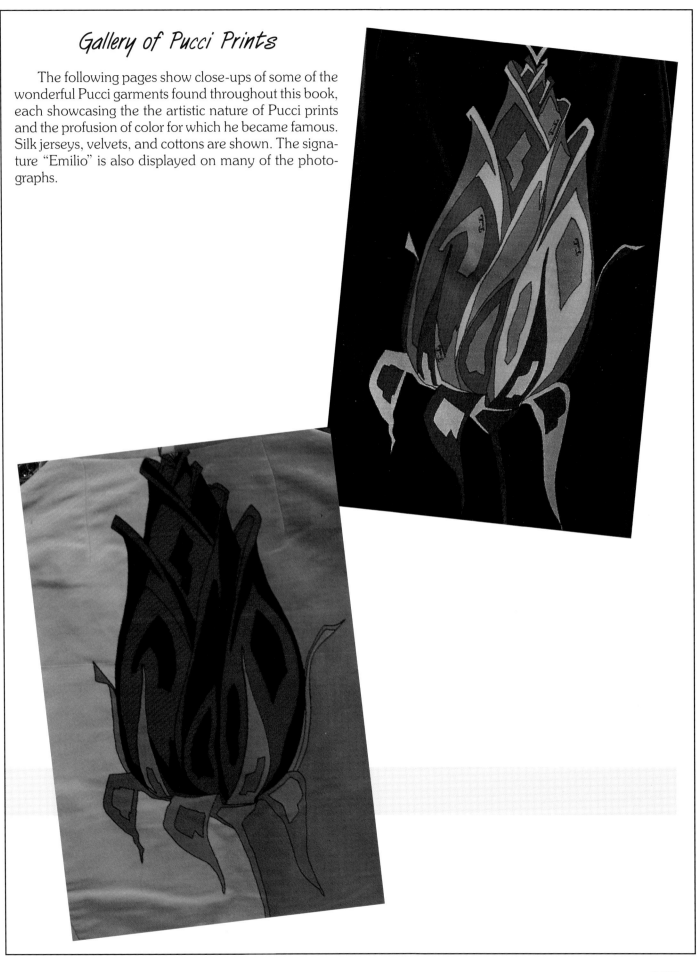

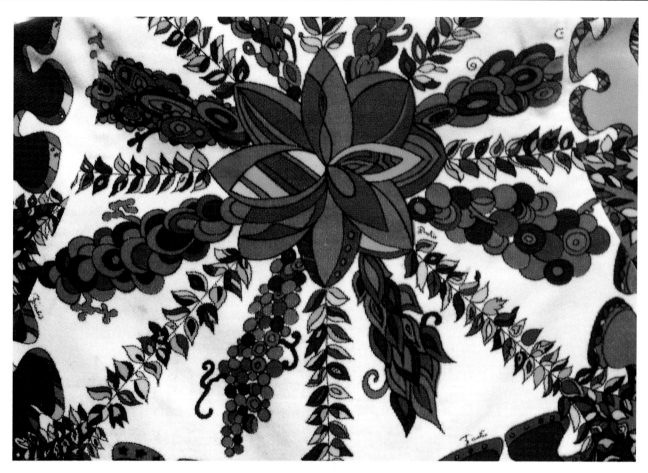

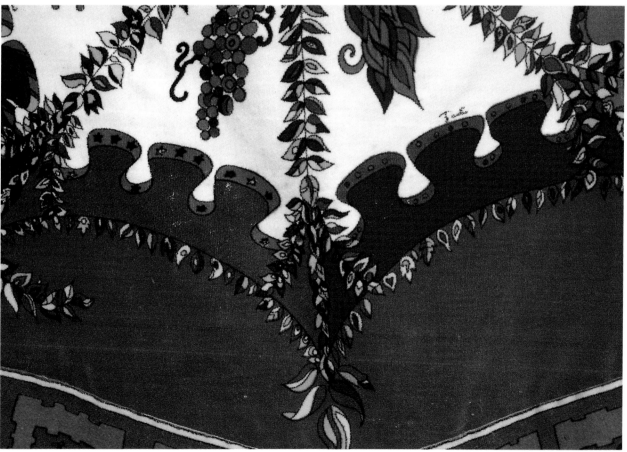

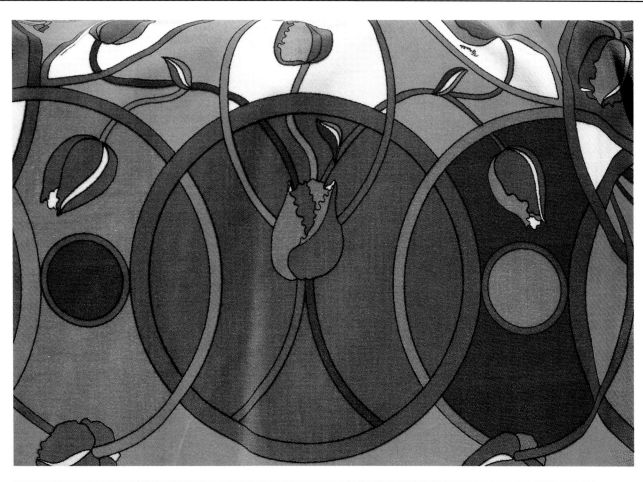

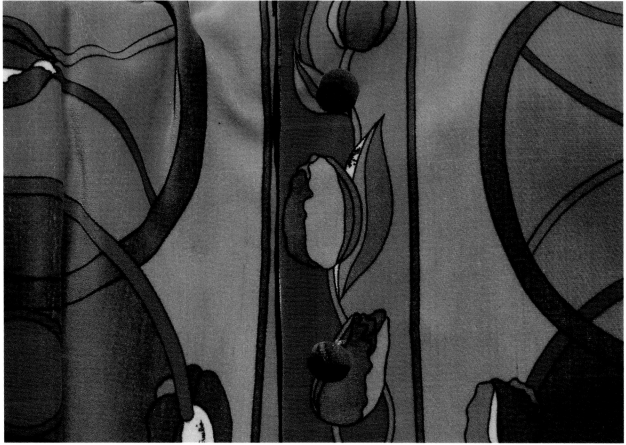

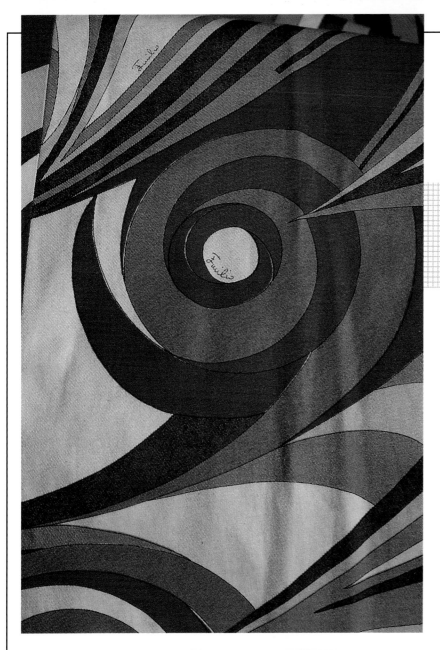

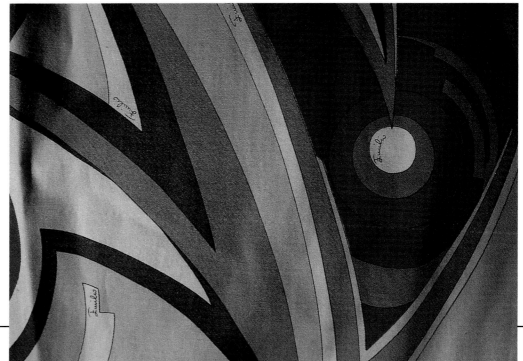

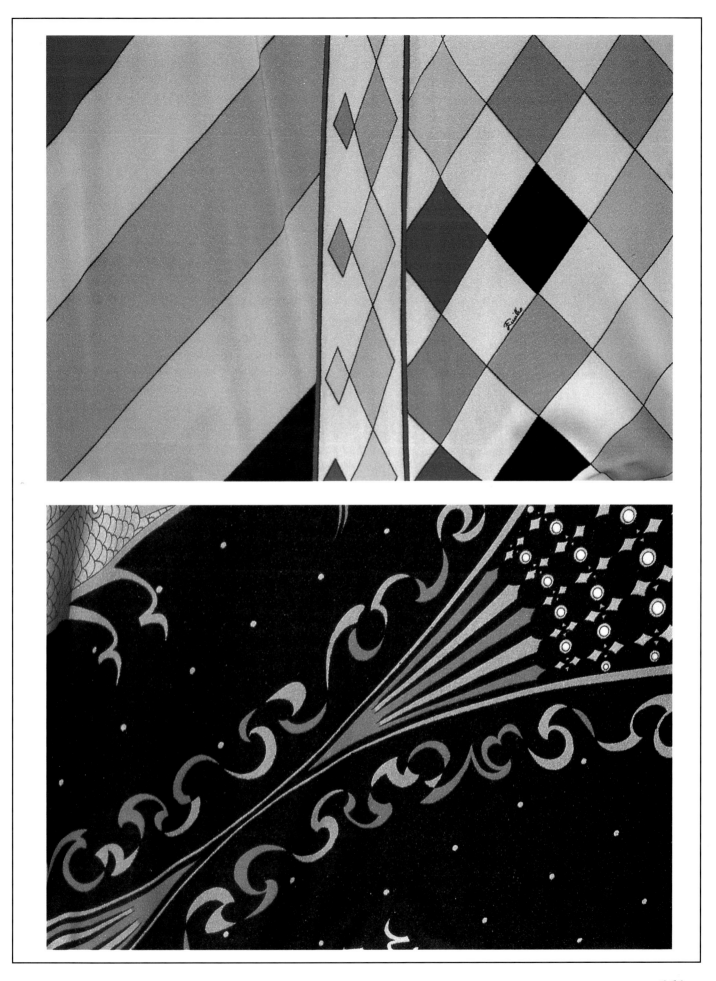

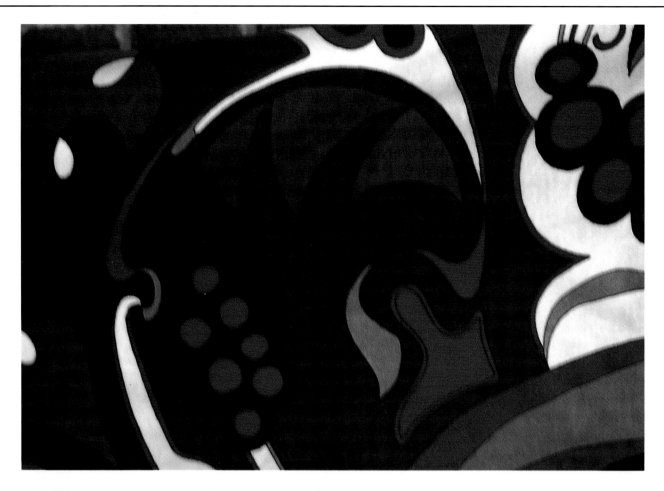

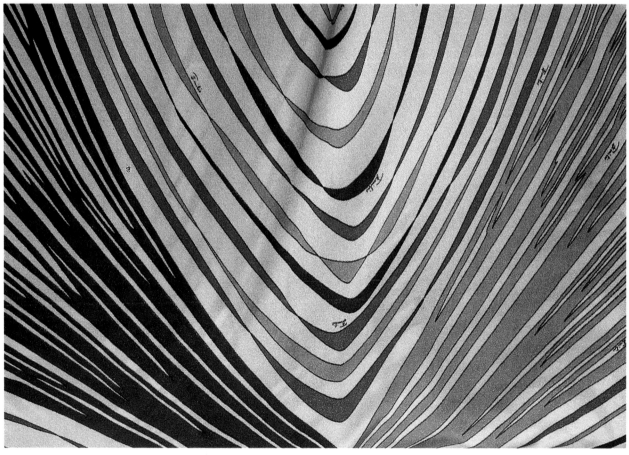

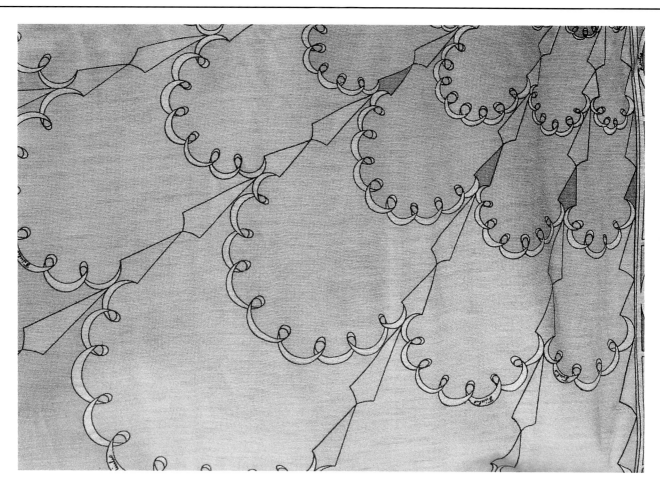

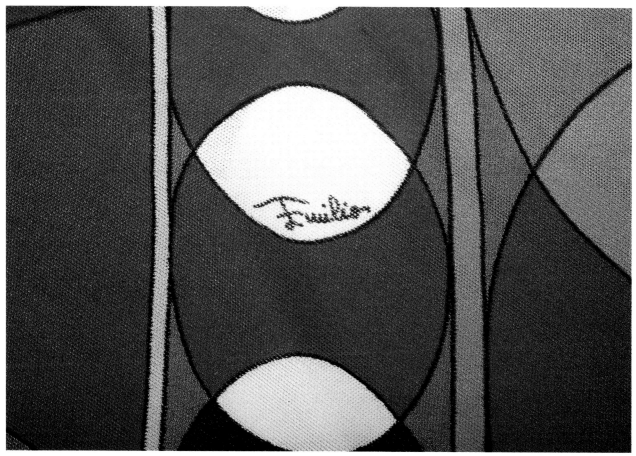

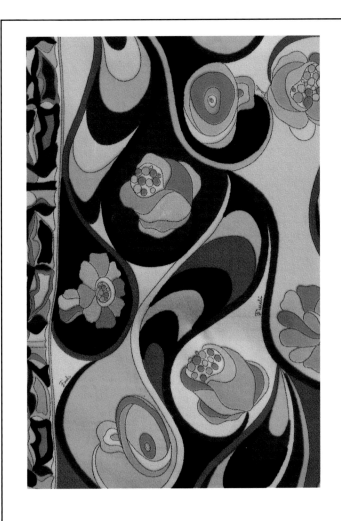

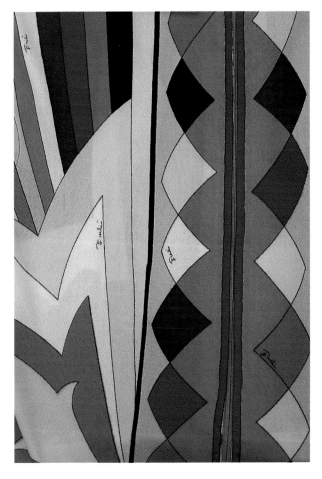

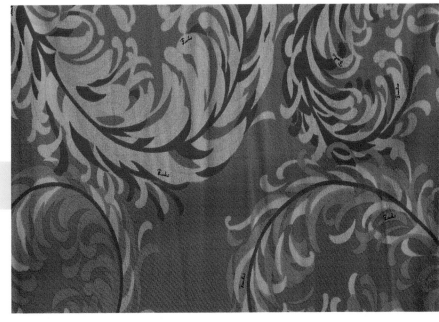

164

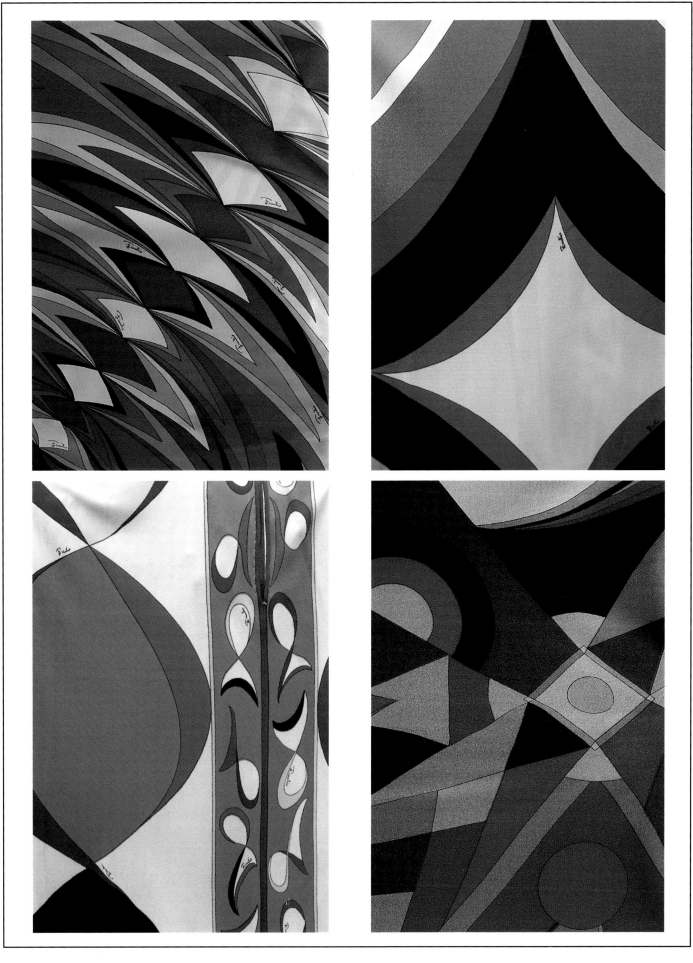

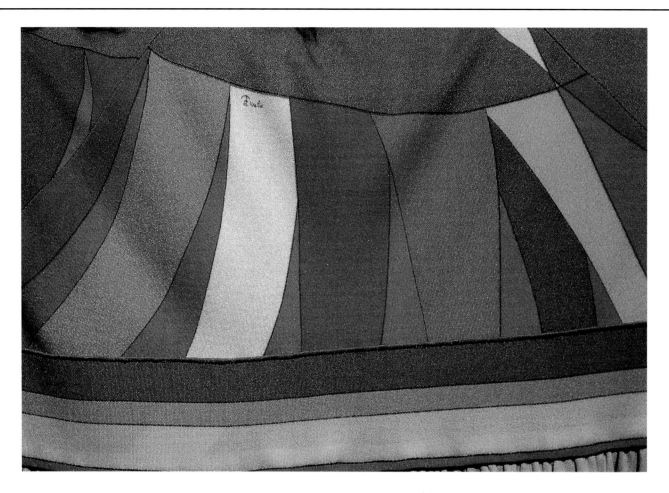

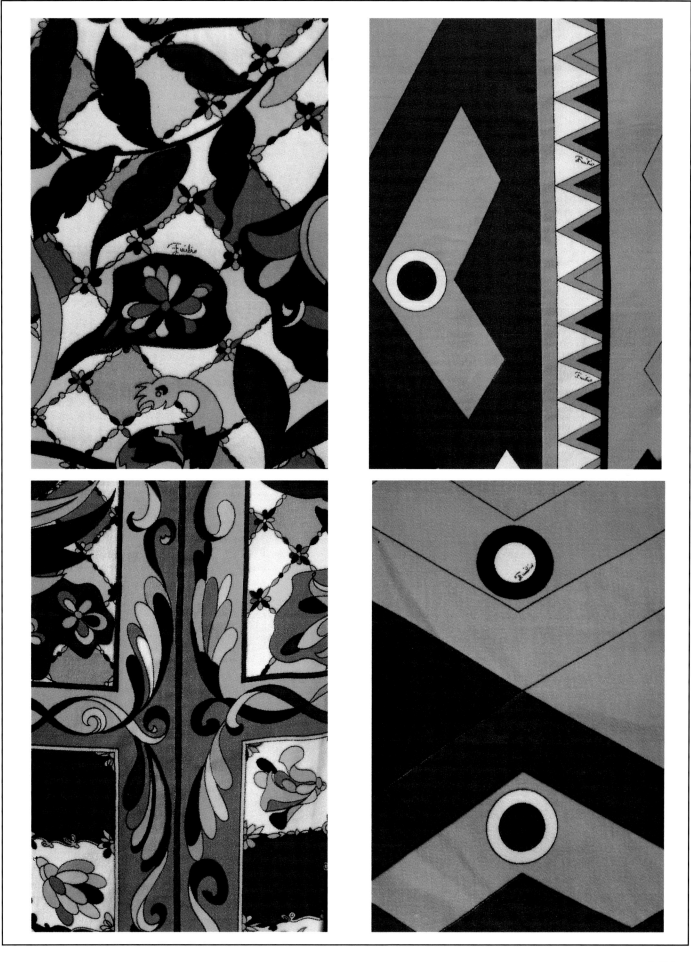

Candid Contemporaries

A renewed interest in 1960s and 1970s retro styles has been apparent for the last few years. Season after season, popular styles and prints from the past are entering the fashion scene once again. Clothing designed for all age groups and featuring floral, psychedelic, and Op Art prints is available in department stores, large chains, and even small boutiques and speciality shops. Polyester blouses with exciting conversation prints are in vogue once more. My three daughters are now wearing designs reminescent of what I wore almost thirty years ago. Now I really feel old!

The following candid photos display contemporary fashions with the retro look of the late 1960s and early 1970s. Is psychedelic chic making a comeback?

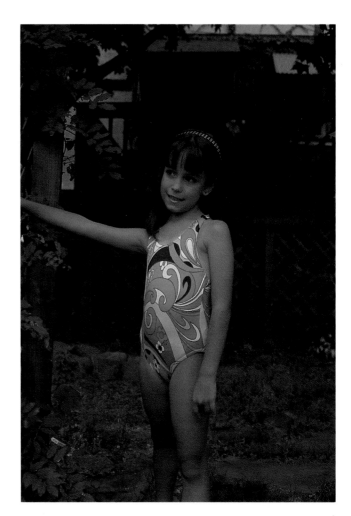

Contemporary Pucci-like bathing suits designed for little girls, modeled by the author's daughters, Sabrina and Alexandra Ettinger.

168

Floral shifts designed for little ones in the 1990s.

Above two photos:
More contemporary floral prints designed for
little girls. Sixties' retro is blooming again in the
Nineties.

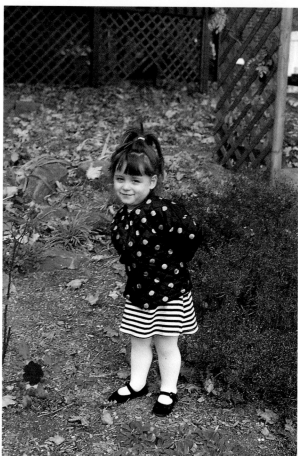

Contemporary animal prints designed for little ones.

Contemporary stripes and polka dots designed for the little "Mod."

170

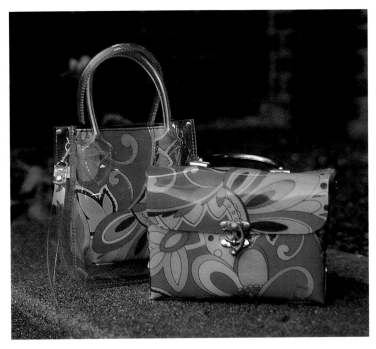

Contemporary vinyl handbags/
shoulder bags with Pucci-like print.
Made in China.

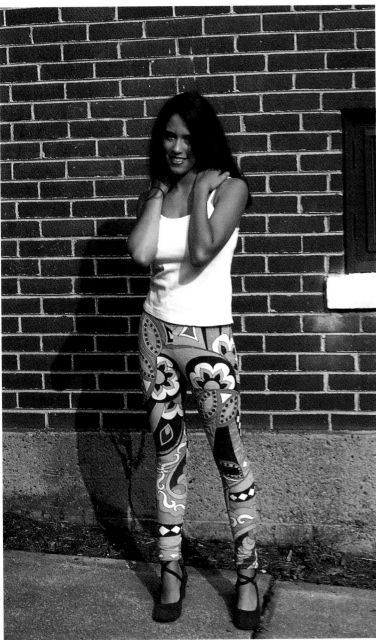

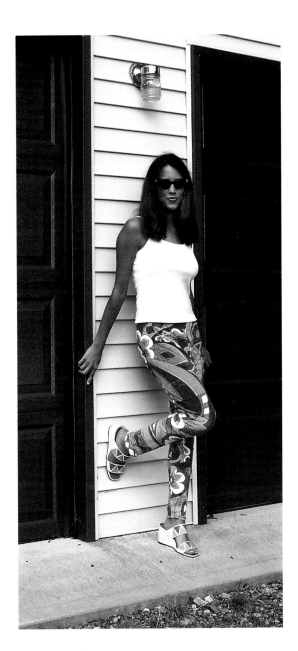

Left and above:
Amber modeling contemporary Spandex pants
with colorful Pucci-like prints. The fabric feels like
velveteen. It is made of 80% Nylon and 20%
Spandex. Labeled: Gottex. Made in Israel.

Contemporary cotton and lycra pants with Op Art print. Labeled: COTU'J Junior.

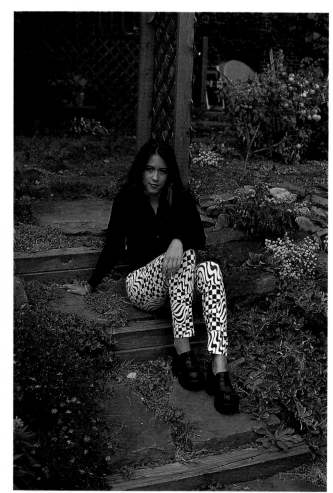

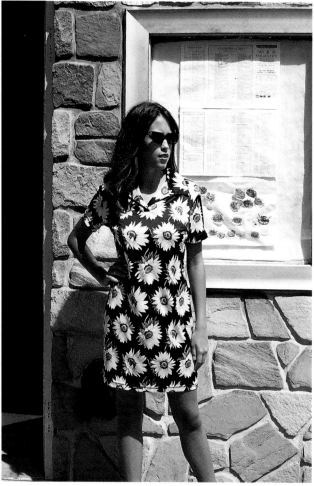

Contemporary short sleeve shift made of 100% polyester with silk-screened sunflower print. Labeled: Design 90.

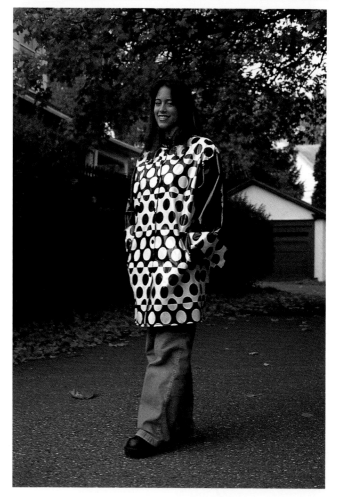

Contemporary vinyl raincoat with black and white Op Art pattern. Labeled: Items International. Made in Taiwan.

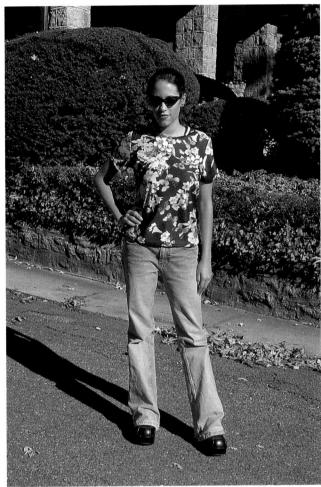

Contemporary short sleeved pullover top, made of nylon and spandex, with silk-screened floral and butterfly print. Labeled: Trends.

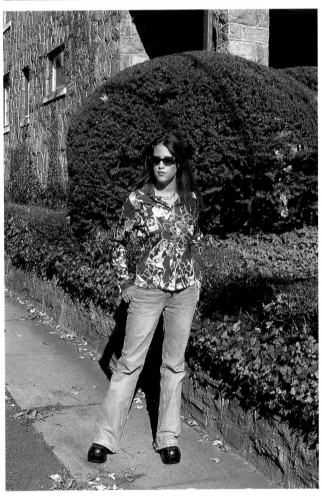

Contemporary conversation print blouse made of polyester, with black and white silk-screened images of famous jazz musicians. Labeled: Daniello.

Contemporary conversation print blouse with silk-screened images showing famous female stars of the silver screen. Printed large red roses add further interest. Labeled: Mgr.

173

Bibliography

Books

Bender, Marylin. *The Beautiful People*. New York: Coward-McCann, Inc., 1967.

Brady, James. *Superchic*. Boston-Toronto: Little, Brown and Company, 1974.

Ettinger, Roseann. *Popular & Collectible Neckties: 1955 to Present*. Atglen, Pennsylvania: Schiffer Publishing Ltd., 1998.

Kennedy, Shirley. *Pucci: A Renaissance in Fashion*. New York: Abbeyville Press Inc., 1991.

Catalogs

Aldens, 1967, 1968, and 1970.

J.C.Penny, 1969.

Montgomery Ward, 1960, 1965, 1966.

Sears, Roebuck & Co., 1968, 1969, 1970, and 1971.

Spiegel, 1968, 1969, and 1970.

William Doyle Galleries Auction Catalogs, 1997 and 1998.

Periodicals

American Fabrics, 1959 to 1969.

McCall's, 1966, 1967, and 1968.

Seventeen, May and June, 1967.

Vogue, 1969, 1970, 1971, and 1972.

Index